IMAGES
of America

CHICOPEE IN THE 1940S

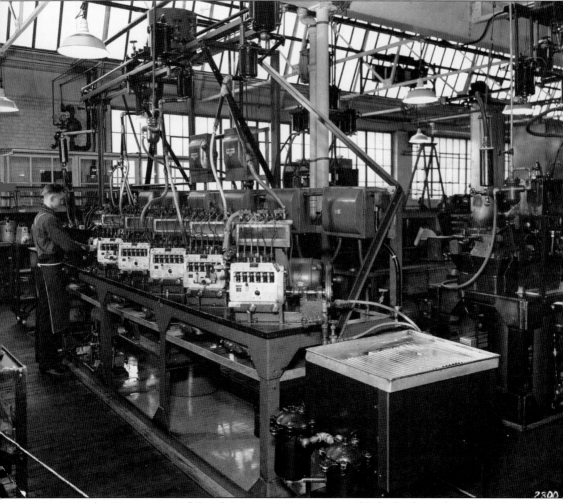

In 1910, the German-owned Bosch Magneto Company established a large factory on Center Street in Chicopee. Following World War I, the company's assets were purchased by American investors. The high tech operation became the American Bosch. Pictured here in 1939, Steve Jendrysik checks the run-in-stand as the fuel pumps undergo a final test before shipment.

On the cover: Pictured here in the Welcome Home parade are veterans marching up Exchange Street on October 12, 1946. (Courtesy of Florence Jendrysik.)

IMAGES
of America

CHICOPEE IN THE 1940s

Stephen R. Jendrysik

ARCADIA
PUBLISHING

Published by Arcadia Publishing
Charleston SC, Chicago IL, Portsmouth NH, San Francisco CA

Printed in the United States of America

Library of Congress Catalog Card Number: 2007929419

For all general information contact Arcadia Publishing at:
Telephone 843-853-2070
Fax 843-853-0044
E-mail sales@arcadiapublishing.com
For customer service and orders:
Toll-Free 1-888-313-2665

Visit us on the Internet at www.arcadiapublishing.com

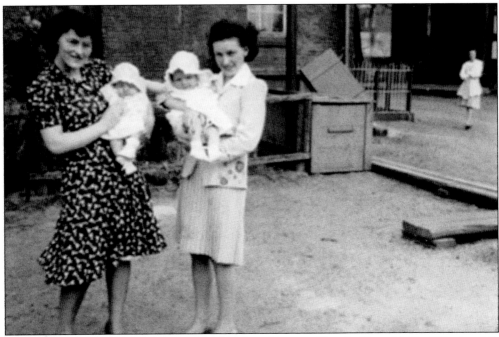

Antoinette Kostek (left) is holding her daughter Virginia Kostek Slate. N. Pat Wisniewski's (right) daughter Patricia Wisniewski Bogia was born on December 7, 1941. Unaware of the events of previous day, Pat awoke in her hospital room just as the nurses were installing the black-out curtains. The United States of America was at war.

CONTENTS

Acknowledgments 6

Introduction 7

1. Prelude to War: 1936–1941 9

2. The Dark Days: 1942–1943 37

3. The Tide Turns: 1944–1945 59

4. Homecoming: 1946–1947 91

5. Centennial: 1948–1949 111

ACKNOWLEDGMENTS

During my 10 year association with the *Springfield Republican*, my weekly column in the paper's *Chicopee Plus* edition has mirrored my fascination with the decade of the 1940s. This book is written in response to the urgings of my dedicated readers and their willingness to share their family pictures. The decision to embark on the project was positively influenced by the family of the late Peter Bardon. To a considerable degree, the availability of Bardon's classic photographic images of the city made this project possible.

Additionally I am most appreciative for the technical assistance provided by Dr. Mark Jendrysik, Dr. John Kozikowski, Sylvia Knowles, and Joseph Pasternak Jr. For the use of materials from their archives, I thank the Chicopee Historical Society, the Chicopee Public Library, the Connecticut Valley Historical Museum, the Edward Bellamy Memorial Association, the Elms College Library, MacArthur Memorial Archives, and the Westover Air Reserve Base.

For willingly sharing their vintage pictures, I am grateful to Thomas Bardon, Michael Baron, Susan Bartnik, Olen and Jane Bielski, Andrew Biscoe, Stella Boleski, Patricia Wisniewski Bogia, Kate Brown, Fred Burek, Raymond Burke, Catherine Hanifan Connor, Jean Crevier, Charles Dugre, Frank Faulkner, Ted Fijal, Sr. Mary Gallagher SSJ, Dick Haslam for the USO collection, Jim Heron, Anne Jendrysik, Florence Jendrysik, Linda Jordan, Madeline Sampson Kapinos, Helen Kitovich Kennedy, Chester Kobierski, Adrienne Krawczyk, Frederick Lafayette, Adele and Bob Love, Elaine Wajda Lavoie, James Lynch, Thomas E. Martin, Stanley Mazur, William Nieckarz Jr., Annette Okscin, Alfred Pinciak, Angela Przybylowicz, Stanley Stec, Emily Stefanik, Marilyn and William Stewart, Fran Sypek, Ann Szetela, Nadine M. Visosky, Gail and Tom Watson, Joanne Zaskey, and Clara Zawada.

I also wish to thank the many people who contributed photographs and memories that, for reasons of space, I was unable to include in this book. I wish I could have included them all.

INTRODUCTION

In his 1998 best seller, *The Greatest Generation*, Tom Brokaw wrote of America's citizen heroes and heroines who came of age during the Great Depression and the Second World War and went on to build modern America. In the decade of the 1940s, the men and women of Chicopee were truly contributing members of our nation's greatest generation.

In 1939, Chicopee was a small New England city with three distinct industrial districts. It was a classic mill town with tenement homes and red brick factory buildings perched on the banks of two rivers and a junction town with three small but vibrant retail centers. Each village had a unique flavor, with shops, stores, and markets providing the necessities of life in Depression–era America.

On September 19, 1939, 18 days after the outbreak of war in Europe, United States secretary of war Harry W. Woodring announced that the tobacco plains of Chicopee had been selected as the site for the Northeast's Army Air Corps base. The superbase named Westover Field was the nation's largest wartime aviation facility.

During World War II, the old mill town would be the smallest of four cities in Massachusetts to produce over a billion dollars worth of war materials. The city's war industries employed 22,000. It had 6,254 of its young people in the military, and 128 of those died in service.

In the postwar era, the cultural gurus such as the psychologists, sociologists, economists, and historians were predicting changes of epic proportions. They were all in agreement that the American way of life was in for a major makeover. In Chicopee, during the two years immediately following the conflict, very little changed as veterans returned to their peacetime careers.

By 1948, the city was in the midst of the cold war as jet planes made their first appearance over the tobacco plains of Westover Field. The newly created United States Air Force was engaged in the Berlin Airlift. In the first great postwar crisis, the local facility served as the command base for Operation Little Vittles.

Chicopee's depression-tested generation confidently raised their children in the uncertainties of an unstable world. They met the challenge as charter members of America's greatest generation united, not only by common purpose, but also by common values—duty, honor, economy, courage, service, love of family and country, and above all else, responsibility for oneself.

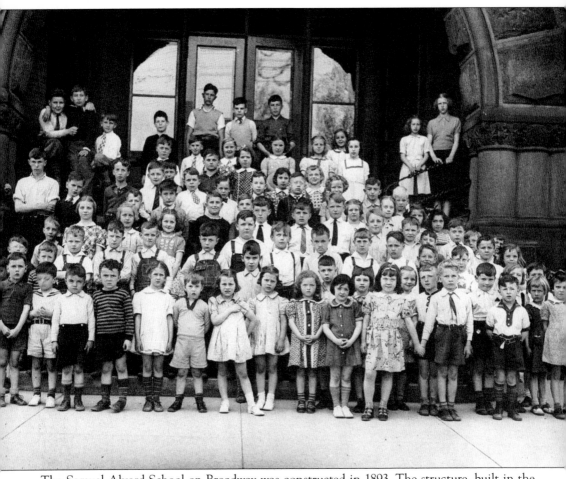

The Samuel Alvord School on Broadway was constructed in 1893. The structure, built in the Richardson Romanesque style, is named for its creator, the great American architect Henry Hobson Richardson. The broad Syrian arch, with its curve springing directly from the ground, created a cavelike effect around the entrances. In 1938, the school's students posed for the camera. These young Americans had a rendezvous with destiny.

One

PRELUDE TO WAR
1936–1941

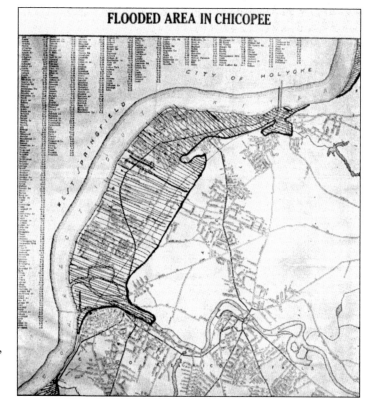

FLOODED AREA IN CHICOPEE

Of New England's many rivers, the Connecticut River alone runs the full length of this rich and historic region. For centuries, the river has given life. It is true that it takes life away, too, because from time to time, it has burst forth to destroy all that stood in its way. In March 1936, a torrent of water, mud, and ice brought massive flooding (illustrated here), creating a giant lake in the Willimansett section of Chicopee.

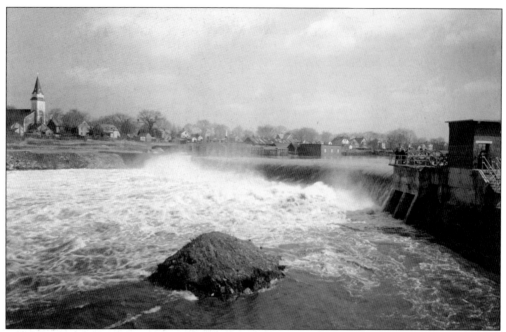

Between March 1 and March 20, 1936, rain in northern New Hampshire totaled an astonishing 19.5 inches. Then torrential rains fell across the entire region between March 16 and 19, and every river valley in New England dealt with flood crest conditions. Tons of water roared over the Chicopee Falls dam.

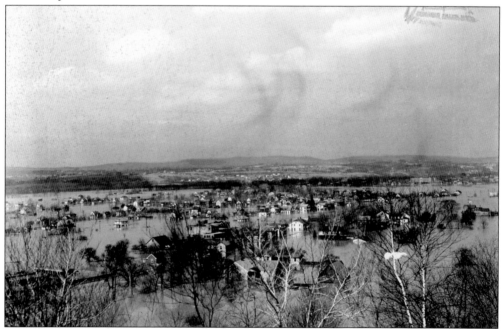

A flood in 1927 had caused a great deal of damage, and high water marks had been placed on many highways and buildings. When the flood of 1936 began to quickly rise above the 1927 high water mark, public officials realized they had a major problem on their hands. The rain created a giant lake in Willimansett and Chicopee Street was under 18 feet of water.

Mayor Anthony J. Stonina ordered all residents of Ferry Lane and Chicopee Street to vacate their homes. He sent an urgent appeal for federal and state assistance reporting that one-third of the city's population had been thrown on public relief. Stonina argued that his depression-ravaged city was unable to build dikes while wealthier communities were receiving funds for flood-control projects.

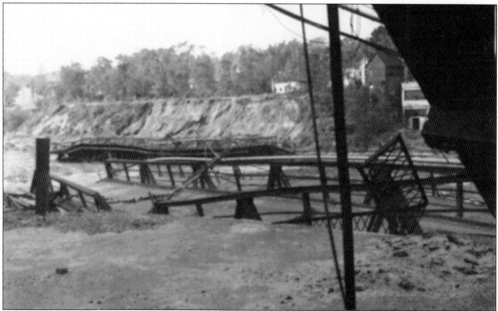

September 21, 1938, brought the hurricane they called the "Wind That Shook the World." The monster storm, which, to this day, is unmatched in its statistical fury with winds of over 100 miles per hour, began around 5:15 p.m. and lasted for over an hour. The wind stopped and the rain continued with "almost cloud-burst proportions," flooding the already devastated streets and wiping out the Chicopee Falls bridge.

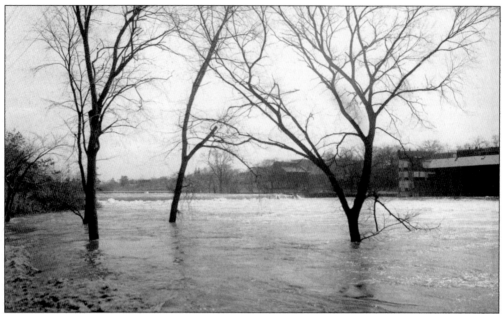

In Chicopee Center, the modern concrete William F. Davitt Memorial bridge that was built in 1930 withstood the onslaught of the storm, but the Chicopee River backed up into the lower floors of nearby factories. In Chicopee Falls, the Chicopee Manufacturing Company and the Fisk Tire Company were under 10 feet of water. For over a week, 200 refugees from flooded areas in Willimansett were lodged in city-owned buildings.

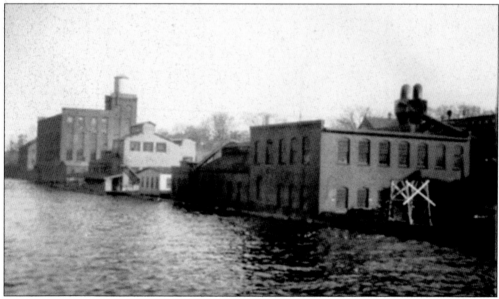

On October 7, 1938, with the city's industrial capacity at a standstill, Mayor Anthony J. Stonina outlined the city's plight in a letter to the White House. The response to the letter came from Harry W. Woodring, the secretary of war. The communication said, "You may be assured that the War Department appreciates the need for additional flood protection in the Connecticut River Basin and that every effort will be made to complete the projects at the earliest practicable date."

Between disasters, Tony Pimental, secretary of the Chicopee planning board, alerted the mayor's administration to the passage of the Wilcox Act. The U.S. Congress had authorized an eastern site for an air base. Chicopee had an ideal site—the tobacco plains on the old Granby Road. On November 22, 1938, a telegram was sent to the secretary of war indicating Chicopee's interest in the site-selection process.

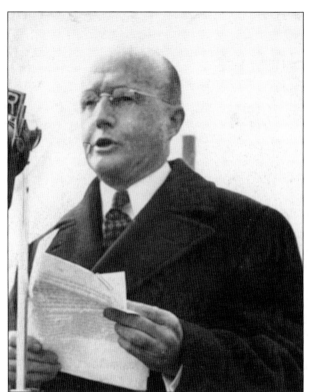

The players in the war department's decision to locate an Army Air Corps facility in Chicopee were Dr. Kenneth Fletcher, chairman of the school committee, who declared that the children of army personnel would be welcomed into the city's schools; Dr. John F. Kennedy, chair of the aviation committee; and Congressman Charles R. Clason (seen here), who presented the city's proposal in Washington, D.C.

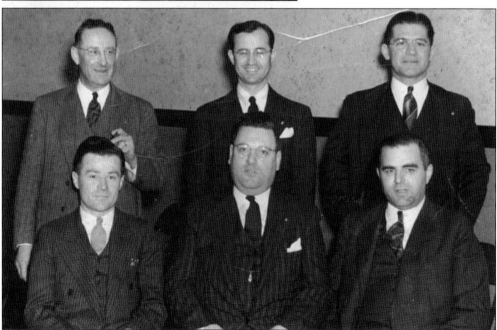

The Kiwanis Club was the city's most important service organization. The group marshaled local support for the establishment of a military airfield in the city. Club president John Korkosz (first row, far left) was a close, personal ally of the mayor. The proposal received nearly unanimous approval from community leaders.

The farmers living on the proposed site were less than enthusiastic about the plan, while the mayor's political opponents were quiet. His support in the Polish community waned. In his book, *Westover: Man, Base and Mission*, Dr. Frank Faulkner comments, "Mayor Stonina had a hard time convincing many of Chicopee's Polish farmers that taking their land was in the best interests of the nation."

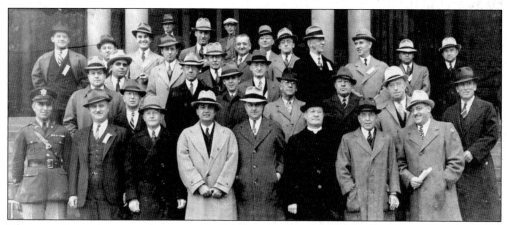

The mayor's aviation committee provided U.S. representative Charles R. Clason (first row, third from left) with the necessary data. Clason urged army generals to consider the tobacco plains because the variation in elevation was only one foot. In July 1939, the mayor took a group of army officers on a guided tour of the Chicopee site and sold them on the tobacco flats.

The city's 10-man aviation committee included Joseph Lafleur, who was the president of the board of aldermen. Lafleur worked hard to convince his fellow aldermen that it would be an economic milestone to locate the base here. In August, the mayor's ally at the state house, Sen. Chester T. Skibinski (second from right) petitioned the legislature to clear obstacles to federal land taking. The next day, the senator left on a trip to Poland.

On August 8, 1939, a truck convoy of army engineers arrived from Alabama. They were here to begin survey work on the flat area of Chicopee and Ludlow. Here aviation committee member Ted Szetela (third from left) takes the visitors on a tour of the site. During their visit, military officials indicated a decision on the site would be forthcoming.

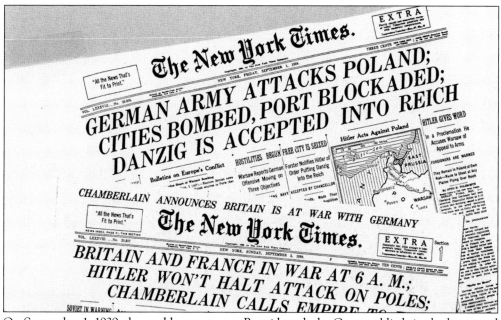

On September 1, 1939, the world went to war. By mid-week the German blitzkrieg had captured the world's attention. England and France declared war on Germany but did little to help the valiant Poles. State senator Chester Skibinski, just back from Poland, briefed the mayor. At a press conference, he commented that the Europeans firmly believe that the United States would enter the war before long.

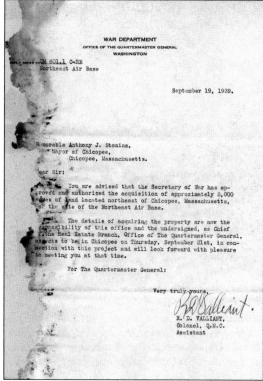

Two weeks after the outbreak of hostilities, secretary of war Harry W. Woodring announced that the tobacco plains had been selected as the site for the Northeast Army Air Corps Base. Pictured here is the original water-stained communication that informed the city that the chief of real estate from the office of the quartermaster would arrive on September 21 to begin taking over the land.

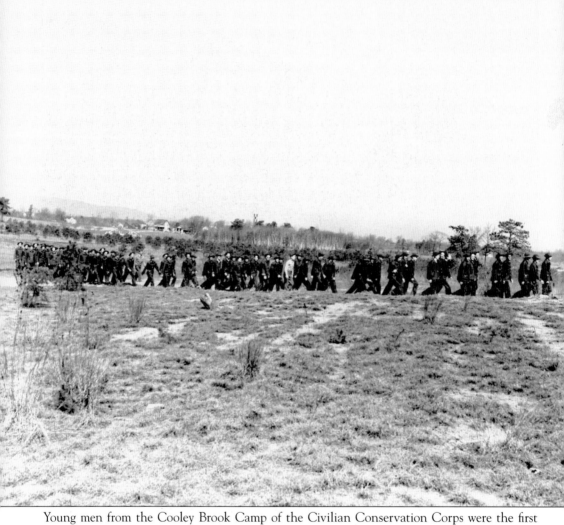

Young men from the Cooley Brook Camp of the Civilian Conservation Corps were the first marching men on the tobacco plains. They were assigned the task of clearing brush and scrub pine. The war department had allocated $2,070,918 to purchase a 7.5-square-mile plot for the air base. Notices were sent to 129 individual property owners stating that the United States government technically owned their property.

The first construction equipment arrived on October 2, 1939. Maj. Murdock A. MacFadden, construction quartermaster assigned to supervise the work, set up his temporary headquarters in the vacant isolation hospital building in Aldenville. Two weeks later U.S. Attorney Edmund J. Brandon filed an order of seizure by eminent domain and deposited $2,070,918 with the federal court in Boston.

The gem of Anthony J. Stonina's public works program was the development of the Bemis family property on Front Street. The facility that was built was the community's largest Works Progress Administration project and, to this day, is a frequent venue for high school state championship games.

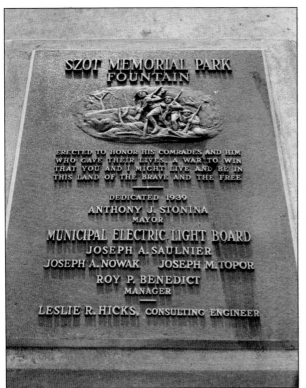

On Saturday afternoon, October 15, 1939, the city dedicated the new park on Front Street. Frank J. Szot was the first soldier from Chicopee killed in World War I. A lighted fountain, dedicated that day, honored the Chicopee men who served in the war. The unique facility, modeled after those at the 1939 New York World's Fair, cost $17,000 and was paid for by the Chicopee Electric Light Department.

Federal and state officials and members of Szot's family were honored guests. The damp, cloudy day fit the times, especially for Chicopee's Polish Americans whose homeland had fallen to Adolf Hitler and Joseph Stalin in the closing days of September. The dedication ceremonies honored the heroes of the last war, while the speeches confirmed the looming specter of another war.

The Massachusetts Works Progress Administration earmarked $750,000 for site preparation. As Chicopee people were being hired, residents of the plains were receiving their eviction notices. Failure of the property owner to take the amount offered by the government permitted the owner to challenge the condemnation order in court. The government offered between 20 to 40 percent above the properties assessed valuation.

The track's largest parcel, owned by the Consolidated Tobacco Corporation, accepted the government's offer, and the heavy equipment moved in. Small landowners argued that the original assessments by the city were too low. Many went to court, where in the atmosphere of a national crisis, they lost. Local people who worked for Consolidated Tobacco Corporation became unemployed. The tobacco farm workers and the independent farmers blamed the Anthony J. Stonina administration.

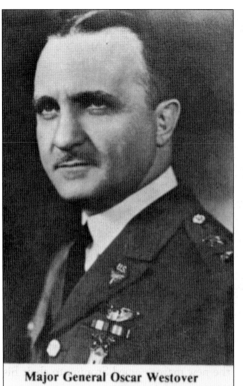

Major General Oscar Westover

In 1938, Gen. Henry (Hap) Arnold became the Army Air Corps chief of staff after his friend Maj. Gen. Oscar Westover died in a plane crash. Arnold announced on December 1, 1939, that the airfield under construction in Chicopee would be designated Westover Field. Westover, a two-star general who died at age 55, was a pioneer of military aviation.

In December, Maj. Murdock A. MacFadden, construction quartermaster, received the approved layout plan for the new airbase. The original plan called for housing, a chapel, a theater, a post office, a library, a gymnasium, a hospital, a fire and guard house, as well as hangars, barracks, mess halls, a railroad spur track, and runways. Pictured here, army civil engineers inspect sewer work.

The committee to reelect Anthony J. Stonina highlighted Westover Field as the hope for the city's future. As construction for the new base sewer line began, the mayor's fate was sealed. Franco-Americans residents of the city united in support of the chairman of the board of assessors, Leo P. Senecal. Soon after the election, the new mayor named Stonina to chair his aviation committee.

April 6, 1940 was designated "army day" in the Pioneer Valley. As air corps officers, state and local dignitaries, and thousands of area residents gathered for the official dedication ceremonies, former Chicopee mayor Anthony J. Stonina led the groundbreaking as work crews took a brief break to watch the ceremonies.

In April 1940, workers from the Civilian Conservation Corps and the Works Progress Administration were hard at work clearing the site, and contractors began laying miles of water and sewer lines. That month, as war raged in Europe, the U.S. Congress debated a massive increase in defense spending. Eventually the law provided an added appropriation of $5 million for Westover Field.

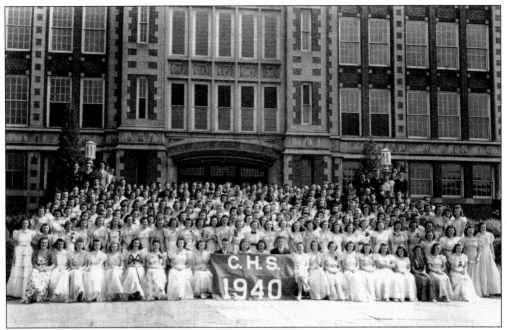

During the warm spring days of 1940, the seniors at Chicopee High School relished the final weeks of high school. The local economy had rebounded. Their families were making plans for graduation parties in recognition of their academic achievements. For many, they were about to become the first member of their family to graduate from high school.

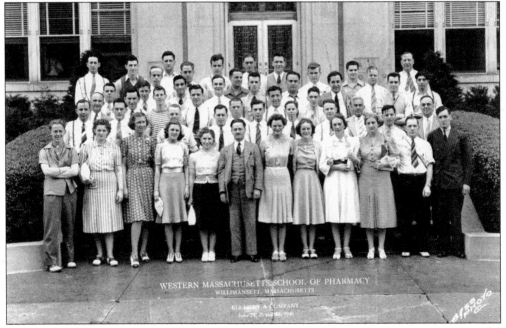

The Western Massachusetts School of Pharmacy was located at 694 Chicopee Street in the Willimansett section of the city. In this group photograph, the students were visiting the research laboratories of Eli Lilly and Company. The three-day field trip in June 1940 was under the supervision of the school's dean, Dr. Joseph Gagne (first row, center).

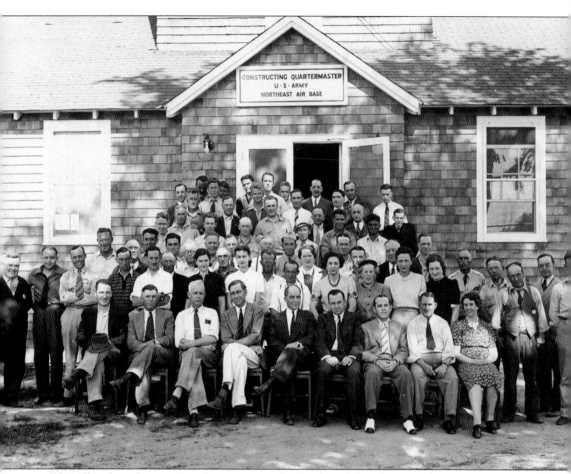

After months of operating from tents and abandoned farmhouses, the engineering staff moved into its new headquarters on July 20, 1940. That week, a New Jersey firm was awarded a $1.6 million contract to erect five huge steel and brick hangars. The staff took time out for a photograph. Maj. Murdock A. McFadden, construction quartermaster (first row, fifth from left), was dealing with constantly changing orders, as the military situation in Europe deteriorated.

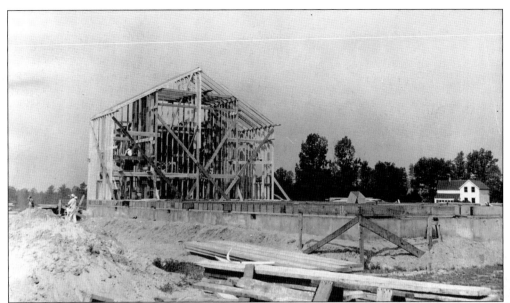

Five enlisted men arrived from Maxwell Field in Alabama on July 29, 1940. They were the first U.S. Army Air Corps men to be stationed at Westover Field. Construction crews had just started building the new barracks. Airmen Glenn E. Flanders of Mississippi reported that, "There were no runways, no hangars here. I remember a pilot landing and taking off from a tobacco field." On September 14, 1940, in response to Adolf Hitler's conquest of Europe, congress instituted a peacetime military draft.

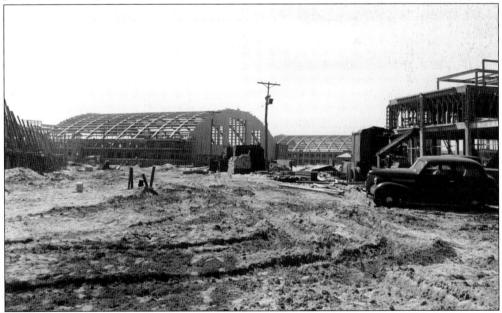

As the pace of construction quickened on October 16, 1940, as 8,500 Chicopee men between the ages of 21 and 30 registered at various polling places for the nation's first peacetime draft. The first call was for six registrants. It was immediately answered by volunteers, including Leo Gagnon, Edward J. Martel, Edward W. Midura, Eugene F. Petit, Walter Zajachowski, and Albert Granger.

That month, the construction of the first permanent building was complete. The brick photographic laboratory was officially accepted by the war department. On October 10, 1940, a B-10 Bolo Bomber became the first to land at Westover Field. On board for the initial flight was second district congressman Charles R. Clason.

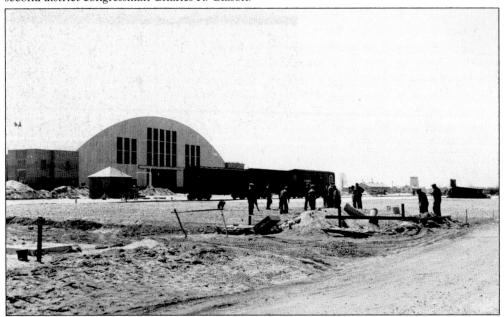

In November 1940, Pres. Franklin D. Roosevelt won the reelection, promising that the nation's young men would not be sent to fight on foreign shores. As the first giant hangar took shape, the new base commander, Col. Richard H. Ballard, arrived. By January 1941, the original plans had been scrapped and 1,600 construction workers employed by 10 firms were building the largest air base in the country.

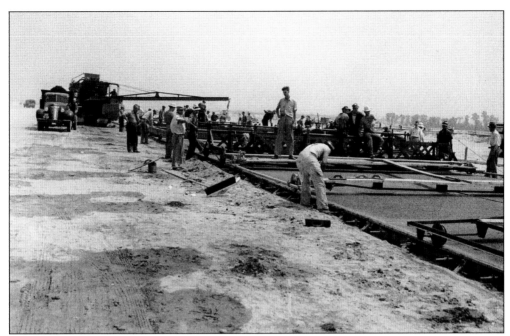

In Chicopee's taverns and pool halls, men were talking about a war the country was not a part of. On the tobacco plains, workmen were building the longest runways on the East Coast. Westover Field was designed to have four runways, two of which were more than two miles long, and two about a mile and a half long.

In *Westover: Man, Base and Mission*, Dr. Frank Faulkner wrote, "As the Battle of Britain raged, Westover Field became touted as 'America's biggest air base.'" The *Boston Sunday Advertiser* noted on March 23, 1941, that "the largest hangar at Mitchell Field would fit inside one of Westover's five hangars and the main landing strip was twice the length of the runway at Boston Airport."

According to the base's public relations officer, by the beginning of 1942, the base would be fully operational with five hangars, a brick fire station, 106 buildings housing nearly 3,000 troops, a 500,000-gallon water tower, and 12 miles of roads. The people of Chicopee were convinced that a small city was being built on the plains.

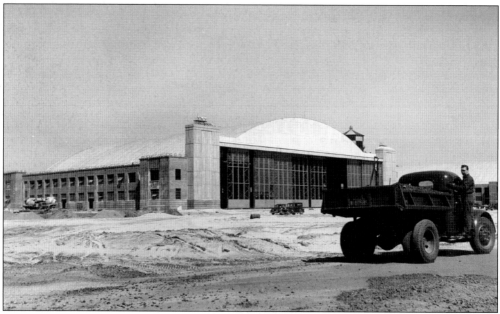

On June 22, 1941, Adolf Hitler launched a massive assault on the Soviet Union. Joseph Stalin requested and immediately received aid from the United States and Great Britain. In Chicopee, the locals were picking berries at Johnny Cake Hollow in the Cooley Brook watershed and watching the feverish pace of base construction. Hundreds of tank trucks were transporting aviation gasoline to storage containers for 200,000 gallons of fuel.

On June 10, 1941, five silver B-17s with red and white rudders flew low over Chicopee and landed on the new runway. The arrival of the B-17s marked the true activation of the base. By the end of the month, the 13-mile fence around Westover Field was complete, and the base was officially closed to the public.

Stanley Stec and his buddies were set to join the army but were informed that they were about to be drafted. On March 12, 1941, there was 10 inches of snow on the ground as the young men walked to the draft board office in the Ferris building on Center Street. Barely trained, within weeks, the 26th Infantry Division, nicknamed the Yankee Division, was in North Carolina participating in the largest military exercise staged on American soil.

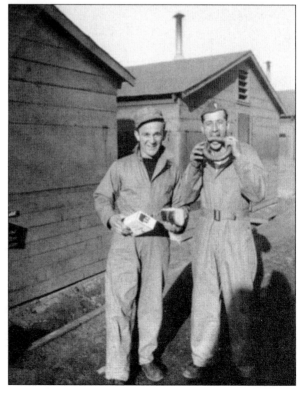

Here are Frank Jazab (left) and Steve Koknicki with a kielbasa sent from home. The guys from Sandy Hill, Ferry Lane, China Town, and the West End were not soldiers yet, but they realized that, in 1941, the U.S. Army was still a work in progress. The outfit returned to Camp Edwards on Cape Cod on December 6, 1941, as their one-year enlistments were up.

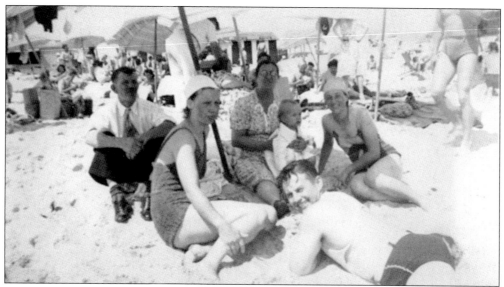

For Chicopee's summer beach crowd, Misquamicut Beach in Rhode Island was the favorite destination. During the summer of 1941, one-year-old Steve Jendrysik made his first trip to the beach. The three-hour trip was a family affair. Pictured here in the foreground are Lena and Andrew Jendrysik; in the background are Zygmunt, Katarzyna, and Anne Jendrysik.

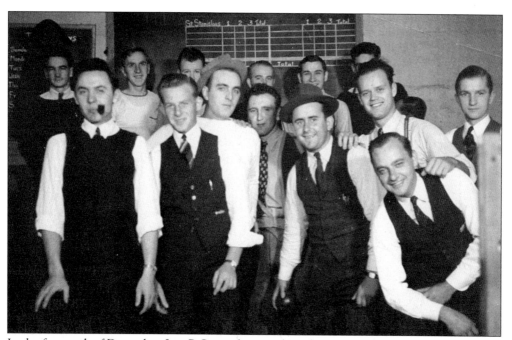

In the first week of December, Leo P. Senecal was reelected to a second term as the city's mayor. The communities' numerous bowling leagues were organizing their winter schedules. At the St. Stanislaus Lanes, members of the Polish Falcons Team look on as Martin Topor (first row, third from left) prepares to start the new season.

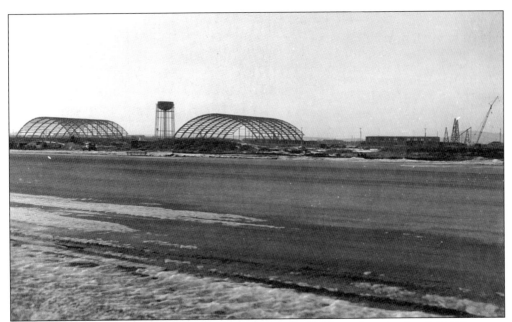

An early snow covered the rapidly-growing base in 1941. In November, the first B-24 Liberators began arriving at Westover Field and were assigned to the 34th Bombardment Group. The Liberators immediately began antisubmarine missions to protect convoys carrying war materials to the embattled British Isles. A week after their arrival, antiaircraft guns were installed, and machine gun positions were set up along roads leading to the base.

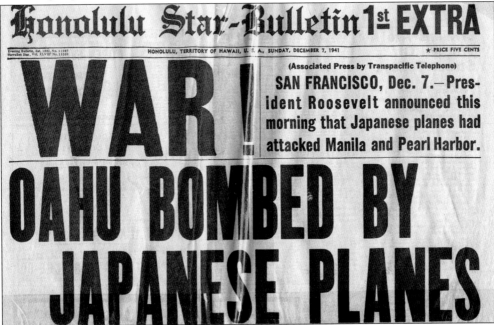

Honolulu Star-Bulletin 1st EXTRA

Evening Bulletin, Est. 1882, No. 11267
Hawaiian Star, Vol. XLVIII No. 15269 HONOLULU, TERRITORY OF HAWAII, U. S. A., SUNDAY, DECEMBER 7, 1941 ★ PRICE FIVE CENTS

WAR !

(Associated Press by Transpacific Telephone)

SAN FRANCISCO, Dec. 7.—President Roosevelt announced this morning that Japanese planes had attacked Manila and Pearl Harbor.

OAHU BOMBED BY JAPANESE PLANES

Retired Chicopee attorney John Wagner recalls, "I was studying for exams while attending American International College. At the same time I was listening to a football game between the New York Giants and the Green Bay Packers which was broadcast over the radio. The game was interrupted with the news of the attack on Pearl Harbor by Japan. It was hard to believe."

Radioman first class Joseph Gosselin, who grew up on Maple Street in Chicopee Falls, was the son of Adolph and Herminie Gosselin. He enlisted in the navy on March 24, 1936. On that fateful Sunday morning, he was 5,000 miles from home and in harms way. At around 8:10 a.m., Gosselin was aboard the USS *Arizona* when it exploded after being hit by 1,760-pound armor piercing bomb.

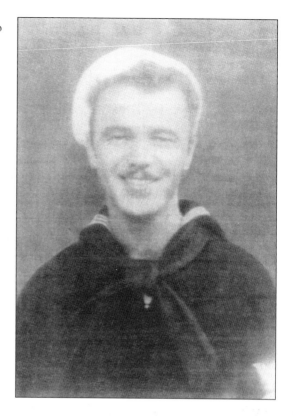

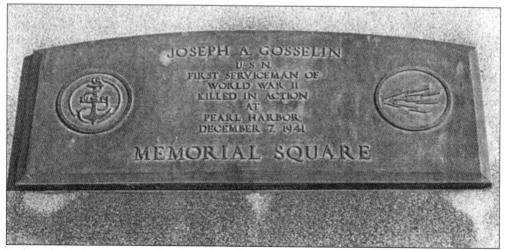

In less than nine minutes, the *Arizona* sank with 1,177 of her crew. They are, to this day, entombed in the Arizona Memorial at Pearl Harbor. America was in the war for less than 15 minutes when Gosselin became the first Chicopee casualty. In his memory, the city established Gosselin Square at the foot of Memorial Drive in Chicopee Falls.

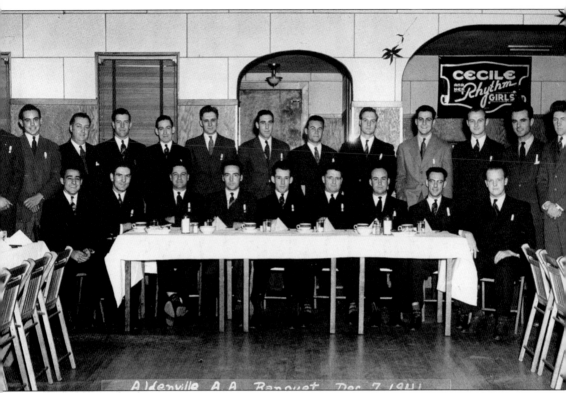

The Aldenville Athletic Association was one the area's most dominant athletic powerhouses. Pictured here at their annual awards banquet, the association was celebrating another successful season. When the news of the war reached the hall, plans for the 1942 season seemed premature, and games were cancelled. Pictured, from left to right, are (first row) Norman "Goose" Gosselin, Edward Benoit, Valere Desrochers, Jim O'Neil, Raoul "Chic" Chicoine, Alec McDonald, Rene "Sparky" Harnisch, William (Billy) Fortin, and Gil Brown; (second row) Roland Cote, Sam Carrigan, Edward Beaulieu, Charles McDonald, Roland "Pep" Henault, Frank "Dago" Strepka, Paul Lussier, William (Billy) Marczak, Lawrence "Lefty" Skinner, Armand "Pete" Fortin, Ted Kozaka, Al "Tootsie" St. George, and Art Parsons.

Two

THE DARK DAYS
1942–1943

As the new year dawned, Americans awakened to a National Day of Prayer, declared by their commander-in-chief, Pres. Franklin D. Roosevelt. Their prayers were backed by the moral outrage of nations world wide. On January 1, 1942, 26 nations signed a declaration stating that they would pour all possible resources into the war against the Axis powers.

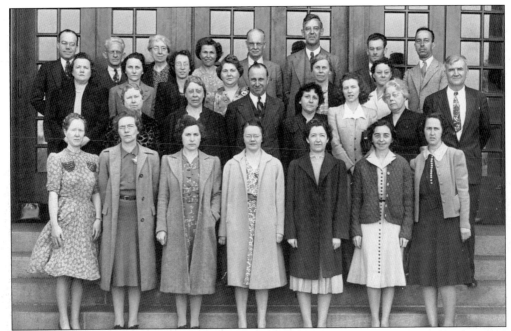

In the early days of 1942, the faculty of Chicopee High School, pictured here, faced a myriad of challenges as the young people in their charge entered the most uncertain year in American history since the out-break of the Civil War. Principal Christopher Fitzgerald (fourth row, third from right) would lead the school through the unnerving remaining three years of global war.

HOW YOU CAN QUALIFY TO WIN YOUR WINGS IN THE *AAF*

Answers to questions most frequently asked about the Army Air Forces and the Air Corps Enlisted Reserve by young men and their parents

In 1942, the U.S. Army Air Forces were charged with the responsibility of bringing the war to the German mainland. High schools all over the country were urging students to enroll in science and math classes in order to qualify to win their wings. On January 30, 1942, 21-year-old Lt. Thomas C. Bittner of a prominent Trenton, New Jersey, family was Westover Field's first fatality. The sobering news of aircraft accidents at the base did not deter the volunteers.

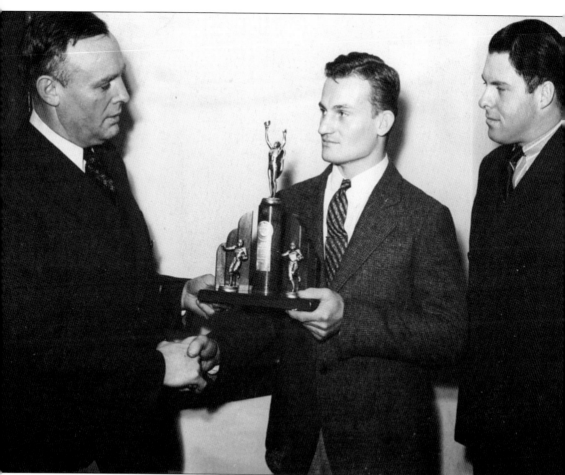

Chicopee's most illustrious athlete, Bronislaw J. "Bones" Stepczyk, receives Brown University's most valuable player award. Stepczyk, who was cocaptain of the football team, joined the U.S. Army Air Corps following graduation in 1942. He was killed in the closing days of the war and is buried in Arlington National Cemetery.

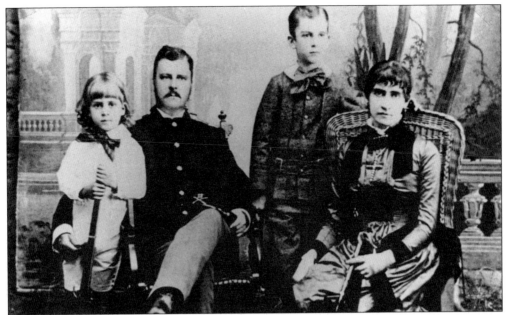

Newspapers reported that Lt. Gen. Douglas MacArthur, who was in command of the American army in the South Pacific, had ties to Chicopee. He was the son of Lt. Gen. Arthur MacArthur, who was born in Chicopee Falls. Douglas is pictured here with his parents, Mary and Arthur, and his older brother Arthur III. Both father and son commanded American forces in the Philippine Islands.

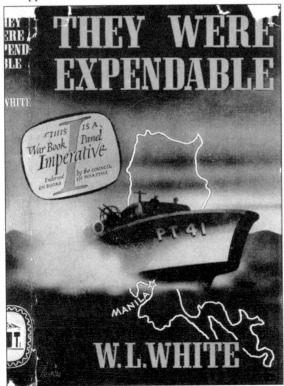

In *They Were Expendable*, W. L. White tells the story of Douglas MacArthur's daring escape from the Philippines. Featured in the book was chief torpedoman's mate John L. Houlihan of Chicopee Falls. Houlihan was credited by MacArthur with saving lives when he disarmed a live torpedo during the dramatic escape.

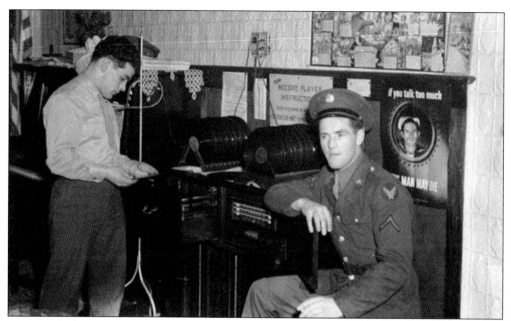

On March 15, 1942, the United Service Organization established the Westover USO Center at the corner of Church and Main Streets in Chicopee Falls. The facility, housed in the old Chicopee Falls High School, provided a home away from home for soldiers training for the air war in Europe. Dr. Lester Crasper of Springfield College was appointed the center's first director.

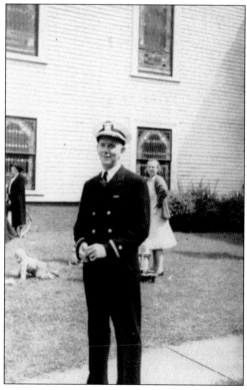

The USO served local soldiers who were home on leave. Pictured here attending services at the Chicopee Falls Methodist Church is Lt. Clayton Cartmill. Cartmill and his twin brother, Clifton, both graduated from Springfield College and joined the navy. Clifton was serving in Coral Gables, Florida, while Clayton was preparing to leave for duty in the South Pacific.

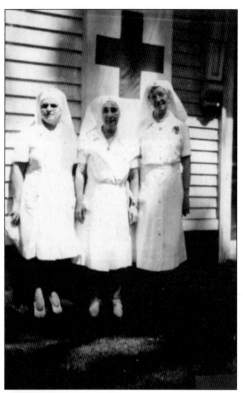

The Church Street USO center coordinated the Red Cross volunteer program in Chicopee Falls. Pictured here, from left to right, are Mrs. Frank Witherspoon, Helen Sampson, and Jennie Sampson, who met weekly at the Chicopee Falls Congregational Church, where they spent the entire day rolling bandages for the war effort.

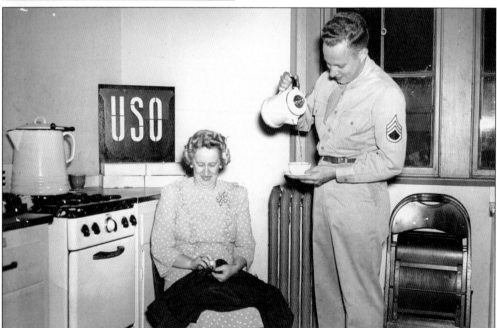

A senior hostess repairs a soldier's jacket in the kitchen of the Church Street USO center. In 1942, the city turned the building over to the USO without rental charges for the duration of the war. The city contributed $5,000 toward the renovation of the building. In June, the USO approved an appropriation of $17,760 to upgrade the facility.

Chicopee residents were living under blackout conditions every night. An army of volunteer air wardens were on patrol in every ward. Fire chief Albert N. Bunyan had trained an auxiliary defense firefighting force of 100 and was responsible for the air raid alarms and sirens. Police chief Francis Linehan had an equal number of auxiliary police officers and a volunteer mounted patrol guarding the Cooley Brook Watershed.

Madeline Sampson Kapinos was a wartime volunteer. For the first time in the nation's history, citizens outside during the evening needed proper identification. Heightened security was evident during daylight hours as well. Members of the Kennedy Post American Legion put into operation a 24-hour air raid warning observation post on top of the old isolation hospital in Aldenville.

UNITED STATES OF AMERICA
OFFICE OF PRICE ADMINISTRATION

N? 876182-FF

WAR RATION BOOK No. 3

Void if altered

NOT VALID WITHOUT STAMP

Identification of person to whom issued: PRINT IN FULL

James G. Heron

(First name) (Middle name) (Last name)

Street number or rural route _____ *18 Garrity St.* _____

City or post office ___ *Chic. Falls* ___ State ___ *Mass.* ___

AGE	SEX	WEIGHT	HEIGHT	OCCUPATION
9	M.	56 Lbs.	4 Ft. 2 In.	

SIGNATURE _____ *James Heron* _____
(Person to whom book is issued. If such person is unable to sign because of age or incapacity, another may sign in his behalf.)

WARNING

This book is the property of the United States Government. It is unlawful to sell it to any other person, or to use it or permit anyone else to use it, except to obtain rationed goods in accordance with regulations of the Office of Price Administration. Any person who finds a lost War Ration Book must return it to the War Price and Rationing Board which issued it. Persons who violate rationing regulations are subject to $10,000 fine or imprisonment, or both.

LOCAL BOARD ACTION

Issued by _____
(Local board number) (Date)

Street address _____

City _____ State _____

(Signature of issuing officer)

Another immediate effect of the war was the scarcity of many basic necessities of life. There were meatless and sugarless days. In the early months of 1942, rationing boards were established in every Pioneer Valley community. Pictured here is the ration book of nine-year-old Jimmy Heron of 18 Garrity Street in Chicopee Falls.

The local rationing board had four panels—A for tires, bicycles, and typewriters; B for foods; C for gas and oil; and D for price control. One stamp might allow the holder to purchase three pounds of sugar, another stamp might have been for a pair of shoes, while a third would entitle the owner to purchase a pound of coffee. Rationing was grudgingly accepted as a wartime necessity.

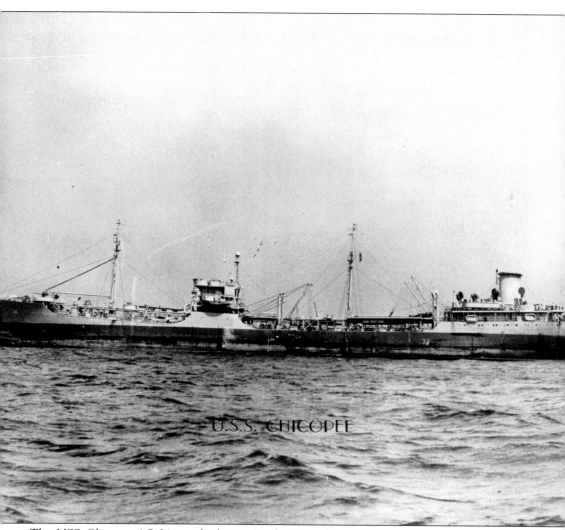

U.S.S. CHICOPEE

The USS *Chicopee* AO-34 was built in 1941 by Sun Shipbuilding and Dry Dock Company in Chester, Pennsylvania. The original name of the ship was the *Esso Trenton*. Following the attack on Pearl Harbor, the ship was acquired by the U.S. Navy on January 3, 1942. The USS *Chicopee* was commissioned on February 9, 1942, with G. Bannerman placed in command. The ship was awarded four battle stars for World War II service. In the fall of 1942, the allies launched Operation Torch, which was the invasion of North Africa. The USS *Chicopee* made three voyages to a mid-ocean point with the ranger task group to launch U.S. Army planes to North Africa.

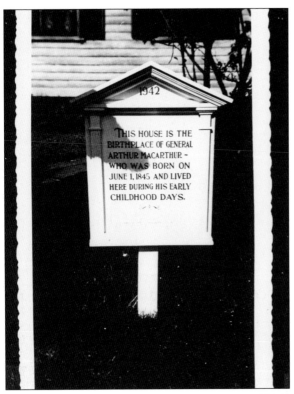

In the spring of 1942, Gen. Douglas MacArthur was leading a valiant defense of the embattled Philippine Islands against an invading army of a quarter-million Japanese troops. According to local legend, Cmdr. Wilfred J. Messier of the Charles C. Kennedy American Legion Post approached Mayor Leo P. Senecal with the idea of honoring the general's father. In 1845, the elder MacArthur had been born in the Belcher Homestead in Chicopee Falls.

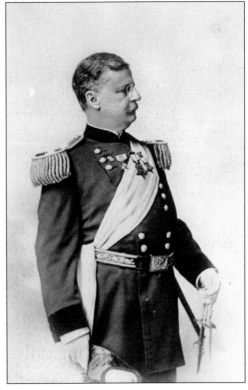

Lt. Gen. Arthur MacArthur was the son of a Scottish immigrant father, and his mother was a descendant of one of New England's earliest settlers. He had a brilliant military career. As the legendary leader of the 24th Wisconsin Volunteers, he was the youngest regimental commander in the Civil War. The "Boy Colonel of the Civil War" went on to command American forces in the Philippines during the Spanish American War.

In 1942, there was a traffic island in the middle of the street at the junctions of Broadway, East, and Belcher Streets. The committee decided it was an ideal place to locate the MacArthur Memorial. On September 7, 1942, dedication ceremonies included a parade featuring military units from Westover Field. An official proclamation designated the site as MacArthur Square.

SOUVENIR PROGRAM

for the

DEDICATION OF

GEN. ARTHUR MacARTHUR SQUARE

IN CHICOPEE FALLS, MASS.

MONDAY, SEPT. 7TH, 1942

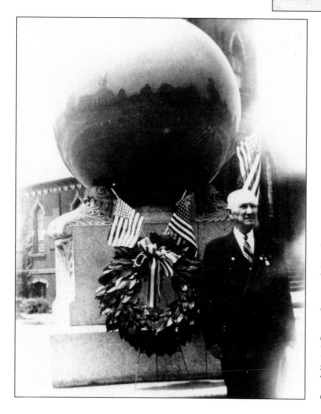

The committee selected a huge, seven-and-a-half-ton memorial. The giant granite ball represented the globe. Since MacArthur had commanded the American army in the nation's first global war, the design was perfect. Pictured here is Dr. Patrick M. Moriarty, who served as general chairman for the event. Today the memorial remains as one of Chicopee's most familiar sights.

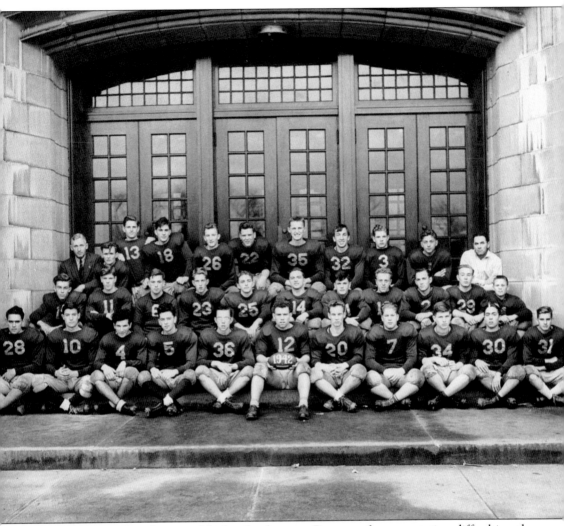

Wartime restrictions hampered high school sports. Because of transportation difficulties, the Chicopee High School varsity football team played only six games during the entire season. The team, coached by Buck Drennan (third row, left) and Napolean (Nap) St. Francis (third row, right), posted a four and two record. Pictured in the center of the first row is fullback and team captain Ray Bibeau (No. 12). Also pictured is Roy White (No. 14), who, 20 years after the war, became the first head football coach at the new Chicopee Comprehensive High School and, for the first time, the team played on the brand new gridiron at Szot Park.

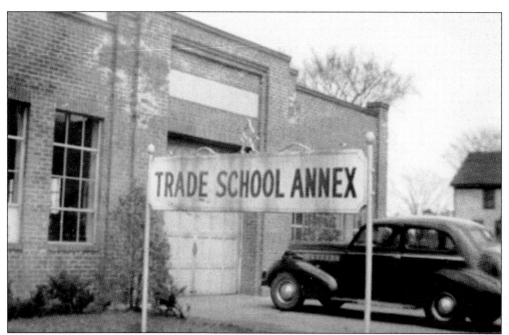

The Chicopee school system established a Trade School Annex at the municipal garage on Front Street. There hundreds of young women received machinist training in preparation for jobs in the region's burgeoning defense industries. Federal funding was obtained from the War Production Training Program.

Raymond Wandolny, a member of the U.S. Army's 460th Airborne Brigade, was home on Christmas leave and photographed here with his parents, Antonia and Ferdinand, in front of their home at 22 Lucrecia Avenue in the Willimansett section of Chicopee.

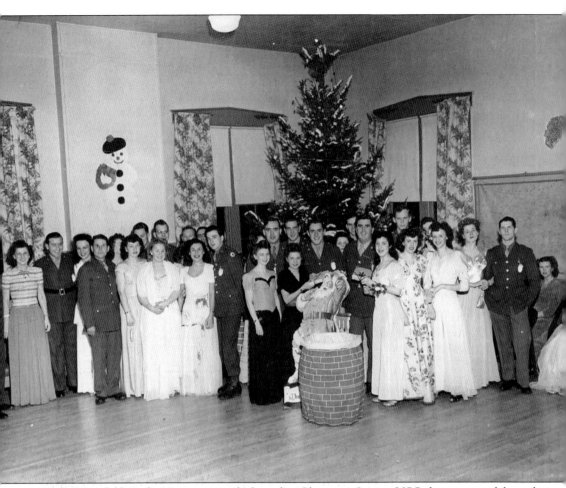

The *Springfield Daily News* reported that the Chicopee Junior USO hostesses celebrated Christmas at the Westover USO club with a barrel of gifts and well wishes for servicemen who attended the Christmas tree dance sponsored by the organization. Music was an enormous morale booster for Americans fighting in the jungles of the South Pacific and on the searing sands of North Africa. In 1942, Irving Berlin wrote a bittersweet melody called, "White Christmas." Radio broadcasts carried Bing Crosby's baritone rendition to the corners of the globe. The song became an instant classic, as millions of servicemen and women dreamed of the snow-covered hills of home.

On January 1, 1943, military policy makers put an end to volunteering for the armed services. As of that date, the draft went into effect. All men between the ages of 18 and 37 became subject to the selective service system. Chicopee High School students received orders to report for induction. Many returned to finish school after the war.

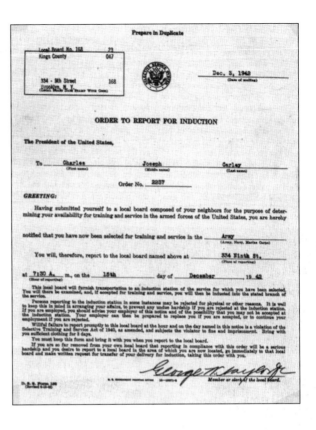

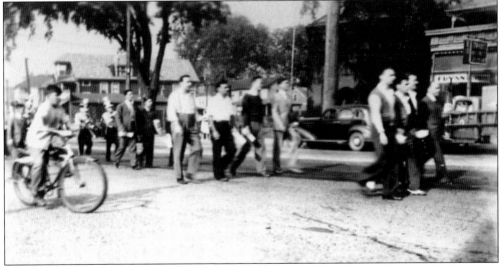

Congress had responded to Pres. Franklin D. Roosevelt's call for 18 and 19 year olds. Secretary of War Henry Stimson declared that the army was getting too old. Draft director Gen. Lewis B. Hershey stressed that the army needed men who could jump from planes without breaking ankles, drive tanks in 130-degree temperatures, or swim ashore. Pictured here, draftees march to the Willimansett railroad station.

The Willimansett draftees were given a proper send-off. Municipal officials and the high school band paraded to the depot. The tide of the war was changing and those that were needed the most were the foot soldiers—the men who led ground actions and served as riflemen, machine gunners, and mortar men. The infantry, in keeping with the Latin root of the word, needed the young.

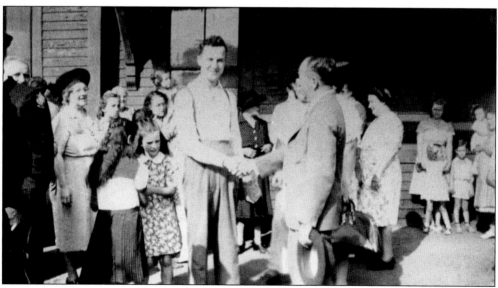

A young inductee, surrounded by friends and family, receives the mayor's handshake. Mayor Leo P. Senecal, a resident of the Willimansett section of the city, knew most of the boys by name. The city's chief executive had a keen understanding of military service. He was a decorated combat veteran of World War I.

Andrew Pinciak, who lived at 139 South Street in Chicopee, is pictured here working at his forge. He was one of several thousand Chicopee men and women employed at the Springfield Armory. The facility was a major producer of rifles for the Allied armies with a staff that reached as many as 13,750 workers at the height of production.

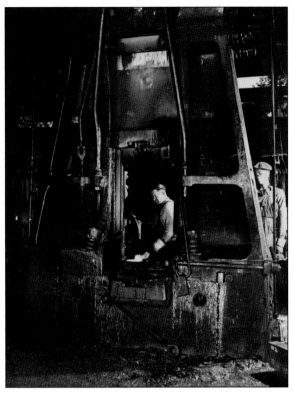

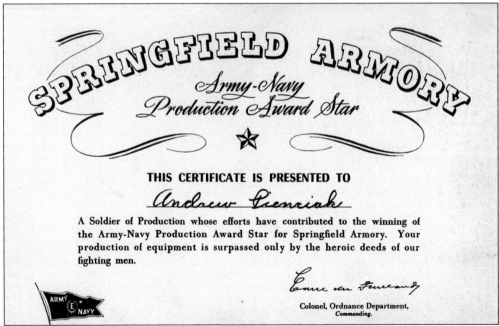

During World War II, the Springfield Armory produced more than four million Garand (M1) rifles. Pinciak, who was a combat veteran of the Polish army, was declared a "Soldier of Production." He was cited for his contributions in helping the Springfield Armory win the coveted Army-Navy Production Award star.

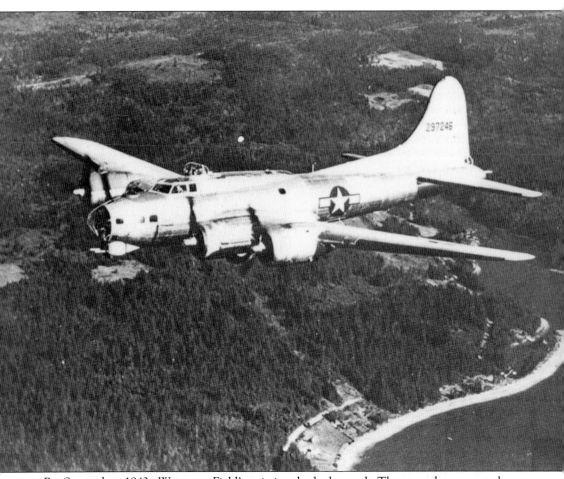

By September 1943, Westover Field's mission had changed. The war department became more confident that the base would not be needed for coastal defense. The facility became an advanced-training base and its main product became air crews. The best highly-trained graduates of air combat training began arriving at the base. The men were teamed to provide bomber crews for B-17 Flying Fortresses and B-24 Liberators. U.S. Air Force historian Dr. Frank Faulkner reported that "their time at Westover allowed the pilots, copilots, bombardiers, navigators, flight engineers and gunners to fly as a team and begin building the spirit needed to survive in the skies over Europe." Nearby Quabbin Reservoir was used for high and low altitude bombing practice.

The fully renovated old school on Church Street was an around-the-clock center of activity. Since the air crews were there for such a short time, the USO club made a whole-hearted effort to coordinate community involvement. Families invited air crews into their homes and provided transportation to the USO in Chicopee Falls and to the Butterfly Ballroom in Chicopee Center. These community-minded citizens realized that these brave young men were headed in harm's way.

DEDICATION WEEK

October 24 through
October 30, 1943

WESTOVER USO CLUB
CHICOPEE, MASSACHUSETTS
Located on Church Street, Chicopee Falls

Operated by
UNITED SERVICE ORGANIZATIONS

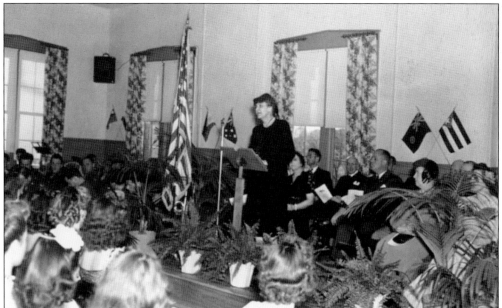

Mrs. C. Duncan Brainard, chairwoman of the USO program committee, addresses the audience during Sunday afternoon dedication ceremonies. Col. U. G. Jones, commanding officer at the base, officially accepted the USO facilities on behalf of the men and women at Westover Field. Mildred Marczak, president of the Girls Service Organization, was in charge of the guided tour of the facility.

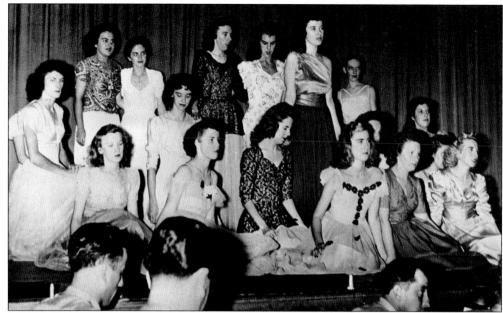

Early in 1943, Everett H. Sittard, supervisor of music in the Chicopee Public Schools, organized a Glee Club for the Chicopee Girls Service Organization. At the dedication ceremonies, the talented young ladies stopped the show when they sang "God Bless America." Newspapers reported that the group was in constant demand, not only at the USO club, but also at the base hospital, chapel, and the service clubs at Westover Field.

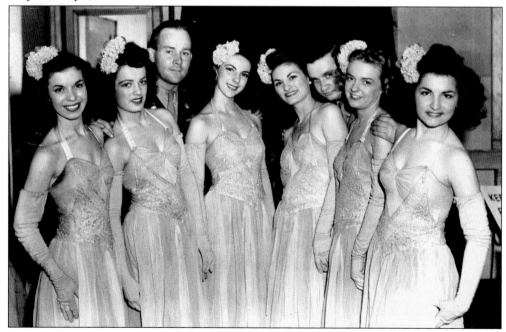

On Monday evening the Girls Service Organization and senior hostesses sponsored a formal military ball in the newly-refurbished auditorium. Music was provided by Eddie Abrahamson's Orchestra. The special guests for the evening were the members of the air crews that were already holding orders for the European Theatre of the war.

56

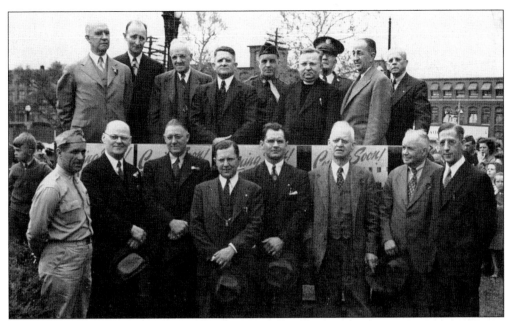

Mayor Leo P. Senecal joined local dignitaries to announce plans to construct an honor roll on the lawn of the library in Market Square. The Roll of Honor was to bear the names of Chicopee's 4,500 men and women serving in the military. During the brief ceremony, Thomas Wilson, the chairman of Chicopee war bond drive, proudly announced that the city had already exceeded its war bond quota by over $1 million.

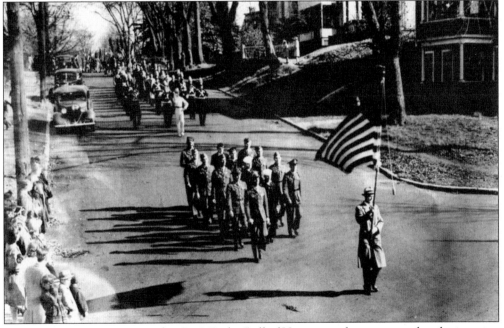

On Sunday afternoon, November 7, 1943, the Roll of Honor parade commenced at the junction of Springfield and South Streets. Pictured here, Stanley Pietras carries the flag down South Street, followed by service men and the Polish Falcon Drum and Bugle Corps. The line march proceeded to Market Square for the unveiling ceremonies.

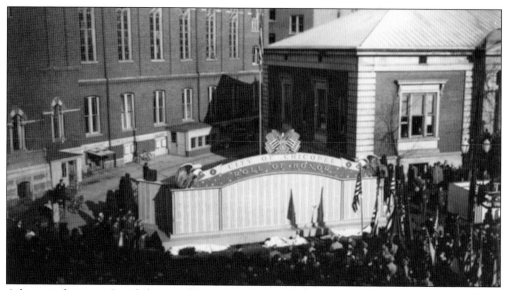

A huge gathering greeted the marchers upon their arrival at city hall. The crowd was silent as the principal speaker, Col. Frank A. Derouin, reminded his audience that America's first Roll of Honor was erected in Lexington. He declared, "No matter how hard the struggle, we will emerge victorious." The brothers and sisters of the 23 men who died in the war helped to unveil the Roll of Honor.

Leo P. Senecal was 48 years old when the Japanese attacked Pearl Harbor. No matter, the mayor informed the war department of his willingness to serve. He received a polite response asking him to list his qualifications. In 1943, as plans were being formulated for the invasion of occupied Europe, the Pentagon established the U.S. Army's 1st Civil Affairs Regiment. In September, Senecal was accepted with the rank of major. Two weeks before Christmas, he reported for active duty adding his name to Chicopee's Roll of Honor.

Three

THE TIDE TURNS
1944–1945

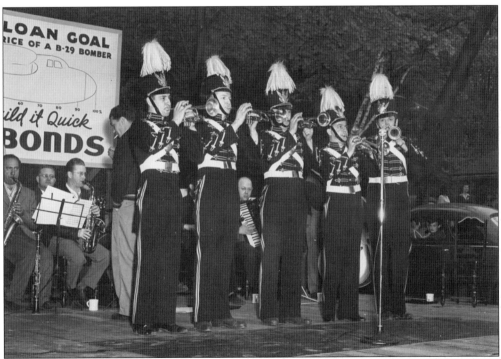

In January 1944, Allied forces were fighting on the Italian peninsula, while the daylight strategic bombing of Germany was crippling the Nazi war machine. The U.S. Army Air Corps knew that strategic bombing was feasible, as long as American industry and training bases like Westover Field could keep the planes and crews coming. The new B-29 Flying Fortress launched the air war over Japan. Pictured here, a bond rally at the American Bosch raises funds for the new plane.

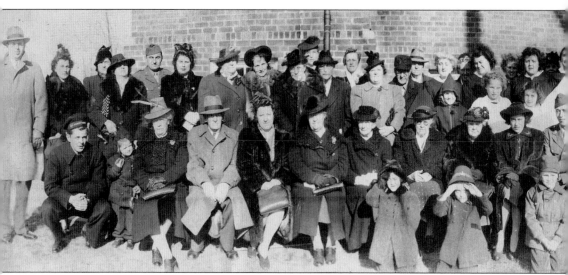

The Faith United Methodist Church of Fairview celebrated its 50th anniversary on Sunday morning, December 2, 1943. Following the anniversary service, the congregation posed for picture in front of their 10-year-old church. The guest preacher was the Reverend Roy S. Graffam, a former pastor (second row, tenth from right). The pastor Rev. Herbert H. Blair (second row, right) came to the church in May 1940. In 1941, when the church could not meet the interest payments on the construction loan for the new building, the bank threatened foreclosure. A new fund drive was launched to reduce the $13,000 mortgage. Under the energetic leadership

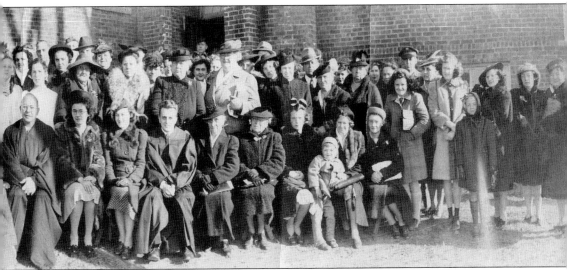

of Blair and mortgage fund chairman Harold Hansen, the congregation responded and the entire amount was amortized in two years. The church history reports that the highlight of the week was when the mortgages of both the church building and the parsonage were burned that Sunday evening. In this era of unprecedented wartime full employment, church congregations and individual homeowners were able pay off their mortgages. In 1944, as the members of the Faith United Methodist Church of Fairview faced a third year of global war, cautious optimism was expressed, hopefully, that the tide had turned.

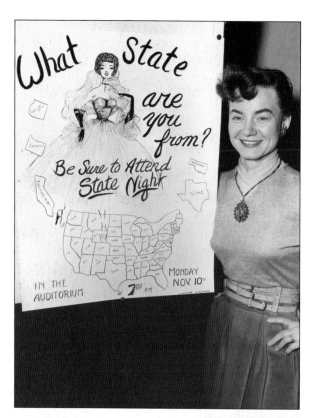

Helen Kitovich lived in Willimansett. She worked as a clerk and typist at Westover Field. She volunteered as a junior USO hostess at the war memorial in Holyoke. A talented graphic artist, she poses here with a poster she created for state night at the war memorial. The intrepid boys and men who flew the B-24 Liberators had volunteered from every state in the union.

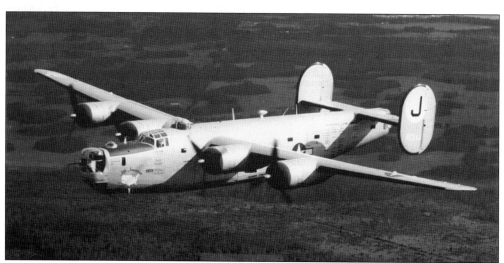

The B-24 Liberators arrived at Westover Field in 1941 for antisubmarine missions. By 1943, the U.S. Navy had ample crews for the coastal surveillance, and the Westover crews were quickly trained for high-altitude bombing. Consolidated Aircraft Corporation chose the name Liberator because the airplane could carry destruction to the heart of Germany and thus help to liberate those enslaved by the Nazis.

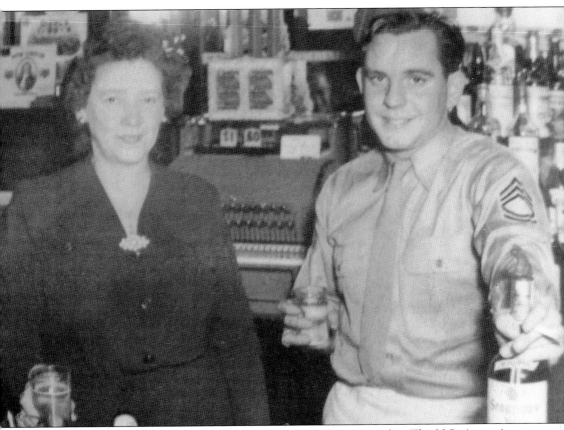

An air crew's survival depended on every man doing his best every day. The U.S. Army Air Corps encouraged the officers and enlisted men to stay together during the brief periods when they were off duty. Two miles down the road from the main gate was the ideal place to hang out. The proprietor of "Hangar 13," Josephine Manning was a red-haired lady everybody called "Ma." Manning's Café on James Street had a softball diamond and a picnic grove. The 10-man crew that it took to fly a B-24 Liberator was just the right number needed to play a Friday night softball doubleheader. Clams were 25¢ at the café, and the coolers were full of local favorite, Hampden Beer.

John L. Sullivan's
RED BARN

DINE AND DANCE IN A UNIQUE ATMOSPHERE

Phone 1790 Chicopee Falls, Mass

The U.S. Army Air Corps brass frequented the Red Barn on Montgomery Street. The nightclub featured live entertainment and dancing and was the classiest spot near the base. The original barn was constructed early in the 19th century by Ellis Chapin. Apparently there was a brook alongside the barn. Since the road was well traveled by farmers, the brook became a popular stop-off for watering horses and the barn became a popular stop-off for watering farmers. The thirst quencher of choice was rum imported from the island of Antigua in the West Indies. The barn came to be known as "Tiqua" and later the entire farm was referred to as Tigua Farm in honor of the rum. In 1908, the barn was struck by lightning and burned to the ground. The same year, Marcellin Croteau built a new barn on the site. In 1944, local personality John L. Sullivan owned the old watering hole. Many of the officers and men who flew the plane they scornfully called a "Flying Boxcar" enjoyed their last dance in the Tigua barn as their B-24s were being prepared for the flight to Italy. In 1944, the bulk of Westover's air crews were assigned to the 15th Air Force under the command of Maj. Gen. Nathan F. Twining. During the first quarter of 1944, 125 crews were trained and departed from Westover for Europe.

ACCIDENT No.

WAR DEPARTMENT

U. S. ARMY AIR FORCES

REPORT OF AIRCRAFT ACCIDENT

(1) Place **Westover Field, Mass.** (2) Date **4 May 1944** (3) Time **0947**

Aircraft: (4) Type and model **B-24 E** (5) A. F. No. **42-7103** (6) Station **Westover Field Mass**

Organization: (7) **1st AF** (8) (9) **Section D - 112th AAF B U**
 (Command and Air Force) (Group) (Squadron)

PERSONNEL

Duty (10)	NAME (Last name first) (11)	RATING (12)	SERIAL NO. (13)	RANK (14)	PERSONNEL CLASS (15)	BRANCH (16)	AIR FORCE OR COMMAND (17)	RESULT TO PERSONNEL (18)	USE OF PARACHUTE (19)
P	Melkonian, Harold H	P	O-441029	Capt	01	AC	1st AF	Fatal	None
P	Davis, William F	P	O-816435	2nd Lt	18	AC	1st AF	Fatal	None
E	Schultz, Harry	E	37146309	T/Sgt	38	AC	1st AF	Fatal	None

(20) **Melkonian** **Harold** **H** (21) **O-441029** (22) **Captain** (23) **01** (24) **AC**
 (Last name) (First name) (Middle initial) (Serial number) (Rank) (Personnel class) (Branch)

Assigned (25) **1st AF** (26) (27) **112th AAF B U Section "D"** (28) **Westover Field Mass**
 (Command and Air Force) (Group) (Station)

Attached for flying (29) **1st AF** (30) (31) **112th AAF B U Section "D"** (32) **Westover Field**
 (Command and Air Force) (Group) (Station)

Original rating (33) **P** (34) **3/7/42** Present rating (35) **P** (36) **3/7/42** Instrument rating (37) **3/8/44**
 (Rating) (Date) (Rating) (Date) (Date)

FIRST PILOT HOURS:
(at the time of this accident)

(38) This type......... **748:45** (42) Instrument time last 6 months......... **13:15**
(39) This model......... **268:25** (43) Instrument time last 30 days......... **3:00**
(40) Last 90 days......... **57:10** (44) Night time last 6 months......... **18:20**
(41) Total......... **1483:35** (45) Night time last 30 days......... **None**

AIRCRAFT DAMAGE

	DAMAGE	(49) LIST OF DAMAGED PARTS
(46) Aircraft	W	Completely burned
(47) Engine(s)	W	"
(48) Propeller(s)	W	"

(50) Weather at the time of accident **Unlimited ceiling, Visibility 2 miles with smoke and haze, Wind SSW 5 MPH.**

(51) Was the pilot flying on instruments at the time of accident **No**
(52) Cleared from **Local** (53) To **Local** (54) Kind of clearance **Contact**

(55) Pilot's mission **Emergency procedure and transition check.**

(56) Nature of accident **Crash landing immediately after take-off.**

(57) Cause of accident **Stall after take-off, due to airspeed indicator error, short take-off and probable throttling back of #1 engine.**

RESTRICTED

In 1944, the hamlets and villages of northern Massachusetts and southern Vermont and New Hampshire were on alert as their volunteer fire departments watched the skies. Westover Field's brave young airmen were learning and practicing the dangerous art of air war. Aircraft maintenance was paramount as the crews learned about how to care for the machine that their very lives depended on. The planes used live ammunition, and crashes frequently resulted in explosions that sprayed bullets and hampered rescue efforts. The crashes were unavoidable. There are small memorials for the airmen who died in training in Palmer, Belchertown, North Hatfield, West Hatfield, Ludlow, South Hadley, and Brimfield.

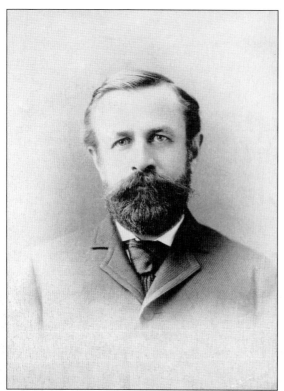

Edward Bellamy gained national fame in the 19th century with the publication of *Looking Backward: 2000–1887*. His utopian novel was a best seller in the 1890s. The author lived on Church Street in Chicopee Falls. In April 1944, his widow, Emma, disclosed that her husband's biography, written by Antioch College president Dr. Arthur Morgan, was going to be released in the spring by Columbia University Press.

During World War II, Henry J. Kaiser attracted national attention by the speed at which he built ships. He ignored the usual methods of building from keel up and used assembly line methods. His ships were assembled in separate sections and welded together. The cargo ships were called Liberty Ships. In 1944, the West Coast admirers of the Chicopee author Bellamy were on hand at the Kaiser shipyard for the launching of the SS *Edward Bellamy*.

FEBRUARY 12, 1944 — A DAY OF HONOR
FOR THE MEN AND WOMEN OF MOORE

In accepting the Army-Navy Production Award, the men and women of Moore pledged continued effort to surpass their already high achievement. They are making good that pledge. The photographs on this and succeeding pages and the honor roll that follows will be a constant reminder of the devotion to duty that won our "E" flag, and of our determination to keep it flying until the day of final Victory.

JOHN M. COLLINS, *President*
MOORE DROP FORGING COMPANY

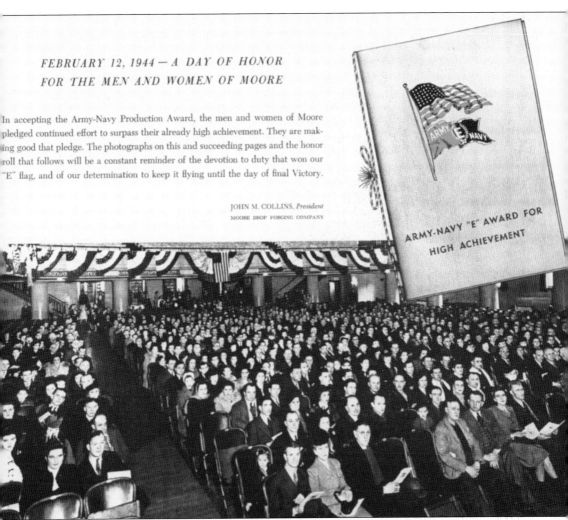

ARMY-NAVY "E" AWARD FOR HIGH ACHIEVEMENT

In Chicopee, there were 22 plants engaged exclusively in war work. In 1944, 20,000 men and women were employed, and 65 percent of the employees were residents of Chicopee. Pictured here at the Springfield Auditorium, employees of the Moore Drop Forging Company receive the coveted Army-Navy E award for high achievement. The company operated two plants. The Chicopee drop forging facility operated around the clock seven days a week. Located at the delta of the Chicopee and Connecticut Rivers, the thunderous roar of the plant reminded everyone that America was at war.

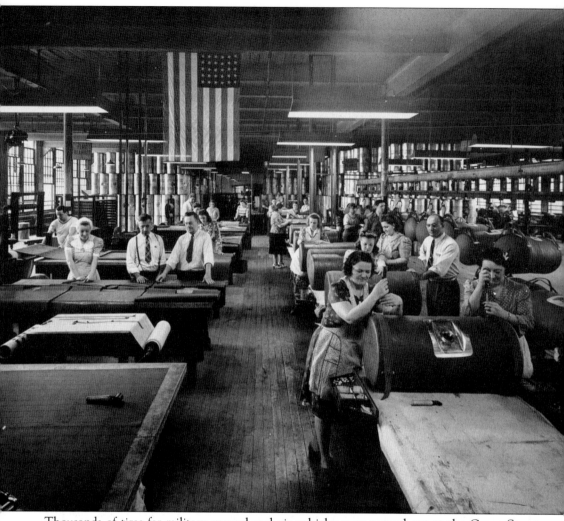

Thousands of tires for military ground and air vehicles were turned out at the Grove Street plant of the Fisk Rubber Company. Pictured here, female workers put the final touches on fuel tanks for long-range aircraft. The top-secret rubber platter was able to sustain minor damage and reseal the tank

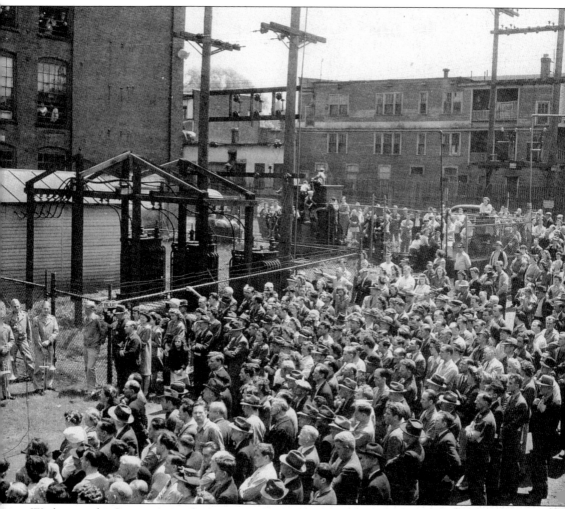

Workers at the Savage Arms Company in Chicopee Falls gather to receive an Army-Navy E award for excellence. By 1944, Chicopee was one of only four cities in Massachusetts to produce better than $1 billion worth of war materials. The textile industry produced millions of yards of surgical dressings and hospital fabrics. F.W. Sickles in the old Dwight Mills buildings produced a myriad of electronic components and manufactured some of equipment used to split the atom.

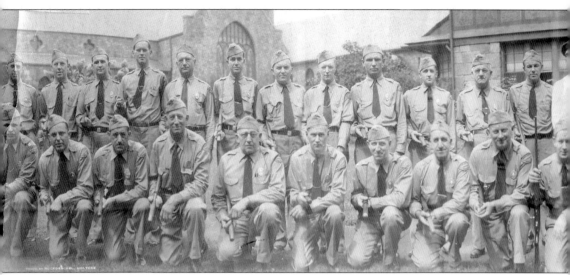

Following the Japanese attack on Pearl Harbor, the U.S. government encouraged municipalities to organize a local defense force of civilians. Charles V. Barry, chairman of the Chicopee Defense Committee joined with police chief Francis A. Linehan and fire chief Albert Bunyan urging all able-bodied men in the city to lose no time in getting registered with one or the other defense forces as volunteers. The auxiliary police and fire departments coordinated their efforts with the city's air raid wardens. Following America's entry into the war, Raymond W. Snyder was named the city's chief air raid warden. Chicopee's largest industries assigned additional armed guards at every gate. Defense contractor Savage Arms added 30 additional armed guards to protect

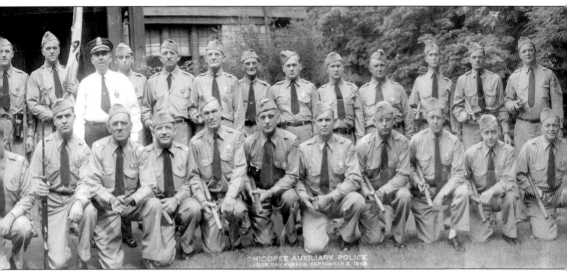

its two plants in Chicopee Falls. The city wanted 300 auxiliary firemen and 200 additional auxiliary policemen. By 1944, the blackouts had ended and fears of Axis sabotage had abated. The men pictured here all had full-time jobs. As members of the Chicopee Auxiliary Police, they were assigned evening and weekend duties and all were on call in the event of an emergency. Sgt. Olen Bielski is the first officer in front at left. Bronislaw Fijal (ninth from the left, second row) worked a full shift at the Fisk Tire Company before his nighttime assignment. The picture was provided by his son Ted Fijal.

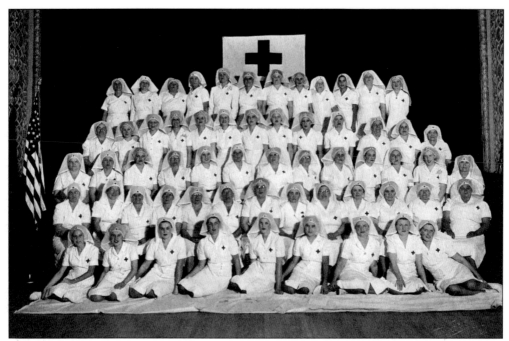

Chicopee's churches were in the forefront of volunteerism. Pictured here on the stage of the parish school are the volunteer Red Cross nurses from St. Stanislaus Parish. The city's parishes supported their men and women in service by oversubscribing bond and blood drives.

The Nurse Cadet Program was established at the College of Our Lady of the Elms in 1944. The young ladies enrolled in the special program had already received their nurse's training in the hospitals staffed by the Sisters of Providence. The students pictured took academic courses to be better prepared for the challenges of wartime nursing.

Pictured here on the College of Our Lady of the Elms campus, Sr. Mary Dooley SSJ (left) and Dorothy Mulry (right) demonstrate the work of Woman Organized for the Relief of the Manpower Shortage (WORMS). The WORMS volunteered to assist with household chores and minor repairs at homes within walking distance of the campus. Years later, Dooley served as the president of the college.

A Westover Field airman captured this aerial view of his temporary home in the Sheridan Circle wartime housing project. Built primarily to provide homes for war workers and military personnel, Chicopee's three housing projects were managed by the newly-created Chicopee Housing Authority. In 1941, federal housing funds turned the old Chicopee Falls Tigers ball grounds into 200 low-income housing units.

In 1944, Rheo Gagne was the chairman of the Chicopee Housing Authority. Paul W. Geissler was the executive director and Alfred J. Plante served as the secretary. In 1941, working in conjunction with U. S. government, they built Chicomansett Village, a defense housing project in the Willimansett section of the city.

The United States Housing Authority invested $2.8 million in Chicopee's three housing projects. The Chicomansett Village construction, pictured here, was completed at a cost of $ 1,262,971. The Willimansett tract was the largest, with 300 dwelling units.

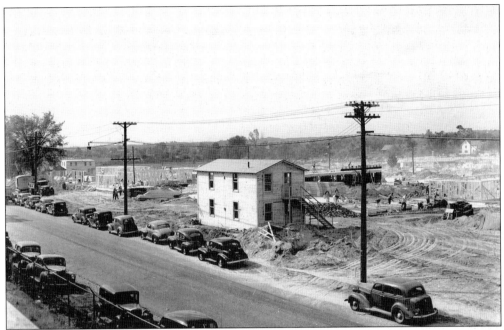

The construction of the Sheridan Circle and Chicomansett projects and the planning for the Curtis Terrace development were under the direction of Capt. Nelson S. McCraw. He served as the Chicopee Housing Authority's executive director until entering the service. In February 1944, McCraw died in a plane crash in Italy.

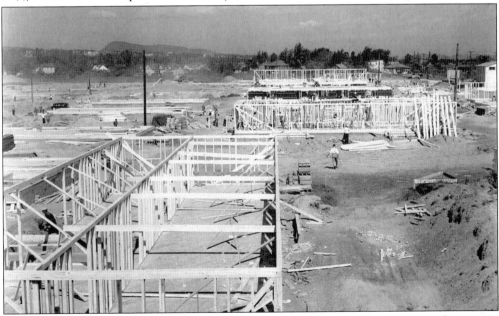

The Curtis Terrace project on Hampden Street in Chicopee was built as emergency housing in 1943. The project, built in a barrack style was the least attractive of the local tracts. Living in the apartments were war workers who had migrated from all sections of the United States. The Office of Price Administration set the rents between $11 and $35 a month for the 750 families living in the city's government housing.

The 1942 Chicopee city directory lists John Joseph (Jake) Stefanik's occupation as a clerk in the city auditor's office. In April 1942, he traded his typewriter and account book for the flight manual of aviation cadet school in Alabama. The young lieutenant was very good. He was headed for 18 months of combat in the skies over North Africa. Pictured here with Lt. Charles Leaf (right), they toast the insignia of their 66th squadron, "the Exterminators."

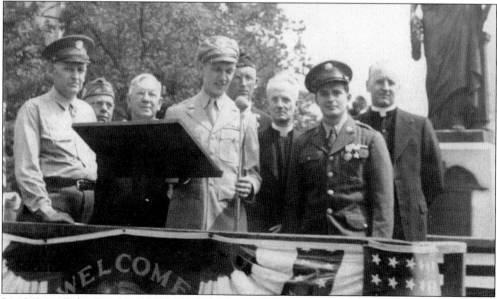

In 1943, on Palm Sunday, Lt. Jake Stefanik's squadron would ambush 80 huge German Junker Transport Planes off Cape Bon in Tunisia. Stefanik and his P-40 Fighter Bomber were credited with downing four of the large planes. Promoted to captain, he commanded the 66th Squadron, which was the first group to bomb German held ports in Yugoslavia. On his 25th birthday the much decorated flyer was promoted to the rank of major. In 1944, he was the guest of honor at Chicopee's Memorial Day events.

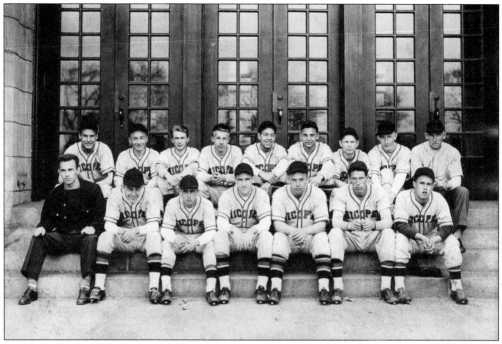

In England, the Allies had assembled three million men in preparation for the invasion of Nazi-occupied France. Playing that spring, coach John "Buck" Drennan's Chicopee High School baseball team complied a record of six wins and five loses. Richard "Whitey" Demers (second row, fourth from left), the team's star center fielder, went on to serve as the city's mayor from 1966 to 1969.

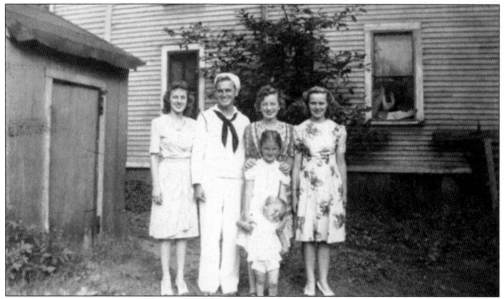

Seaman Ed "Cheesecake" Ciszek was the treasurer of the Chicopee High School class of 1942. Home on leave from the naval base in Norfolk, Virginia, Ciszek joins his five sisters in the family's backyard on Dwight Street. Seen here from left to right are Louise, Edward, Mary, and Stella with Virginia and baby sister Barbara in front.

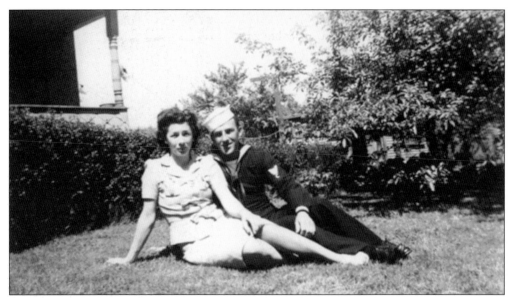

John Krawczyk was a baker by profession. His wife, Adrienne, worked at A. G. Spalding and Brothers Company making batteries for the army. The navy sent John to bakery school in Pensacola, Florida. Here they are photographed on the front lawn of their Orchard Street home. After a brief home leave, John was sent to join the Pacific fleet.

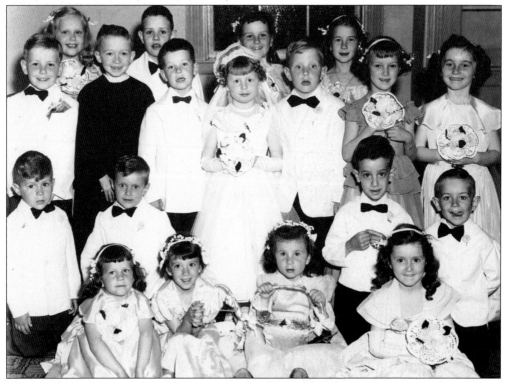

The members of the spring wedding party at the White Church pose for pictures. The Sunday school event was called a Tom Thumb wedding. The youngsters in gowns and tuxedos charmed the war-weary congregation.

Anne Jendrysik is pictured with her son Richard, who stands near the framed picture of her brothers Joe and Mike. The picture was taken on her family's farm in West Springfield. Jan Galus and his youngest son, Walter, kept the fields at full capacity in support of the war effort. Richard and his brother Stephen spent many hot afternoons helping their mom on the farm. Most of the time, they just ran around barefoot.

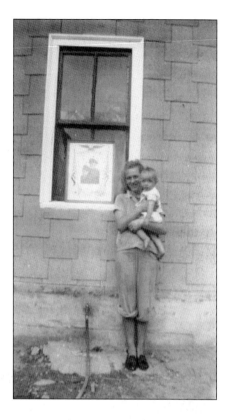

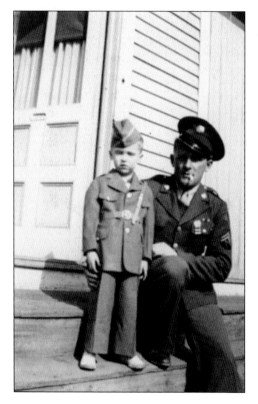

Sgt. Joseph Galus was on leave from Fort Hood, Texas. Pictured here with his nephew author Stephen R. Jendrysik, each is wearing the uniform of the 12th Armored Division. Galus piloted his Sherman Tank across France into Germany. In 1945, he served as a Polish interpreter for the American Occupation Forces.

"All the News That's Fit to Print"

The New York Times.

6 A.M. EXTRA

VOL. XCIII.No. 31,545. NEW YORK, TUESDAY, JUNE 6, 1944. THREE CENTS

ALLIED ARMIES LAND IN FRANCE IN THE HAVRE-CHERBOURG AREA; GREAT INVASION IS UNDER WAY

Pres. Franklin D. Roosevelt and Prime Minister Winston Churchill met in Quebec during August 1943 and agreed on the outline for the planned invasion of France. In the fall of 1943, British officers arrived at Westover Field to watch C-47s of the Troop Carrier Command tow Waco gliders and to learn airborne tactics that would be used in the invasion. Air Transport Command cargo planes at the base were a portent of the field's postwar mission.

THE CHICOPEE PLAN

BY

ANTHONY FRANK PIMENTEL

Sponsored by the Chicopee Planning Commission

In 1944, Chicopee mayor Edward O. Bourbeau named city planner Anthony Frank Pimentel to the chairmanship of the city's post–World War II planning committee. He also chaired the Master Plan Study committee, which included civic leader Frank Byrnes, architect Henry Tessier, and city engineer Sebastian Beauchamp. The group formulated the Chicopee Plan. At the heart of their proposals was a 10-year public works program for Chicopee.

The mayor expected the war to end in the early months of 1945. Peacetime would have a real downside in local employment. Bourbeau pointed out that a return to normal production (with 1940s figures as a 100 percent baseline) would result in Chicopee having 9,632 fewer people employed than on January 1, 1944, and more than 6,000 war veterans would be coming home looking for jobs.

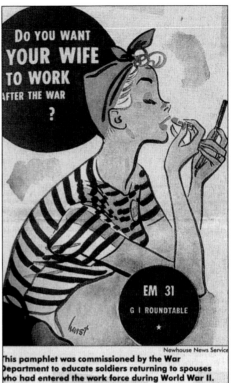

This pamphlet was commissioned by the War Department to educate soldiers returning to spouses who had entered the work force during World War II.

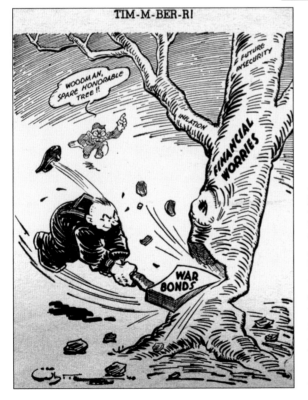

Its official title, the Servicemen's Readjustment Act of 1944, was rarely used because it was simply referred to as the GI Bill. It said "our nation, out of gratitude for the sacrifices being made by our men and women in arms, promised a free education, or assistance in finding a place in society when peace came." America's leaders recalled the joblessness, strikes, and two-year depression following World War I. As this popular 1944 cartoon illustrates, there was a serious concern for the nation's financial future.

In August 1944, it was official. The regulars at LaCroix's Luncheonette on Chicopee Street reported increased activity at Roy's Lumber Yard. The Meadow Street Construction Company had the contract. They were building a prison camp at Westover Field. While the lunch counter crowd worried about the dangerous prisoners, the Roosevelt administration was planning to give the young soldiers an introduction to democracy at its grass roots. The Roy company was awarded a $ 25,000 contract to build a prisoner of war compound on the base. The POW camp, complete with sentry towers and guard shacks, was surrounded by chain link fences. In truth, the Germans spent most of the daylight hours away from camp. In western Massachusetts they were dispatched to the fields of Hatfield, Amherst, and Hadley, where they worked harvesting potatoes and tobacco for 80¢ a day. In the shadow of Mount Sugarloaf, 523 Westover POWs saw freedom and independence in the faces of the valley's farmers. When they left for home in 1946, they carried with them an American promise of a new democracy on the Rhine.

This volunteer chorus line from the Westover USO got their start in the Everett Sittard's Glee Club production of *Stairway to the Stars* in 1943. The junior hostesses all held full-time positions, managed family responsibilities, and still found time to appear in shows all over the valley.

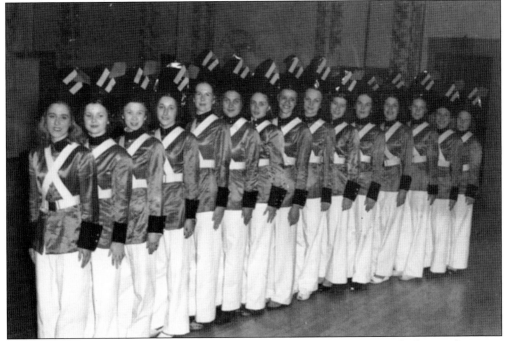

The Wooden Toy Soldiers USO drill team was formed in 1943. Composed of junior hostesses from the Church Street unit, they marched in military and civilian parades. The team executed a precision professional stage program that made them wartime favorites.

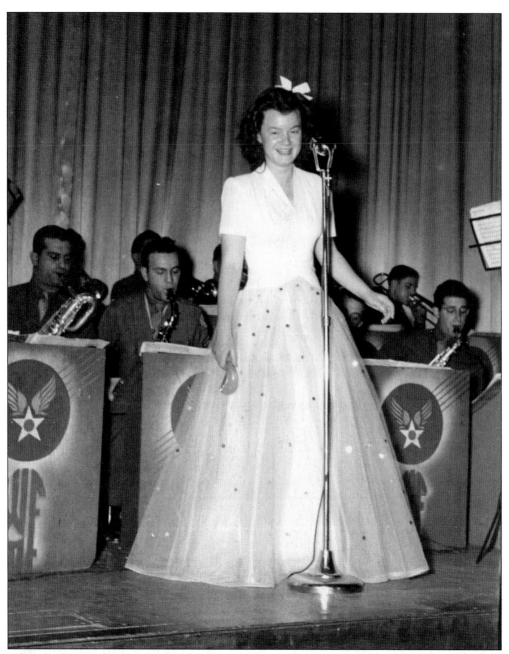

Following her graduation from high school, Helen Kitovich secured an office job at Westover Field. The vivacious young lady began her singing career in the church choir. Captain Baruch, her supervisor at the base, convinced her to audition for the Westover Army Air Corps band. The young lady from Willimansett became the female vocalist for the base's big-time dance band. She kept her daytime job. In the evening she became known as "Kay Kitovich," singing duets with the nationally famous baritone Clyde Whalen. Prior to being drafted into the army, Whalen was the lead singer for Xavier Cugat's orchestra. She recalls that it was like singing a duet with Bing Crosby. In 1944, the big band visited military hospitals in Massachusetts, Connecticut, and Rhode Island, representing Westover Field.

In November 1943, servicemen from all over the world were directing their Christmas V-mail messages to their families in Chicopee. In 1942 a film called *Holiday Inn* introduced Irving Berlin's Academy Award–winning song "White Christmas." By 1944, Bing Crosby's recording was a wartime classic as millions of young Americans were dreaming of the snow-covered hills of home.

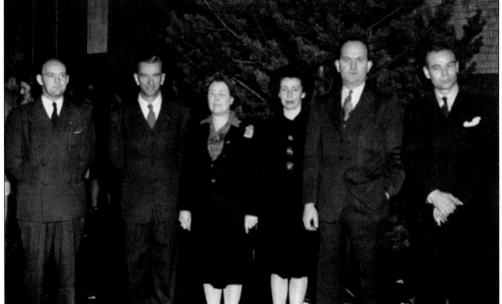

USO executives were on hand at Westover Field to decorate the main hangar for a giant Christmas party. Several parties were planned for Christmas week at Westover. Charles Murray (second from left) told the group that former mayor Lt. Col. Leo P. Senecal sent his regrets but was unable to attend. Senecal was the military administrator of the liberated city of Maastrict in Holland.

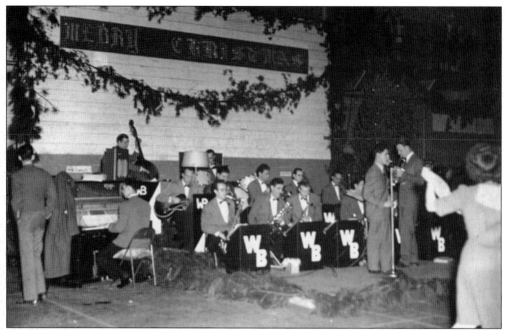

The 1944 Christmas would be America's last wartime holiday. Shortages and rationing led to creative gift giving. In the old mill town, the most popular gift under the tree was a long white envelope containing a war bond. In this photograph, the Westover Band provides the dance music for the USO Christmas party in base's main hangar.

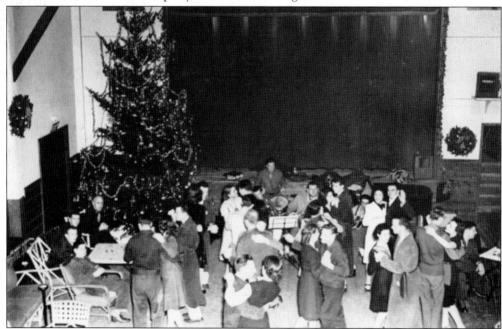

Pictured here, wounded veterans recuperating at the base hospital are treated to their own USO Christmas dance. The event was marred by the week's grim war news. On the morning of December 16, 1944, a half million German troops crashed through American positions in Belgium. The Battle of the Bulge, the largest American battle of World War II, was on.

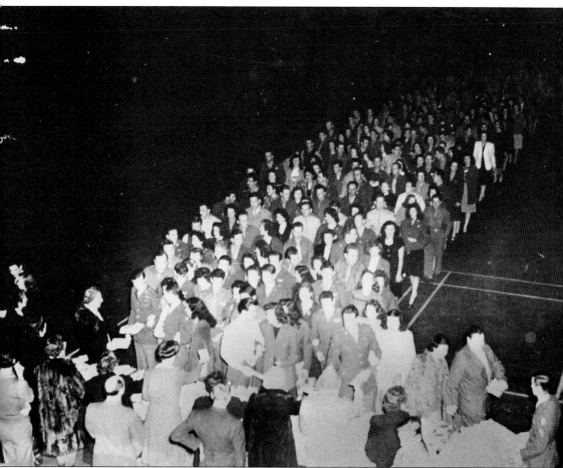

The airmen at the dance were convinced that once the weather cleared, the U.S. Army Air Corps would drive the Nazis back across the Rhine. The 82nd Airborne was trapped in the Belgium market town of Bastogne and the weather favored the Germans. The hangar was the site of the largest dance ever staged at the base. Shown here following the grand march, USO officials distribute gifts to the soldiers and their guests. Two days after Christmas, armored units of the 3rd Army Group pierced enemy lines and relieved the defenders of Bastogne. The next the day, the sun reappeared and U.S. Army Air Corps P-51s joined the fray. It was the last German offensive of the war.

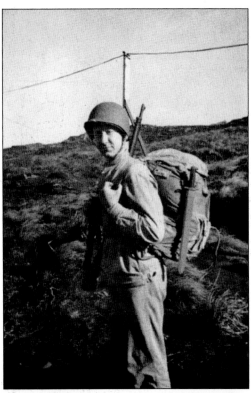

Pfc. John J. Okscin, the son of Anna and Vincente Okscin of 146 Ingham Street, was drafted one year short of high school graduation. The Willimansett soldier was selected for parachutist training at Fort Benning, Georgia. On December 16, 1944, he was a member of the elite 101st Airborne Division 506th Parachute Infantry in Belgium.

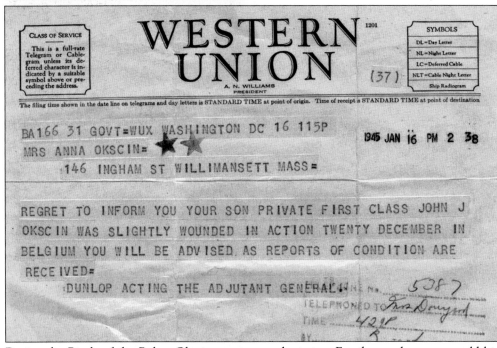

During the Battle of the Bulge, Okscin was reported missing. Family members never told his mother. The telegram arrived at 2:38 p.m. on January 16, 1945. The wounded soldier recuperated in an army field hospital.

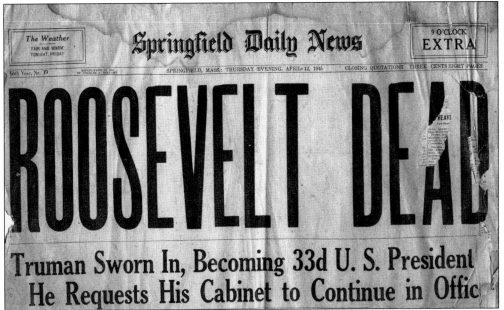

The Weather
FAIR AND WARM
TONIGHT, FRIDAY

Springfield Daily News

9 O'CLOCK
EXTRA

66th Year, No. 39 ESTABLISHED IN 1880 BY CHARLES G. BELLAMY SPRINGFIELD, MASS.: THURSDAY EVENING, APRIL 12, 1945 CLOSING QUOTATIONS THREE CENTS EIGHT PAGES

ROOSEVELT DEAD

Truman Sworn In, Becoming 33d U. S. President
He Requests His Cabinet to Continue in Offic

A news service flashed the message across the nation. World War II had claimed another casualty. On April 12, 1945, Pres. Franklin D. Roosevelt had died of a cerebral hemorrhage at the Little White House in Warm Springs, Georgia. Taken from the newspaper collection of the Chicopee Historical Society, the front page of an extra edition of the *Springfield Daily News* saddened the entire region.

Franklin Delano Roosevelt, 1882–1945

On Sunday, April 15, 1945, at 10:15 a.m., Pres. Franklin D. Roosevelt, was buried at his beloved Hyde Park, New York, birthplace.

Springfield Daily News

Year, No. 142 ESTABLISHED IN 1880 BY CHARLES J. BELLAMY SPRINGFIELD, MASS.: TUESDAY EVENING, AUGUST 14, 1945 THREE CENTS —FOURTEEN

HERE IT IS!

PEACE

Harry S. Truman of Independence, Missouri, became the new president of the United States. Truman was a combat veteran of the First World War. Three weeks into his presidency, Germany surrendered unconditionally on the western front. The first atomic bomb was dropped on Japan. A week later the Japanese empire capitulated. The August 14, 1945, Victory Edition of the *Springfield Daily News* proclaimed the news, and a giant, impromptu celebration broke out in Chicopee's Market Square.

90

Four

HOMECOMING
1946–1947

In 1946, a generation of Chicopee's young men and women came home from World War II. They returned to a small New England city with three distinct industrial districts. It was a classic, ethnic mill town with tenement homes and red brick factory buildings perched on the banks of two rivers, and a junction town with three small but vibrant retail centers. Each district had a unique, village flavor, with shops and markets providing the necessities of life. Chicopee's GIs came home to a true slice of Norman Rockwell's small town Americana.

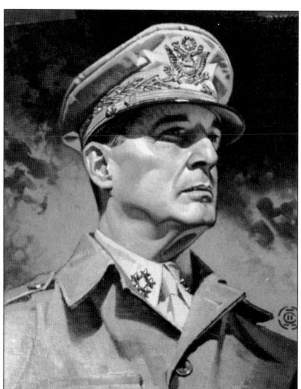

The cultural gurus of the era were predicting changes of epic proportions. They were all in agreement that the American way of life was in for a major makeover. In 1946, a substantial number of young Americans were not coming home. Their new assignment was to keep the peace in a troubled world. Aurelia Belcher MacArthur's grandson again declined an invitation to visit his father's home town. Gen. Douglas MacArthur was the sole administrator of the military government in Japan. (Courtesy of the MacArthur Memorial.)

Westover Field processed thousands of Army Air Force servicemen returning from Europe. In January 1946, the base became the principal port of entry and embarkation for the Air Transport Command's North Atlantic operations to Europe, Africa, and the Middle East. Westover historian Dr. Frank Faulkner reported that 1,500 skilled civilian mechanics were hired for the new C-54 operation.

On June 24, 1945, Pfc. Rene J. "Sparky" Harnisch was playing the outfield for the 28th Infantry Division Invaders in a baseball game played at Keystone Stadium in Kaiserslautern, Germany. In January 1946, he mustered out with the esteem and gratitude of the Commonwealth of Massachusetts. He came back home to Aldenville.

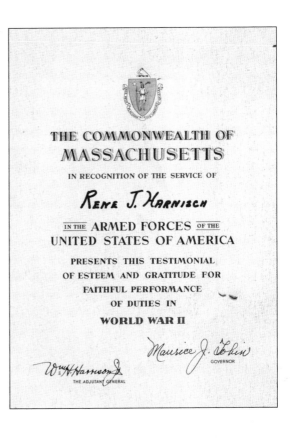

THE COMMONWEALTH OF
MASSACHUSETTS
IN RECOGNITION OF THE SERVICE OF

Rene J. Harnisch

IN THE ARMED FORCES OF THE
UNITED STATES OF AMERICA

PRESENTS THIS TESTIMONIAL
OF ESTEEM AND GRATITUDE FOR
FAITHFUL PERFORMANCE
OF DUTIES IN

WORLD WAR II

Maurice J. Tobin
GOVERNOR

W. H. Harrison
THE ADJUTANT GENERAL

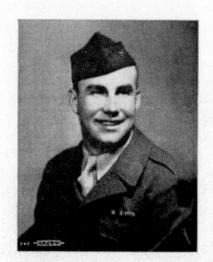

★★★★★★★★★★★★★★★★★★★★★★★★★★★★★★

NOMINATE
RENE HARNISCH
For REPRESENTATIVE
11th Hampden District

MEMBER SCHOOL BOARD 1943
VETERAN WORLD WAR II

YOUNG - HONEST - PROGRESSIVE

PRIMARIES: TUESDAY, JUNE 18, 1946 7

★★★★★★★★★★★★★★★★★★★★★★★★★★★★★★

Harnisch was back on the job at the Gilbert and Barker Company in West Springfield. In the spring, his Gilbert and Barker Company baseball uniform was out of moth balls, and he was again patrolling the outfield in the region's highly competitive industrial league. In the summer of 1946, the Chicopee's City League was back playing at full strength. Harnisch was running for office and playing for the Aldenville Athletic Association.

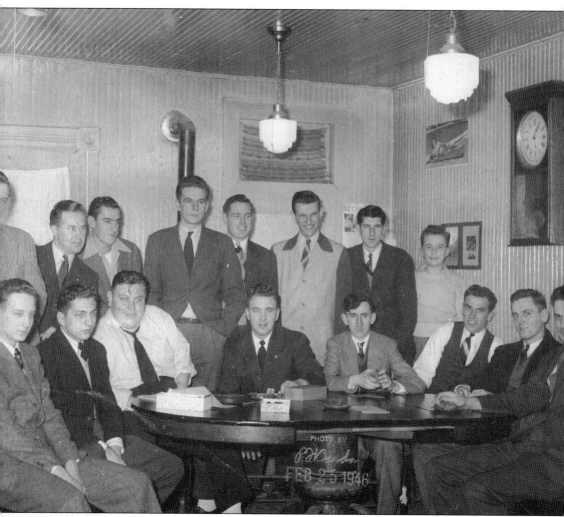

In February 1946, the Colonels Athletic Club redecorated the front windows of their club rooms at 398 Front Street. Only three pictures of the 78 once displayed remain in the window. Surrounded by German and Japanese flags, rifles, helmets, and sabers were the pictures of the three team members who would not be coming home. They were seaman second class George Czelusniak, who was killed with the Coast Guard on the USS *Eccanaba*; seaman second class Andrew Balut, who was killed while serving with the navy on the USS *DeHaven* that was sunk in the battle of the Coral Sea; and Cpl. Edmund Kida, who died in the Battle of the Bulge. The Colonels Athletic Club was organized in the 1930s by a group of mostly teenagers. In 1946, almost all the original members still belonged. With the coming of peace, the group pictured here is making plans for the upcoming baseball season. On Sunday, May 5, the stars were back. The powerful Aldenville Athletic Association inaugurated the Chicopee's City League slate playing the Colonels Athletic Club in a 2:00 p.m. opener.

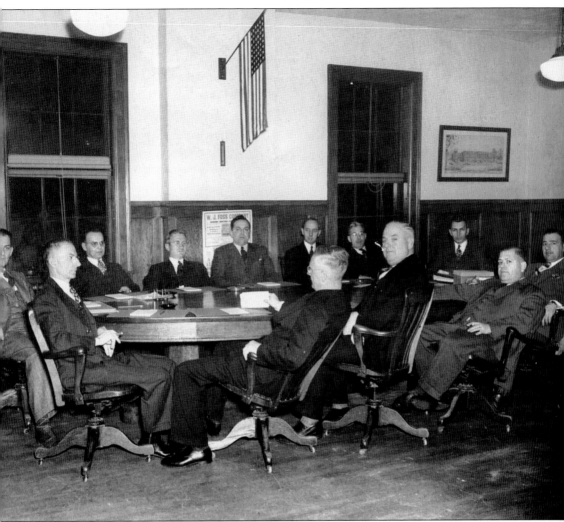

John J. Desmond served as Chicopee's superintendent of schools for 25 years. On February 20, 1946, the governor's council confirmed Gov. Maurice Tobin's appointment of Desmond as the Massachusetts commissioner of education. For the first time in 25 years, the Chicopee school committee would have the opportunity to pick a superintendent. They selected 44-year-old Chicopee native John L. Fitzpatrick. At the time of his selection, he was the supervisor of elementary education in Waltham. During his tenure as Chicopee's educational leader, the city received national recognition for its educational programs. Fitzpatrick is pictured on the left at the head of the table.

Ꮯhicopee Herald

for Better Business and Community Welfare

XX. NO. 6. THURSDAY, MARCH 28, 1946 2c PER COPY

USO Here to Clo[se]
May 31; Propos[ed]
Community Cen[ter]

[LEA]DERS EXPLORE [AL]TERNATIVES FOR [VE]TERANS SCHOOL

[Hi]gh School Principal Christo-
[pher] A. FitzGerald revealed this
[week] that he plans to talk with
[the] superintendent of schools,
[St]ate Commissioner of Educa-
[tion] John J. Desmond, Jr., regard-
[ing] plans for a separate high
[school] for veterans in Chicopee. He
[said] that he was particularly
[anxio]us to learn details of the
[new] Veterans Regional High
[Scho]ol system, which has grown
[rapid]ly during the past few months.

[E]xplains Regional System
[Mr.] Fitzgerald said that the gen-
[eral] system being followed under
[the re]gional set-up is for veterans
[to re]gister for university extension
[cours]es and to attend classes two
[day]s a week at these regional
[schoo]ls where they receive instruc-
[tion a]nd coordinate their study pro-
[gram]s. It is his understanding that
[the] classes are run on a tutorial
[basis] and that each veteran can
[progr]ess as rapidly as he is able
[to co]mplete the work required.

[At] the present time there are
[region]al schools located in Spring-
[field,] Holyoke and Westfield, and
[Mr. F]itzGerald revealed that some
[60] veterans are attending these
[school]s. No veteran can take more
[than] two courses concurrently un-
[der th]e regional school system, but
[can] complete the two courses
[and] delay and take up addition-

POSTER CONTEST WINNERS

Photostatic copies of the winning posters designed by school pupils
pictured above will be distributed throughout Massachusetts by the
State OPA. Prize winners in the contest here, the first of its kind
in the State, are left to right, (top row) John Strycharz, 2nd;
Edmund Skellings, 1st; Walter Wodyka, honorable mention, all of
Center Junior High. (Bottom row) Leonard Roberts, 2nd; Mary
Tomaris, 1st; and Yvette Talbot, honorable mention, all of Kirby
Junior High. The contest was sponsored by the Chicopee Commun-
ity Service Panel, whose chairman is Miss Pauline C. Jette. It was
conducted under the direction of Mr. T. F. Donegan. To the first
prize winners go checks for $3 and to the second prize winners
checks for $2.

Fairview Boys' Club Illustrates
Power of Community Cooperation

At a joint meeting Monday night of the City Property [Commit]-
tee, the USO Operating Board and a committee representing [Com]-
munity Chest, it was unanimously decided to support plans [main]-
taining the present USO installation in Chicopee Falls [as a Com]-
munity Center. This meeting was called as a result of confe[rences re]-
cently with Military personnel at Westover Field and wit[h na]-
tional office of the USO which have confirmed a notificatio[n that the]
local USO installation will be deactivated by May 31, 1946.

Mr. William F. Brennan, chair-
man of the USO Operating Board,
expressed the opinion of the entire
group at Monday's meeting when
he said, "A Community Center will
do more to cement good will and
comradeship in the city than any

other one project that we[have had]
in recent years." He poin[ted to the]
success of the Chico-Teen [installa]-
tion which has been usi[ng fa]-
cilities at the USO for the [past few]
years as an example of w[hat]
service a Community C[enter can]
offer.

Transfer Easy

Transfer from USO to [become]
a Community Center [is quite]
simple. The building [is now]
owned by the city, and [the Com]-
munity, through the C[ommunity]
Chest, owns the furnis[hings. The]
only step necessary for [the opera]-
tion is a reorganization o[f the]
Governing Board into a C[ommunity]
Center committee.

The joint meeting pas[sed a res]-
olution by unanimous vo[te emp]-
ering Mr. Brennan to [appoint a]
committee from the mem[bers of]
the USO operating com[mittee to]
investigate the advisab[ility and]
detailed plans for the tr[ansfer. A]
meeting of this committ[ee was]
held Wednesday night, [March 27.]

Praises Voluntee[rs]

Mr. Brennan noted th[e suc]-
cess of the planned pro[gram for]
servicemen at Westov[er Field]
which was offered by the [USO and]
had emphasi[zed the]

Raw Milk Sales Here Under Investigation

It has come to the attention of
city officials that raw milk has
been sold recently in the city in
violation of local laws. An invest-
igation is now under way by the
Health department and it is ex-
pected that corrective action will
be taken in the near future.

CIVIC LEADERS PLEDGE SUPPORT OF CITY HOSPITAL

Endorsements of the proposal
for establishing a hospital in Chic-
opee continued to pour in this
week, but thus far no definite
steps have been taken to imple-
ment the proposal. Mayor Edward
Bourbeau, reiterating his support,
stated that no committee had

The lead story in the *Chicopee Herald* on March 28, 1946, reported that the national office of
the USO had sent the city official notification that the local unit on Church Street would be
deactivated by May 31, 1946. In the same edition, a small article reported that local fisherman
were complaining that oil and aviation debris was fouling the city's water supply. Aircraft flying
into Westover Field passed directly over Chicopee's Cooley Brook Reservoir. In 1946, Westover
base commander Col. Russell Keillor and Mayor Edward Bourbeau met with Massachusetts
governor Maurice Tobin to discuss the problem. The result of that meeting was a 50-year
agreement for the city and the base to receive water from the Quabbin Reservoir.

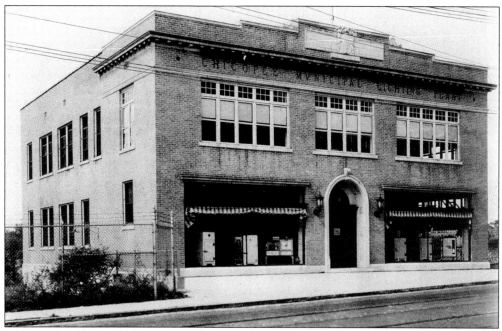

In 1946, the Chicopee Electric Light Department was 50 years old. In 1896, Chicopee became the first city in Massachusetts to own its own municipal power state. In 1946, the total kilowatt hours purchased amounted to 35,330,000. Sales to the U.S. Army at Westover Field totaled 6,422,000 kilowatt hours, 18.2 percent of the total.

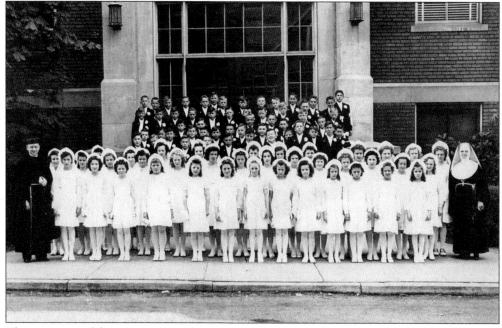

Three quarters of the youngsters graduating from the St. Stanislaus grammar school in 1946 would attend Chicopee High School. The Rev. Josaphat Piasta and the Sister Superior Mary de Sales pose with students as the city's public schools brace for a historic enrollment surge.

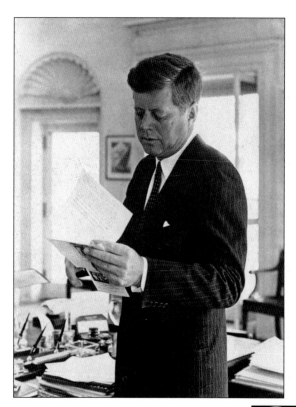

On Palm Sunday weekend in 1946, fresh from his heroics on PT-109, John Fitzgerald Kennedy was the guest speaker for the communion breakfast of the Holy Name Society at the Holy Name of Jesus Church in Chicopee. The young man was in the first weeks of a whirlwind political campaign for the 11th district seat in congress. In a landslide victory, Kennedy won the seat that was once held by his grandfather.

Most returning soldiers were not going to run for office. They headed home to marry the girl they left behind. Billy Stewart was back from the South Pacific. On Saturday, July 27, 1946, he married Marilyn Moody at Faith United Methodist Church in Fairview.

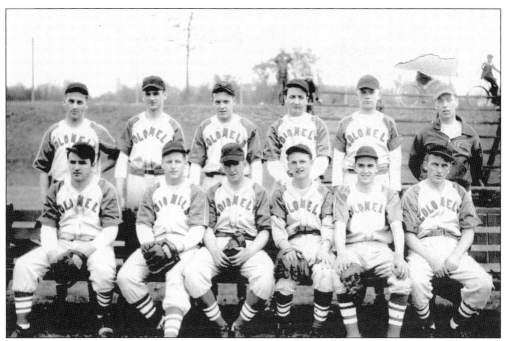

In 1945, the Colonels Athletic Club compiled an outstanding 21 to 4 record. They were the preseason choice to dominate the revitalized Chicopee City League in 1946. The 1945 team featured the play of 15-year-old slugger Clark Wojtowicz (second from right, second row).

The Colonels Athletic Club played their home games at Szot Park, the region's finest baseball diamond. On the old mill towns' ball fields it was homecoming. In Fairview, the Buffalo Club was back at full strength. The Tigers were packing them in at Lincoln Grove. The Sandy Hill Eagles did not organize a squad. Instead they combined with the Chicopee Polish Americans to field a veteran all-star team.

Mitsie "Bunny" Kulig (center) was the third basemen for the Chicopee Polish Americans. Pictured here, the young men are on their way to the Wigwam Restaurant, the city's most popular postwar eatery. Restaurants like the Wigwam in Chicopee Center and the Mount View Club in Willimansett sponsored strong city league teams.

In the era before television sports, the baseball game on a Sunday afternoon was the place to be. In an early season matchup of unbeaten teams, the Colonels played the Wigwam Athletic Association. Two outstanding pitchers, Vince Korzeniowski (Colonels) and Joe Kucab (Wigwam Athletic Association), were the afternoon's star attractions. The crowd streams out of Szot Park after another hard-fought contest.

After a four-year hiatus, city league baseball was back. World War II had been over for nearly a year. The fans were excited as the old cross-town rivalries were renewed. In 1946, the Chicopee Polish American baseball club overcame some key injuries to win the city championship. Outfielder Frank Sypek was one of the players who spent time on the club's disabled list.

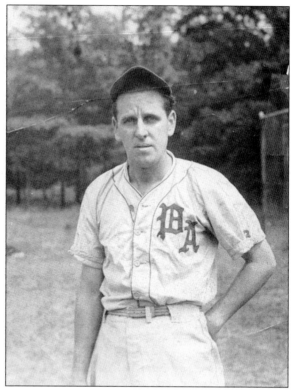

The Chicopee Polish Americans played the Chicopee Colonels Athletic Club in a best-of-three playoff for the city league championship. Game one featured a pitching duel with the Colonels' Vince Korzeniowski beating Angus McKechnie 2 to 1 before a capacity crowd of 6,000 at Szot Park. Pictured here, Colonel's catcher Gene Balicki disagrees with umpire Raymond Lynch's third strike call.

A standing room only crowd at Szot Park stayed for 12 innings before the Polish Americans became the first postwar champions of the Chicopee City League with a 3-to-2 triumph. Poet Walt Whitman saw great things in the game of baseball. "It's our game—the American Game, it will repair our losses and be a blessing to us." As the huge crowd headed for home, the players shook hands. On that historic Sunday afternoon, there were baby carriages parked in the shade beyond the fence. The "boys of summer" were becoming increasing concerned about their adult careers and family responsibilities.

MAY FESTIVAL

SPONSORED BY

COLONEL ATHLETIC CLUB
At The ST. STANISLAUS HALL

Front St., Chicopee, Mass.

Sunday, May 26, 1946, at 8:00 P. M.

Music and Entertainment By

Joe Lazarz and His International Broadcasting Orchestra.

Admission 60c. – Tax Included.

The primary fund-raising vehicle for Chicopee's athletic teams was the weekend dance. Joe Lazarz and his popular orchestra were sure to pack the St. Stanislaus Hall. Dance bands usually played three sites on the weekend. Most returning veterans attended these affairs stag. It was not very long before they found a favorite dancing partner.

Billed as New England's favorite dance band, the Joe Lazarz Orchestra featured the considerable vocal talents of the Zamachaj sisters. Clara and Nell Zamachaj lived in the Ferry Lane section of Chicopee and performed with the orchestra at ballrooms in New York, New Jersey, and Pennsylvania.

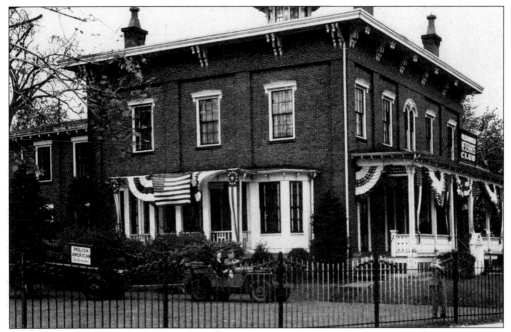

On a slightly overcast Saturday, October 12, 1946, the citizens of Chicopee paused for a bittersweet welcome home celebration. The threat of rain nearly cancelled the event. The Polish American Veterans Club on School Street served as headquarters for the activities. From Chicopee, 6,254 men and women had served in the military, and 128 of them had died in service.

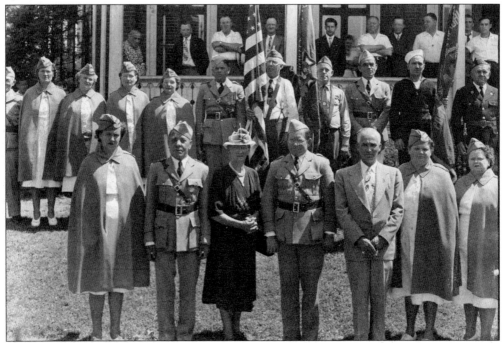

The Ladies of the Polish Army Veterans Auxiliary pose in front of the Post 168 quarters. Their serious demeanors indicate the somewhat solemn nature of the homecoming festivities. Along the parade route, the Gold Star Mothers were a grim reminder of the price of victory.

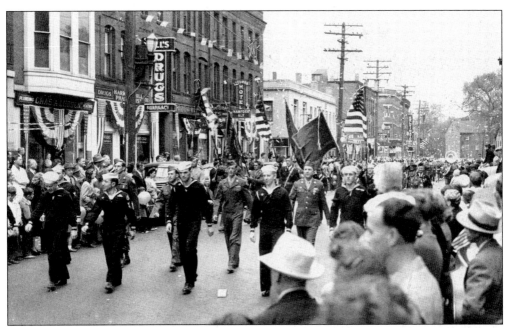

The American Legion was organizing new posts in Fairview, Willimansett, Aldenville, and Chicopee Center. In 1946, veteran's organizations were mobilizing to elect returning servicemen in November's congressional elections. Mayor Edward O. Bourbeau's parade committee had invited all the city's veterans to march in uniform.

Taking a page from big-city celebrations, as the marching units appeared, shredded paper poured from the tenement windows on Exchange Street. As the veterans passed Hill's Drug Store, the pharmacist waved to the passing column.

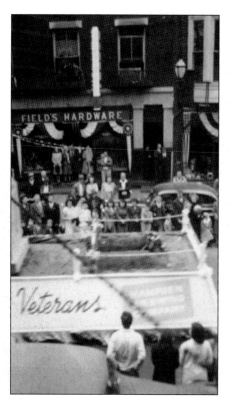

The Hampden Brewing Company's beautifully decorated float displays their honor roll of employees in the service. The float is in front of Chicopee's historic Fields Hardware Store. The Welcome Home Parade Committee awarded the second prize to the company's float.

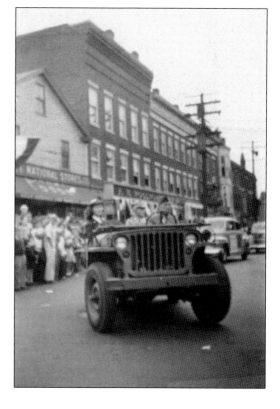

In 1946, the Watertown Arsenal was selling war surplus jeeps. The American love affair with the quirky little vehicle is still going on today. Every jeep in the parade was transporting a pretty servicewoman. Here Jane Guz, who was part of the Women Accepted for Volunteer Emergency Service (WAVES), and her driver are turning into Market Square.

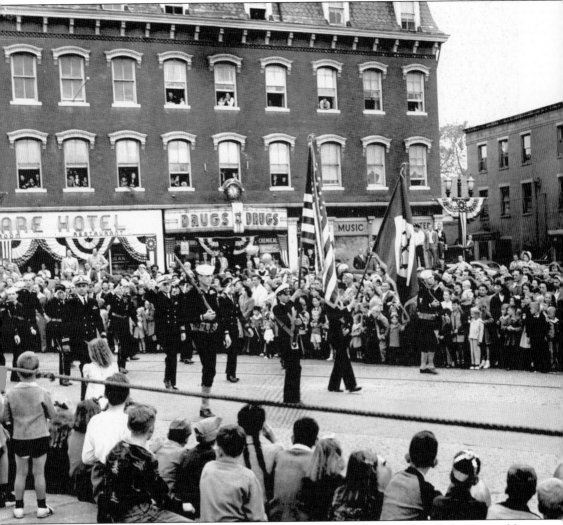

Brig. Gen. Edward Anderson, the guest speaker from Mitchell Field in New York, was unable to attend because bad weather kept his plane grounded. U.S. Senator David Walsh drew loud applause when he assured the veterans that he favored continuation of veterans' benefits. The brief speaking program ended just as the rain began. Mayor Edward O. Bourbeau commended Chief Francis Linehan for the splendid work of the police and the traffic bureau in the orderly handling of the large crowd and in keeping traffic moving.

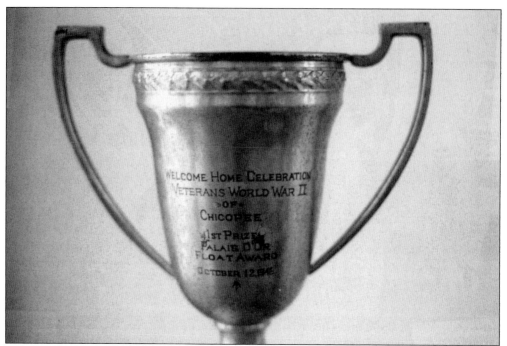

William Nickarz Jr. provided this picture from his home in Pacific Beach, Washington. His father's Palais D'or float was awarded the first prize in the city's Welcome Home parade. No pictures of the winning entry remain. The newspapers reported that the Palais D'or Social and Civic Club float depicted deer hunters in a wooded area.

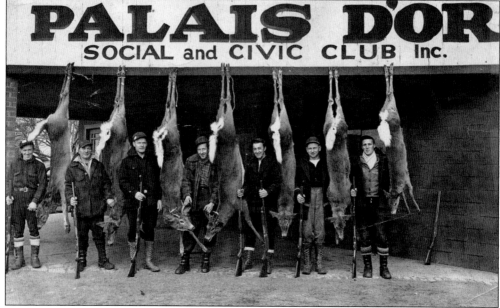

In December 1946, the Massachusetts Fish and Game Department issued a record number of hunting licenses to returning veterans. William Nickarz Sr. (third from right) poses with a group of successful hunters. In January, he hosted his club's annual venison roast.

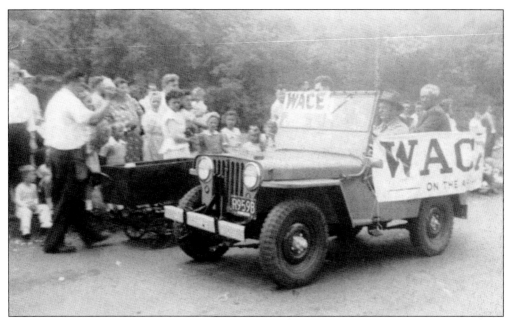

On December 12, 1946, Norman Cloutier, a native of Chicopee and an executive with the National Broadcasting Company (NBC), was the guest speaker at the dedicatory broadcast of Chicopee's new radio station WACE. A large crowd attended the live broadcast of a variety show at the Chicopee High School auditorium. The station's Jeep Mobile Unit frequently provided live broadcasts from the scene of local events.

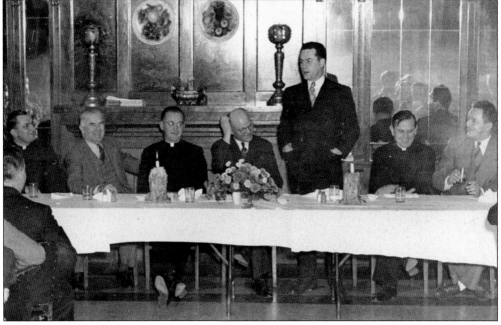

Longtime Chicopee district judge Napoleon J. Vigeant passed away in 1946. In 1947, after a spirited political battle, Daniel M. Keys of Springfield became the youngest judge in the state at the age of 28. Keys (standing) was the guest speaker at the Father's Day breakfast of the St. Stanislaus Parish Holy Name Society.

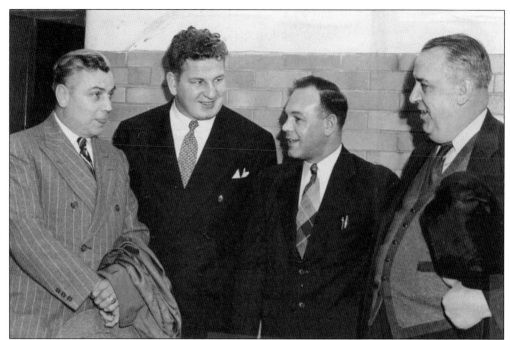

In 1947, for the first annual Chicopee Boosters Association Sports Night at the high school auditorium, 1,000 people were in attendance. The main speaker was Chicopee's George Sergienko (second from left) who played professional football in both the National Football League and All-American Conference with the Brooklyn Dodgers. He told the audience that within a year or two he expected the winners of the two leagues to play for a world football championship.

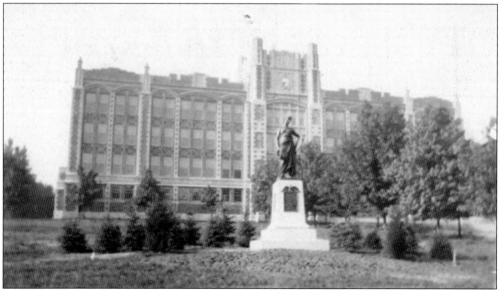

In 1947, Henry Bowles Fay, a teacher at the Kirby Junior High School, moved to Chicopee High School to teach English. That same year he obtained a federal grant for the school system's first guidance program. The following year he established an adult education program at Westover Field. Later as the principal of Chicopee High School, he was the city's leading advocate for educational reform.

Five

CENTENNIAL
1948–1949

The Bill of Incorporation passed the Massachusetts State Senate on April 4, 1848, with one important change. The name Cabotville was crossed out on the senate bill with the name Chicopee written above. The separation from Springfield became official when Gov. George Briggs signed it into law on April 29, 1848. On Memorial Day weekend 100 years later, the city staged a spectacular three-day centennial celebration with a giant parade, a historical pageant, and a music festival at Szot Park. The *Chicopee Herald* published a 76-page special commemorative edition.

In 1893, Albert Goodwill Spalding moved his sporting goods company to the foot of Springfield Street in Chicopee. In the city's centennial year of 1948, A. G. Spalding and Brothers was the nation's leading manufacturer of recreational sports equipment. The sign said it all: "Spalding Sets the Pace in Sports." In 1948, Spalding renovated the Stevens-Duryea plant on Meadow Street. The company's famous baseball division was one of the first to make the move. In 1876, the Spalding brothers signed a contract to manufacture all the balls used in baseball's National League. In 1948 the company produced baseballs for players from the sandlots to the major leagues.

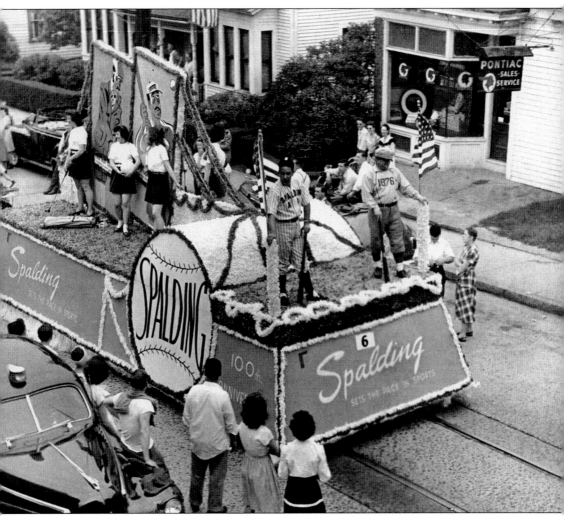

Spalding employees pose with the company's float at the centennial parade's staging area at Dana Park. Famous firsts was the theme of the exhibit. In 1876, A. G. Spalding and Brothers made the nation's first precision-manufactured baseballs; in 1887, the first American-made tennis ball; and a year later, the first modern football at the company's Chicago facility. In Chicopee in 1894, the world's first official basketball was designed for Dr. James A. Naismith of Springfield College. That same year, in the old Ames Company Foundry on Springfield Street, Spalding made the first American golf clubs. In 1895, the company provided the balls for a new game called volleyball. The game was invented at the Holyoke YMCA by William G. Morgan.

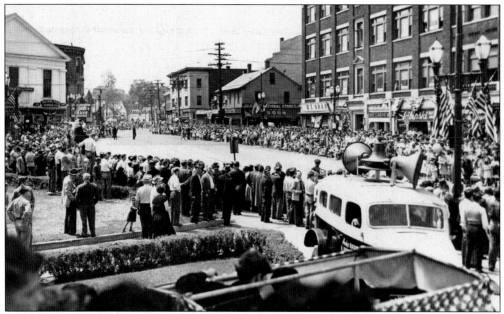

In many ways in 1948, Chicopee was five self-contained little communities, each exhibiting a self-assured independence. The *Chicopee Herald* reported, "City-wide cooperation to an extent never before realized in Chicopee's eventful history will bring hundreds of men and women from all sections and all groups to make the event a real community success." This huge crowd awaits the parade's arrival in Chicopee Center.

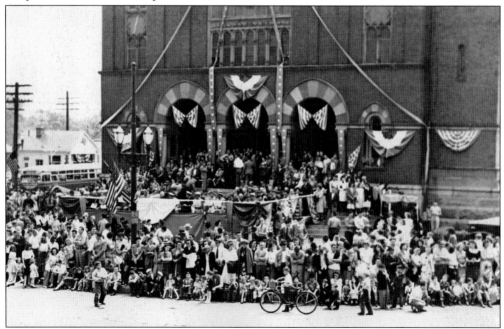

The parade kicked off at 11:00 a.m. from Dana Park, with the line of march via Springfield Street, South Street, and Center Street into Market Square. On the reviewing stand in front of city hall was Chicopee's oldest living resident. Alice Thomas was born on March 29, 1854. For 40 years, Thomas was a public school teacher in Chicopee.

114

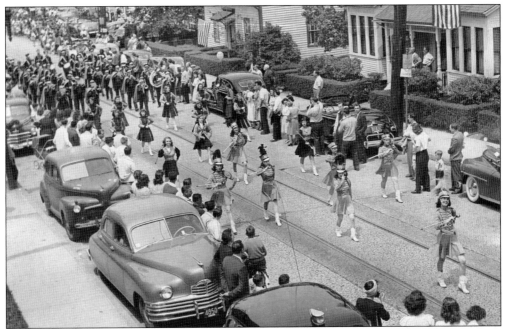

Jane Nowak leads the Chicopee High School marching band up Front Street. The parade traveled up Front Street to Szot Park. The mechanized portion of the parade proceeded through Szot Park to Broadway. After a 10-mile journey to every section of the city and Westover Field, the parade floats were displayed at Lincoln Grove in Chicopee Falls.

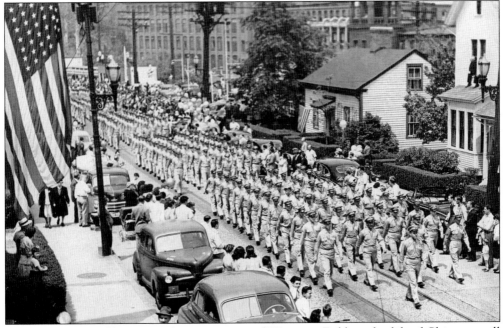

The *Chicopee Herald* wrote, "The importance of Westover Field in the life of Chicopee will be clearly demonstrated when the men from the base participate in Chicopee's Centennial Celebration." Airmen from Westover Field swept up Front Street as planes from the base's 108th Air Reserve Unit zoomed over the line of march.

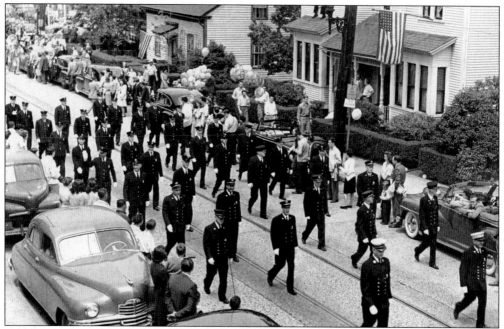

For fire protection, a fire district was organized in 1848 and was called the Central Fire District. The volunteer department's equipment was funded by the local textile mills. By 1948, the department had a chief, two deputy chiefs, seven captains, one mechanic, 67 privates, 15 pieces of equipment, and six station houses.

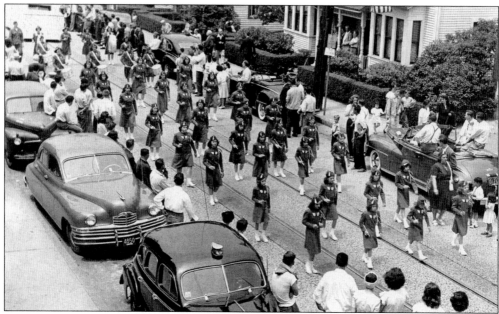

St. Ann's Fife and Drum Corps was one of 40 such units participating in the parade. They were competing for $1,400 in cash prizes in addition to trophies and medals. Following the parade, a special competition in playing, drilling, and baton twirling took place at Szot Park. The competition was hosted by Chicopee's Assumption Corps with Edward Dupuis serving as chairman.

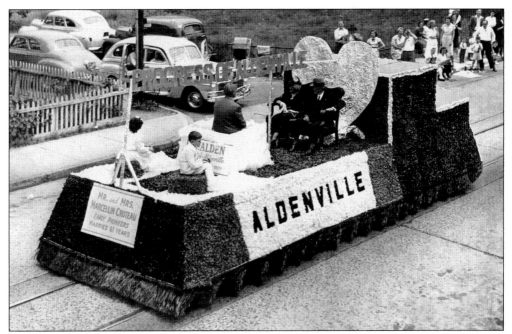

The Aldenville section of the city presented a truly historic float. Marcellin and Marie Croteau were described as early pioneers who had been married for 61 years. He was the building contractor who constructed Aldenville's first church in 1897. The land for the St. Rose de Lima chapel had been donated by Edward S. Alden.

In September 1914, the St. Joan of Arc School opened under the direction of the Sisters of the Presentation of Mary. In 1948, Thaddeus M. Szetela's *History of Chicopee* reported that 3,000 pupils were enrolled in the eight Catholic parochial schools located throughout the city.

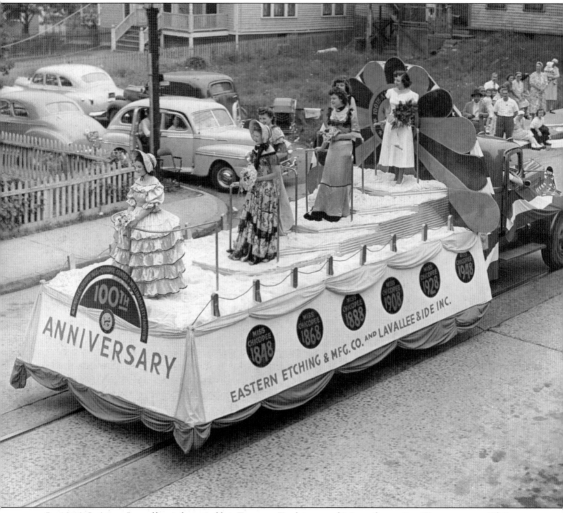

In 1940, J. Aime Lavallee relocated his Eastern Etching and Manufacturing Company to Chicopee. The company was one of the main suppliers of etched and lithographed nameplates to several of the nation's leading manufacturers. The company took over buildings in the old Ames Company Foundry at the foot of Grape Street. In 1948, Eastern Etching and Manufacturing Company and its sister company Lavallee and Ide were two of the city's fastest growing companies with 200 employees. In this photograph, six of the companies' lovely employees represented 100 years of Miss Chicopee.

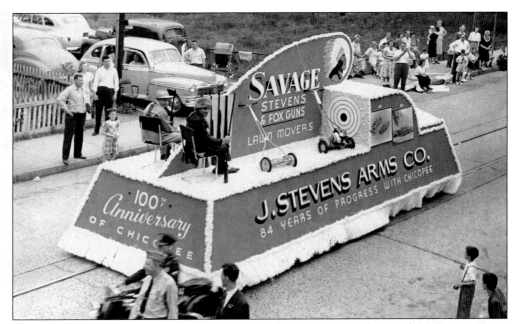

The postwar-era's conversion to peacetime production was most evident at the J. Stevens Arms Company of Chicopee Falls. The company, founded in the 1850s by Joshua Stevens, was a leading small-arms manufacturer. Following the postwar trend in the arms industry, the firm diversified with the introduction of the Savage line of lawn mowers. In 1948, Stevens-made shotguns reached a global market. The factory complex on Broadway employed 1,800 people.

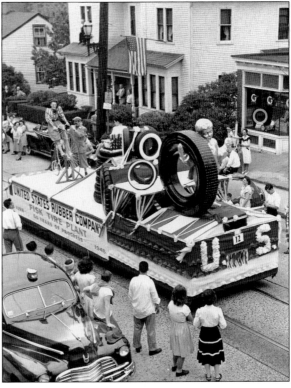

In 1939, the United States Rubber Company paid over $7 million for the Grove Street plant of the Fisk Tire and Rubber Company. The transaction was the biggest such purchase in the history of the rubber industry. The centennial float features the trademark "Time to Retire" of the Fisk Company. In 1948, the Fisk Tire plant of the United States Rubber Company was Chicopee's largest employer with a manufacturing and office staff of 4,100.

On February 1, 1948, Westover Field became a Military Air Transport Base. At 12:30 p.m. on June 28, 1948, Pres. Harry Truman announced that, in an attempt to force the allies out of West Berlin, Germany, the Russians had blocked access to the city. He announced, "We are staying in Berlin. Period!" The sleek new C-54 pictured here was a major player in what became known as the Berlin Airlift.

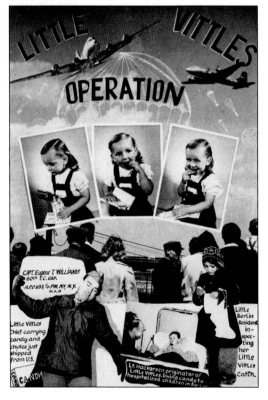

The allies defied the Communists by supplying the city from the air. Code-named "the Big Lift," Operation Little Vittles at Westover was under the command of Gen. William Tunner. Lt. Gail S. Halvorsen, a Westover pilot from Utah, dropped three handkerchiefs filled with candy bars and gum in parachute style from the flare tube of his C-54. By the end of September, the children of Berlin had a new name for the 17th Squadron. The kids called them the "candy bombers."

On October 7, 1948, the organizational meeting of the Chicopee chapter of Operation Little Vittles took place in Room 109 at Chicopee High School. Mary Connors of the College of Our Lady of the Elms was the president of the local committee. The former Engine Company No. 4 Fire Station was where the parachutes and candy were packaged for shipment overseas. The school children of Chicopee made and packed the candy chutes.

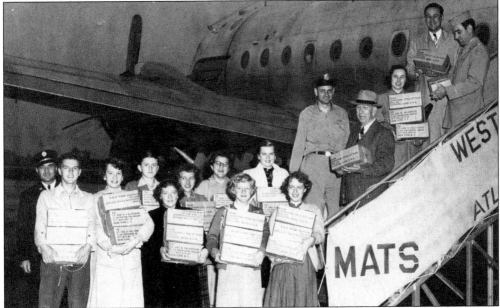

Chicopee's volunteers packed about 500 pounds of candy a week for delivery to the children of Berlin. This photograph shows some of the Operation Little Vittles crew with Chicopee fire chief Ernest LaFlamme (far left), Westover base commander Joseph E. Barzynski Jr. (on ramp, left), and Chicopee mayor Edward O. Bourbeau (on ramp, second from left). One minute after midnight on May 12, 1949, the Soviets reopened the autobahn into West Berlin.

In 1948, Charlie Dugre (right), Sam Carrigan, and Leo Asselin (left), opened Sam and Charlie's, a small sandwich shop and ice cream fountain on Grattan Street. A few years later, Dugre would buy out Carrigan. The business became Charlie's Lucky Strike Restaurant. Today the family-owned eatery is a local landmark.

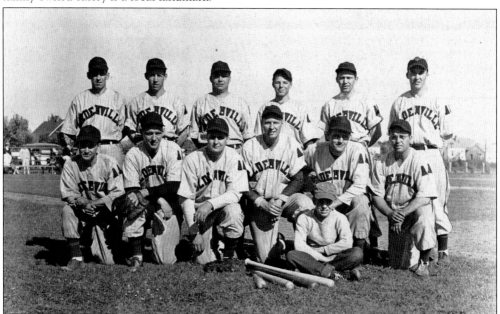

On Sunday, August 29, 1948, the baseball season ended with the final games of the western Massachusetts baseball tournament at Szot Park. The Aldenville Athletic Association team emerged as tournament champion. The tournament was well attended, but the crowds were smaller than in previous years. On Sunday afternoons, Major League baseball was now on television.

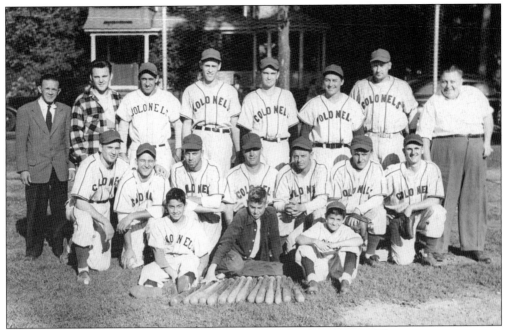

The Chicopee Colonels won the city baseball championship in 1949. The organization was in its 10th year under the leadership of Ted "Snapper" Drewniak (second row, far right). That year, he made his first run for political office. He served several terms as the president of the Chicopee Board of Aldermen.

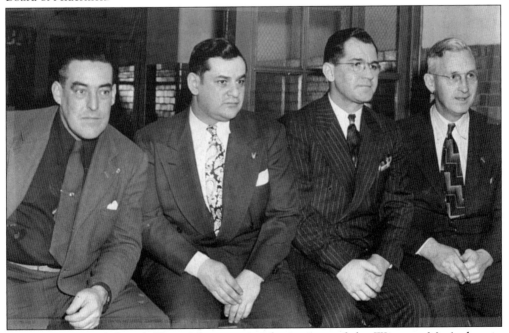

Eli Cohen (second from left) was the owner and proprietor of the Westover Men's shop in Chicopee Falls. Since 1927, he had written about the Chicopee sport scene for the *Chicopee Herald*. Cohen and Chicopee Boosters' Association president Ted Szetela (third from left) played a key role in publicizing the expansion of the community's youth sports program.

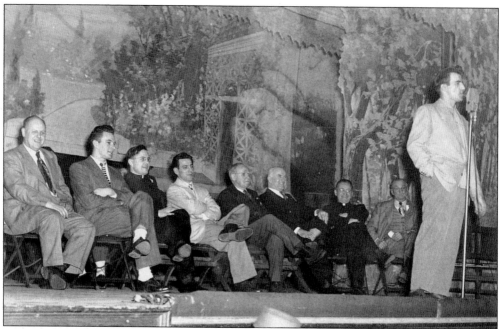

At St. Stanislaus Parish in 1944, Fr. Thomas Gralinski (third from left) organized the Holy Name Society. Clarky Wojtowicz, who had just signed a contract with the New York Yankees, is seated second from left. Holy Name Society sports nights were very popular. Here Boston Red Sox second baseman Johnny Pesky wows a full house in the school auditorium.

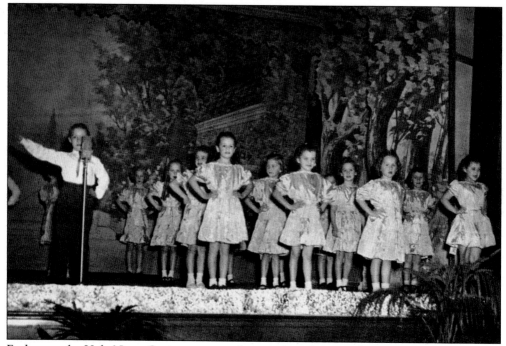

Each year, the Holy Name Society sponsored musical productions featuring students from the parish school. The events always drew large, enthusiastic crowds of parents and grandparents. Here members of Sister Veronica's fourth grade class display their talents.

St. Patrick's Church on Sheridan Street was dedicated on December 15, 1872. In 1946, the parish purchased the Irving Page property on Broadway to serve as the parish rectory. The new church was constructed in the Romanesque style using Pennsylvania face brick trimmed with limestone and granite. Bishop Thomas M. O'Leary dedicated the new edifice on Sunday, May 8, 1949.

On January 13, 1899, the Springfield Diocese purchased land on the east side of Springfield Street. The growth in Chicopee's Catholic community through the 19th century brought the city a new institution in the form of the Elms Academy. By 1928, the school had evolved into the first Catholic women's college in western Massachusetts. On the school's spacious lawn, members of the junior class bear the daisy chain during class day ceremonies.

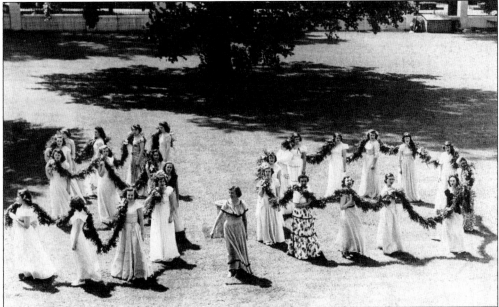

In 1949, there were 4,912 children enrolled in the Chicopee public schools. In 1950, 113 students graduated from Chicopee High School. In the next seven years, the number of high school graduates doubled. The Chicopee School Committee's publication, *Your Schools in Action*, proposed a five-year plan anticipating a 50 percent increase in the number of students attending the city's public schools.

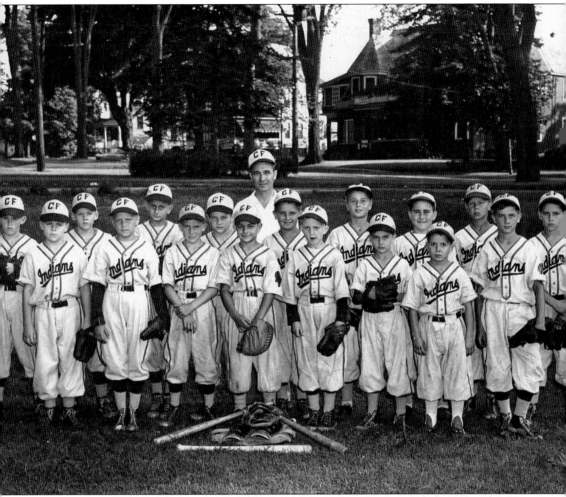

The Chicopee Falls Indians epitomized the community's new level of commitment to sandlot sports. Peewee teams wore major league-style uniforms and played on landscaped fields before large crowds. These "boys of summer" were Chicopee's greatest asset. Pictured, from left to right, are (first row) Richard Havican, Bernie Leonard, Ed Sheridan, Mike Godek, Bob Christiansen, Bob Walat, Tim Monahan, and Gene Walat; (second row) Gerald Cove, Bob Churchill, Stan Forys, Tommy O'Connor, Bob Skibinski, Bob Dobrowski, Tom Watson, Frank Boron, and Ed Costello. The team's coach was Leo Valliere.

ACROSS AMERICA, PEOPLE ARE DISCOVERING SOMETHING WONDERFUL. *THEIR HERITAGE.*

Arcadia Publishing is the leading local history publisher in the United States. With more than 3,000 titles in print and hundreds of new titles released every year, Arcadia has extensive specialized experience chronicling the history of communities and celebrating America's hidden stories, bringing to life the people, places, and events from the past. To discover the history of other communities across the nation, please visit:

www.arcadiapublishing.com

Customized search tools allow you to find regional history books about the town where you grew up, the cities where your friends and family live, the town where your parents met, or even that retirement spot you've been dreaming about.

Heartfelt and at times heart-rending, "Seaweed and Shamans" details Brenda Paik Sunoo's journey through grief into solace. Written with courage and generosity, her collection of essays traverses personal memory and Korean-American history, as well as the thoughts and drawings garnered from diary entries of the child she lost. A testimony to the endurance of faith and art, life and love, "Seaweed and Shamans" is a gift of healing.
Nora Okja Keller, author of *"Comfort Woman"* and *"Fox Girl"*

This is a wonderful book: warm, honest, intelligent, funny, unsentimental, and heartbreaking, too. Brenda Sunoo weaves the experience of her grief over the death of her son with the story of her life and family, and it works beautifully. Is it possible to heal from the loss of a child? This book says yes: to heal and to transcend, but never to forget, never to lose that child living now in your heart. This is a story that will stay with you for a long time.
Sharman Apt Russell, author of *"Songs of the Fluteplayer: Seasons of Life in the Southwest"*

Brenda Sunoo has learned from her personal experience that the death of a child is one of the most painful experiences you can have. She has also learned that there are gifts in grief and shares them with the reader. But the greatest gift, perhaps, is that the bereaved can now receive comfort from such a wonderful book.
Allen Klein, author of *"The Courage to Laugh: Humor, Hope and Healing in the Face of Death and Dying"*

"Seaweed and Shamans: Inheriting the Gifts of Grief" gives us a most precious gift: the powerful emotional insights from a parent's worst nightmare, the death of a child. By sharing her teenaged son's life, a mother's deep love, and a four-generation Korean family's journey, Brenda Sunoo allows us to witness—and to feel—the intense heart and soul of her emotional and cultural truths. This book will sweep you away.
Helen Zia, author of *"Asian-American Dreams: The Emergence of an American People"*

Brenda Sunoo writes eloquently about keeping family rituals yet at the same time, making changes after the untimely death of Tommy—son, brother and friend extraordinaire. The reader is privileged to get a glimpse into the world of an insightful young artist and writer with a vivid imagination, who was wise beyond his years. Brenda writes with love, humor, sadness, spirituality and compassion about her family. This book is a must-read for anyone who has experienced a loss.
Sandy Lipkus, B.Ed, B.S.W., M.S.W. and founder of ShareGrief.com

Many bereaved individuals try so desperately to hang on to the moment before their loved one has died. Brenda Sunoo's search for peace after her son's death has redefined her. She not only let that process unfold, but embraced it. While keeping her son's spirit alive, the author has also discovered deeper meaning in her life.
Joel Hetler, Ph.D., Child Psychologist and Manager of Children's Mental Health Services in Ramsey County, Minneapolis, Minnesota.

Seaweed and Shamans
Inheriting the Gifts of Grief

Designed by C. David Thomas, Director, Indochina Arts Partnership, www. iapone.org.

ISBN 89-91913-03-2

First Published on April 3, 2006
by Seoul Selection
B1 Korean Publishers Association Bldg., 105-2 Sagan-dong,
Jongno-gu, Seoul 110-190, Korea
Tel 82-2-734-9567
Fax 82-2-734-9562
www.seoulselection.com

Printed in Seoul, Korea

Seaweed and Shamans

Inheriting the Gifts of Grief

Brenda Paik Sunoo

For Art + Peggy,
may you continue
to receive and sift
the sift of compassion
+ play more jazzy!

love,
Brenda
Hà Nội, Việt Nam
6/2006

"I will turn their mourning into joy. I will comfort them and give them gladness for sorrow."

Jeremiah

In memory of Tommy

acknowledgements

This book would not have been completed without the encouragement of so many gift bearers. I wish to acknowledge the generous assistance of my Antioch University mentors during the MFA in Creative Writing Program: Bernard Cooper, Sharman Apt Russell, Louise Rafkin and Lisa Michaels. They have all helped me learn to write with more simplicity, honesty and with a wordsmith's eye for detail. I also wish to thank Eloise Klein Healy and Keith Rand, for being our lighthouse and compass; Club Kay (Teri Pastore, D'Arcy Fallon and Sara Kirschenbaum) for being my invaluable writer's community—online and off.

Also, Steve Bagatourian, Abe and Andrew Lin, Anthony Wong for their youthful compassion and remembrances; Hind Baki, for helping me understand the loss of a sibling; Mark Doty, for writing "Heaven's Coast" and for encouraging me to own my story; Allen Fergurson, for sharing the lighter sides of grief; Allan Halcrow, for his editorial wisdom and respect for writers; Carol Janes, for rekindling a friendship never lost; Marian Kwon, for laughter and her 24-hour hotline; Chiyo Maniwa, for lightening my vulnerable moments; Julia Randall and Tamara Thompson, for their affirmations; Sakada, for generating Reiki light; Elizabeth Siemens, for heartfelt letters and our extended Siemens family; Charlene Solomon, for previous collaborations and enhancing my work life; Steve Stewart, for challenging me to return to grad school; Harold and Sonia Sunoo for decades of faith and encouragement; Cooke and Elaine Sunoo, for their patience and devotion; The Compassionate Friends, especially Bruce Giuliano and Judy Zuckerman for taking me under their protective wings; Gail Whang, for being Tommy's Godmother in his physical and spiritual life; Jai Lee Wong for staying close at all the right times; Linda Yim, for her ongoing generosity; Trina Nahm-Mijo for her pivotal suggestions; Rose Moxham for her impeccable eye; Steve Yum, Edward Hwang and Peter Park for their technical wizardry and levity; Jan and David, for being my two best reasons for living. If I haven't mentioned you here, trust that you are remembered. And lastly, I want to thank my mother, Katherine Yim Paik, who taught me what it means to live with courage and grace.

introduction

Nothing in life prepares you for the death of your own child. When my 16-year-old son Tommy died suddenly on February 16, 1994, I prayed that God would take me in my sleep. It hasn't happened.

Whereas once we were a family of four, we now were a family of three: my husband Jan, our first son, David, and me. It took several years before we could feel the stability of our new triangle. Most of those times, we appeared flat-lined.

Ask anyone who's suffered from grief. Getting out of bed is like trying to lift a giant redwood off your chest. Even though I had a full-time job as a magazine editor, I felt I deserved to be called Mother Failure. Regardless of the circumstances of a child's death, parents inevitably feel guilty for not protecting them from harm.

For the first two years, I chronicled my emotional chaos in private journals. None of that, in my opinion, merited public consumption. But after attending several meetings of The Compassionate Friends—a national support group for bereaved parents—I began as a journalist to listen to other parents' stories. Many of them complained that, as grief-stricken employees, they had been isolated, ignored, demoted, laid off or fired: "My boss is worried that I'm affecting company morale," or "My supervisor wants to know when I'm going to get over my loss."

A fellow writer, Charlene Marmer Solomon, and I, pitched a story idea to our then-editor, Allan Halcrow. He encouraged us to co-write an article for *Workforce* magazine entitled "Facing Grief at the Workplace." We wanted to write an article that would help employers and human resources managers create a culture of compassion. Interestingly, our article became a magazine finalist for a Maggie Award in the Service category.

After reading and writing about other people's losses, I began to wonder if my own experiences would be of any public value. And to whom? It actually took four years after Tommy's death before I began my own memoir. Frankly, I felt too immersed—and emotionally spent— living in grief to write about it.

A recurring comment eventually hastened my endeavor: "I can't

imagine what I would do if it were me." People were expressing their fear. If a tragedy were to suddenly occur in their lives, how would they handle it?

Simply, in their own way.

The human spirit, quite thankfully, is more resilient than we think. Early on, one of my psychologist friends, Kenyon Chan, warned me, "Now, Brenda…don't try to be a perfect, conscientious griever. It's not about doing tasks, but working through your pain."

Having survived the first few years, I could now call upon the wisdom of reflection. I also could draw that necessary line of distinction between me as Tommy's mother and me as a writer. My work would have to undergo scrutiny. After considerable search on the Internet and an on-site visit, I enrolled in the MFA in Creative Writing Program at Antioch University, Los Angeles. My mentors and fellow students provided me with the necessary literary community. I am indebted to their generosity of time and feedback.

In particular, I remember a conversation I shared with one of my mentors, Sharman Apt Russell. Upon asking her if my story had any arc, she said, "Yes, it's your movement toward healing. Your book isn't a lesson plan for recovery. We just want to know what it's been like for you."

"Seaweed and Shamans" is not a griever's manual. It is a memoir of intense emotional labor, active discovery and inspired growth. At each moment when I thought I wanted to die, someone or something came to me as a gift: a book, an uncle's legacy, a mentor, a dream, travel adventures, nature, restored health—and other surprises. Thank God, I paid attention.

I have also included some of Tommy's artwork and memorable essays, saved over the years. They are among the best gifts of all. Without them, I might only remember his last days, rather than the blessings of his 16 years.

My intention is to share my odyssey through grief. In doing so, I hope my puddled path of renewal will inspire yours. Be patient and attentive, though. It won't happen overnight. Grief drifts in and out like a ribbon of seaweed—floating ashore one wave at a time.

table of contents

The Rose Thief - *Gift of Flowers* 13

Breathing Lessons - *Gift of Wellness* 19

Schnip Schnaps - *Gift of Journals* 29

Faux Pas - *Gift of Emotions* 35

Matter Over Mind - *Gift of Courage* 39

Grace and Good Deed - *Gift of Generosity* 43

A Grave Situation - *Gift of Burial Grounds* 49

Crow as Messenger - *Gift of Imagination* 53

H.M. Lee - *Gift of Memoir* 57

You've Got Mail - *Gift of E-mail* 65

Stone Spirits - *Gift of Spirituality* 71

Art in Private Places - *Gift of Art* 81

Seaweed and Shamans - *Gift of Compassion* 87

Santo Domingo - *Gift of Honesty* 95

Don Diablo Drive - *Gift of Family Memories* 103

Say It With a List - *Gift of Healing* 111

In Memory of Helen Foster Snow - *Gift of a Mentor* 117

Close Encounters of a Different Kind - *Gift of Love* 131

Free Fall - *Gift of Faith* 137

Afternoon Meditation - *Gift of Meditation* 143

Last Day, First Day - *Gift of Dreams* 149

Author's Epilogue 161

the rose thief

Gift of Flowers

What I love about my friend Judy are the unexpected words that vault off her tongue. I once asked her, "How do you comfort yourself since your son's death?"

"I steal flowers, and believe me, it's an art!" she said.

Judy began this crafty habit years ago, albeit slowly. But after her son, Scott, died in a motorcycle accident on July 24, 1987, her obsessions could barely keep pace with her nimble imagination. Before, she happily plucked a bunch of daisies, a few sprigs of red berries. Today, she's equipped with state-of-the-art accessories: her 14-year-old Bichon-Frise named Cameo, a "Little Brown Bag" for carrying flowers (from Bloomingdale's) and a stainless steel pair of Cutex cuticle scissors. No longer satisfied with the common stuff, she's graduated to roses, bird of paradise, lilies and voluptuous pink hydrangeas. She often arrives at my doorstep with a wicked smile.

I don't judge her harshly. After all, she convinced me that joy cracks the cement of grief. That death ends a life, not a relationship. My husband, Jan, and I first met her in 1994 at The Compassionate Friends, a national support group for bereaved parents. We started attending meetings a few months after our 16-year-old son, Tommy, had died. Judy was one of the local chapter's founders—a cheerleader among the walking wounded. I still remember our first meeting. I couldn't believe that I was seated among a circle of deadpan faces. "I don't belong here," I thought, masking my loss underneath a stoic face of denial. I didn't know that newly bereaved parents often assume such attitudes.

On two Wednesdays of every month, we drove to the Senior Citizens' Center in Irvine, California. We weren't even qualified members of AARP then. As we walked through the glass sliding doors, we faced a

13

wooden easel with a yellow poster advertising free flu shots. Orange construction paper, bordered with cutout daisies, stapled on to the bulletin boards with schedules for bus tours to San Diego Zoo, a lecture on diabetes. OK, there were also postings about tap-dancing and oil painting. But for the most part, I didn't feel ready for Meals-On-Wheels, much less grief.

We entered the meeting room. It matched the size of a dance floor with banquet tables connected in rectangular formation. Boxes of Kleenex lined the perimeter. The physical layout didn't offer the living room atmosphere one expected for such a needy group. I felt like an alien. In fact, beyond one wall I could hear a group of aging cloggers with taps glued to their shoes; beyond the other, a mellifluous Indian voice invoking students of yoga to chant, "Yogena chittasya padena vacam...." In our room, there were at least 20 parents. Most attendees were mothers who were single, divorced or unsuccessful in coaxing their husbands to the gathering. But there were some fathers who came to uncork their bottled-up stress day at the office, where they felt compelled to act competent and in control.

Along the perimeter of our square were boxes of Kleenex—conveniently placed within arm's reach. Against the wall were more tables with the largest collection of grief literature I'd ever seen: Books entitled "Roses in December," "The Bereaved Parent," "Companion Through the Darkness," "Only Spring," "In the Midst of Winter" and "Our Children Forever." Special handouts for those whose children died of leukemia, drunk driving, drug overdose, suicide, a drowning. And a box of files to explain every conceivable emotion that we were expected to face: shock, denial, depression, envy, confusion, anger, guilt, absence of sex drives.

And, of course, we were offered coffee, tea and cookies. No one warned me that my first bite into that chocolate chip cookie would eventually lead me to gain 20 pounds. And I don't even claim a sweet tooth.

Before the meeting began, Jan and I signed the attendance sheet. It would entitle us to monthly newsletters—our lifeline in between the bi-monthly meetings. After sticking our nametags to our lapels, we took a seat and waited for the discussion to begin.

As facilitator, Judy—then a stranger—asked me to introduce myself. I could barely squeak my name and explain why we were there. A frequent public speaker, I stammered: "My name is Brenda. My son Tommy..." I couldn't utter the final arrangement of words. As a younger mother slid a box of Kleenex toward me, I shook my head and turned to Jan.

Judy then explained the importance of the necessary ritual. Each parent, if so inclined, could introduce himself or herself and share the name of their child and circumstance of the death. "It's a validation of

who we are and what's happened to us," she said. Something about Judy invited immediate trust. Perhaps I liked her convincing voice. "Things will get better. You will laugh again," she assured us.

Every "will" she uttered became a guarantee of hope. Judy also wore her hair in a curly perm with brown shoulder-length locks. She wore make-up and carried a hand-crocheted shoulder bag that demonstrated how a bereaved mother could regain self-esteem and flaunt a sense of whimsy. I even loved her name, Judy. It made me laugh to myself as I silently imitated Cary Grant's movie line: "Jee-udy, Jee-udy, Jee-udy." I wanted to believe this woman possessed the wizardry to romance my pain away.

That evening, the group talked about obsessions. One mother, Laura, shocked me by instructing another mother on how to retain the scent of her son. "Well, what I do is put Greg's T-shirt in a ziplock bag. That way I can smell him whenever I want to."

If I didn't kick my husband's leg under the table, I must've snickered something snotty to him later. "Boy, someone in there sure needs therapy."

But as the weeks and months passed, Jan and I found ourselves kneeling on Tommy's bedroom carpet, poking our heads inside his closet, hoping to get a whiff of our younger son's faded musk. His folded baggy jeans, red T-shirt and purple-plaid shirt no longer emitted a familiar scent. But we did come nose-to-nose with the past when we unzipped his green sleeping bag. "Eureka!" I shouted. In the absence of touch, taste, sight and sound, his scent left the only palpable evidence of his presence.

By comparison, Judy's obsession with cutting flowers seemed like a creative way to cope with her loss; ours, desperate. Sure, she's had a few close calls. But Judy's not really reckless enough to get caught. Most times, the neighbors probably don't even notice her tiptoeing up to a rose bush, brandishing her weapon with spunk and stealth.

"Never go out on a Sunday morning," she told me, "when the world is clipping away at their hedges. Y'know what I mean?" Her capers, she said, were conducted on weekdays, around 9 a.m.—after the two-income couples have left for work.

"Don't you ever get nervous?" I asked.

"Yeah, but I've always been a goodie two-shoes. That's why this is a bit like living on the edge."

So when flower thieves like Judy prowl around their neighbors' gardens, snip others' youngest buds, are they not practicing the art of mourning? And is she not teaching me the art of seizing life?

"If I see something beautiful, or feel some joy or passion, I say 'pick it, pluck it, fuck it!' "

After hearing Stevie Wonder on the album "Secret Life of the Plants," I asked Tommy—then Inchull—-if he remembered how one refers to the alphabet of the visually impaired.

Instead of answering 'braille,' he said, "Polka dots."

Tommy at age 6

breathing lessons
Gift of Wellness

"In health the flesh is graced, the holy enters the world."
Wendell Berry

Before Tommy died, I could barely run down the block without slumping, out of breath. Then, compelled by my son's sudden death, I began to jog at the local track field. First, a quarter mile. Then a half. Then one mile. Two miles. Finally three. I don't know if I wanted to escape the present or run in search of the future. With each step, though, I pounded the earth like a drum. When I felt like giving up, a crow would appear out of nowhere, cheering me on with its friendly 'kaw.' Sometimes I'd run in a circle. Other times, I'd jump in my car and drive five minutes to Newport Backbay—an estuary for migrant waterfowl. It felt liberating to jog against the wind, alongside the mud flats and salt marshes. If I cast my eyes toward the bluffs, I could watch the pampas grass and Brazilian peppers competing with the native willows and elderberry plants. The struggle to balance nature galvanized my run. I didn't feel alone. After all, wasn't I struggling to balance the nature of grief within me?

It took three months before I received Tommy's autopsy report. Others told me to expect this long waiting period. His body already had been cremated, but our family remained confused by his sudden death. Sitting alone at my desk at home, next to an open window, I felt indifferent toward the casual sun in May. As far as I was concerned, I could outlast the dead of winter. But when I sorted through my mail the day the report arrived, I shifted my attention to the return address: Orange County Sheriff-Coroner. The legal-size envelope arrived well sealed—that is, until I ripped it open with a vigorous thumb; the report, only three pages, had several white spaces in between the text.

Page 1:
Name of deceased: Sunoo, Thomas Inchull
Case No. 94-01120-AB

Age: 16 years
Sex: Male
Race: Asian
Date of death: 2-16-94
Time of death: 1254 hrs.
Cause of death: congestive heart failure
Due to: chronic asthmatic bronchitis

I broke the silence, reading each word aloud: "chronic asthmatic bronchitis." Three words, in Helvetica type, had condensed 16 years of life to a space no wider than his hand. Tommy's life had begun in San Francisco on November 13, 1977; it ended abruptly on an indoor basketball court in Irvine, California. No one provided an acceptable explanation. We received no condolence. Just an official, dehumanizing report that arrived in the mailbox on a spring day.

To say that I was shocked is an understatement. To say that I was angry is more to the point. Tommy did have a cold on the day he died. But nothing "chronic." If he had "bronchitis," there had been no visible sign, except a mild cough.

Then I reread the second word: "asthmatic." I didn't want to accept what I read on the page. Asthmatic? It sounded too close, too familiar, too frightening. As a child, my mother frequently took me to the doctor's office, whereupon I never left without a shot. To this day, I live with this inflammatory lung disease, asthma. And the report seemed to point and wag its forefinger at me. I began to tune out. In no way did I want to accept a verdict that I had passed this condition on to my son. Nor was I willing to consider that, perhaps, he had died due to my neglect.

Page 2:
"Specimens submitted: Postmortem blood, brain, liver, urine, stomach, contents and vitreous humor."

I looked up these last two words in the dictionary: *"vitreous humor—clear, gelatinous matter that fills the part of the eyeball between the retina and the lens."* There's nothing funny about this choice of words. And I wonder how these medical terms come to be. On paper, one human life has been reconfigured into component parts. I read further:

"Blood received by: Fung." Who is Fung?
"Tissue received by: DaLie." Who is DaLie?
"From: Trejo"

None of these people are listed by their full names, so I have no idea of their gender or background. Did Fung, when viewing my son's body, even come close to imagining that Tommy could have been his or her own son? Were Trejo's hands clean? The idea of foreign hands groping Tommy's body made me want to scream. When in labor with Tommy, I even recoiled when the doctor wanted to insert his thick hand into my vagina—to feel the baby's crown. Why should a stranger be the first and last one to touch my creation?

"Samples of postmortem blood were screened for barbiturates, cocaine, methamphetamine, opiates and related compounds. None were detected."

I'm not surprised, but I am relieved. I know people will wonder if Tommy used drugs. He didn't. And my instinct tells me to protect my son's name. To save family face—as my Korean "halmoni" (grandmother) ingrained in me since childhood. "Don't tell our family secrets," she often warned me. But I never listened.

"Samples of homogenized stomach contents were screened for acidic, neutral and basic drugs by ultraviolet spectropscopy and thin layer chromatography. No significant findings."

In a medical context, I suppose "no significant findings" infers a positive conclusion. But the use of these particular three words in relation to my son seemed irrevocably cruel. My train of thought became irrational. The report began to feel more like a criticism.

By the third page, I felt enraged by the "final microscopic descriptions and diagnosis." These medical terms had no meaning for me. I just wanted to know, in simple words, what caused my son's death.

Lungs:
Pulmonary edema. Intra-alveolar hemorrhage. Asthmatic bronchitis. Mucus plugs in tracheobronchial tree. Aspirated blood in bronchioles.

Heart:
Minimal coronary atherosclerosis.

Signed by: Joseph J. Halka, M.D., autopsy surgeon. May 10, 1994.
Stamp: Official records of the Coroner's Office. DO NOT REPRODUCE.

21

I felt alienated from the ritual called an *autopsy*. The idea of a medical examiner poking at my child's organs appalled me. Neither Jan or myself could even remember if anyone had asked for our permission. Perhaps, in our sudden shock, we complied. Was it standard procedure? Regardless, I wondered how the sudden death of a healthy teenager could be explained without considering the child's prior history or without seeking further information from the surviving parents. Are people dying so quickly—and in such numbers—that we don't have time to really learn why? Unlike those who can accept authority with greater ease, I am far more contentious in spirit and behavior. Throughout my adult years, my mother often reminded me how she used to spoon vinegar into my mouth. "You were always too sassy," she said.

In my son's case, I didn't believe the coroner's determination because it didn't make any sense. I didn't argue for argument's sake. As a journalist, I've been trained to judge whether all the facts add up. I've heard of youths and adults who've died of asthma. But in those cases, the victims knew they were asthmatic. I still haven't come across cases in which seemingly healthy teenagers have died suddenly from chronic asthmatic bronchitis—without any previous history, warning signs or symptoms.

Since I disbelieved the coroner's report, I decided to pursue my own investigation. Within a week, I drove to the medical examiner's office and paid $150 to obtain my own set of tissue slides. I wanted to get a second opinion from an independent pathologist.

The professional I sought spoke to the *Orange County Register* after Tommy's death. I called the news reporter who had interviewed the pathologist for comments in her article. By coincidence, she told me that she jogged and frequently suffered from exercise induced asthma. She didn't hesitate to give me the phone number of the doctor, whom I later called. We set up an appointment to meet at his office and I gave him my set of slides. Dr. Harold Novey said he would have them examined at the local university's laboratory. "If you'd also like me to accompany you and your husband to a meeting with the coroner, I will," he said.

I felt we had met a valuable ally. Jan and I set up the appointment with Dr. Halka, whose emotionless face and cold hands matched the report he issued. Dr. Novey did most of the talking. We just listened. He asked Dr. Halka to explain his interpretation of the slides. When I could no longer observe in silence, I blurted out, "Don't you think it's strange that a healthy teenager would suddenly drop dead because of chronic asthmatic bronchitis?"

"Well, Mrs. Sunoo. Teenagers, you have to remember, don't like to go to

the doctor's office. They often conceal their symptoms from their parents."

"I don't think so," I shot back. "Tommy wasn't a martyr. He'd tell me when his stomach ached or if he had a sore throat. Are you saying he concealed asthmatic symptoms for 16 years?"

The discussion had reached an impasse. Dr. Halka didn't even consider questioning his determination. Jan and I left without further understanding. At the very least, Dr. Novey did corroborate my doubts. "I can see why you questioned the report. It *is* unusual for something like this to happen to an otherwise healthy young man." His compassion opened a door. He gave me the courage to question myself: Are my instincts right—or am I simply a mother in denial?

I don't *want* to believe the coroner because if he's correct, I incur the guilt: I should've taken Tommy to the doctor's office every year. If I had asthma, wouldn't it be likely that he would too? How could I have been so stupid? Was he sicker than I realized? Why couldn't I stop him from smoking? Did he have an allergic reaction to grass and flowers because we moved from the concrete jungle of Los Angeles to the tree-lined suburbs of Irvine?

In my more forgiving, rational moments, I know that I am not responsible for my son's death. But guilt, I've learned, is normal for us survivors. As parents, we instinctively want to protect our children from harm's way. If they die, we suffer the unforgiving pain of helplessness, of standing by. When I hear the stories of other mothers, I feel less alone.

Perhaps that's why I wanted to visit the Holocaust Museum in Washington, D.C. in 1996. After viewing the exhibit, visitors are invited to watch a video of oral interviews with Jewish survivors—most of whom were young children at the time. One story, in particular, amazed me. It told about the self-sacrificing instinct of a Jewish woman during the Holocaust. The Nazis were rounding up mothers and children. Moments before their assigned deaths, the older woman told the Nazis *she* was her granddaughter's *mother* in order to spare *her* daughter from witnessing the death of her own child. Instead, the grandmother perished with the little girl. There's a saying that "When a parent dies, you lose your past. When a spouse dies, you lose your present. And when a child dies, you lose your future." Somehow, I was prepared for the first two. Never the last.

When I compare my situation to other bereaved parents, I believe I've been spared greater horrors. The Holocaust is the most extreme example. I've also listened to many mothers and fathers retell the nightmares of an auto wreck, a speeding train, gunshots or diseases that ended the short lives of their children. When I hear these stories, I'm

relieved that Tommy died without pain, violence or fearful anticipation of his death. Witnesses told me that he fell quickly to the ground. His right hand reached for the other arm, embracing himself before his collapse. I often wonder what that final second felt like for him.

I've also been spared the additional pain of having to view a mangled, bruised or dismembered body. Tommy left this earth whole; his body unscathed. Even within one's prism of tragedy, there are luminous moments. On the day of his death, we were able to put our hands to his face, kiss his cheek before we said goodbye. And now, when his best friend, Joe, calls to say hello, I can revel momentarily in the details of another young man's life.

There is another part of me, though, that still fears the coroner could be right. Since Tommy's death, I've collected brochures, newspaper articles, books and health pamphlets—all explaining some facet of asthma. They are stored in a plastic turquoise-lidded bin underneath my desk. I've learned that what was once an obscure allergic syndrome has become one of the nation's most vexing health problems. Asthma afflicts nearly 14.6 million Americans, including 5 million children. And the death toll has nearly doubled to 5,000 a year.

I am one of these 14.6 million Americans. As a child, I remember recurring asthma attacks. One time, my mother rushed me to Dr. Kim's office because I panicked and told her I couldn't breathe. After placing a clear plastic mask over my nose and mouth, the doctor instructed me to inhale the oxygen passing through a tube attached to a thin gray metal tank. Asthma had already become a harbinger for the fears I would have to overcome: constriction, suffocation, infections, phlegm, breathlessness, loss of control. Even such joys as swimming became associated with drowning.

In an attack, the immune system becomes sensitized to an allergen and starts treating it as a threat. When an irritant enters my body, my immune system spews out histamine and other inflammatory chemicals. In a worst case scenario, the small airways called bronchioles become doused with histamine. They swell and fill with mucus. As those passages become narrow, the consequences can range anywhere from tightness in the chest to suffocation—and death.

I've also learned that asthma didn't strike pre-industrial societies— regardless of their natural surroundings. As countries developed, asthma quickly followed. The National Jewish Medical Center conducted a study in 1991 of children in Zimbabwe. Only one in 1,000 of those living in rural villages suffered from obstructed airways. Yet asthma afflicted one in

17 of those in Harare, the capital. Similar findings have been documented among Aboriginal people in Kenya, South Africa, Papua New Guinea, New Zealand and Australia. And in Western societies, such as the United States, approximately 5 percent of our population suffer from asthma—with 8.4 percent in New York City and 25 percent among kids in the poorest urban neighborhoods.

Unfortunately, there's no cure for this disease, which the ancient Greeks first named "asthma." Seneca the Younger (c. A.D. 3-65), one of the earliest essayists, wrote about his affliction centuries ago:

"I've been visited by all the troublesome or dangerous complaints there are, and none of them, in my opinion, is more unpleasant than this one—which is hardly surprising, is it, when you consider that with anything else you're merely ill, while with this you're constantly at your last gasp? This is why doctors have nicknamed it "rehearsing death," since sooner or later the breath does just what it has been trying to do all those times."

Until recently, I had always believed I "grew out" of asthma because that's what my mother believed. But after Tommy died, I learned that asthma is a lung disease—one that you don't grow out of at all, but learn to live with and control. In my case, it means I must avoid cats, red wine, dust mites, molds, penicillin, perfumes, dairy products and acidic fruits. Before, I treated these allergens more casually. Today, I am ferociously cautious.

Life is still generous and forgiving, however. As I've begun to acknowledge my condition, I tell myself that even though I couldn't save Tommy's life, perhaps I can enrich my own. I'm still not convinced that asthma caused his sudden death. And I wonder if it really matters anymore. I will continue to collect pamphlets and health reports about chronic asthmatic bronchitis. But the relentless inquisition has stopped. It's led me nowhere.

In terms of my running, I've given up the idea of a marathon, but I've continued to increase my physical and mental stamina. Who could have foreseen that I'd eventually complete two 5Ks, practice yoga, meditate and swim three times a week at the crack of dawn? Through these rituals, I've learned to honor my body. Not fear it. I no longer worry about drowning when I step into a swimming pool. For when I power my arms and kick my legs, I am awakening two worlds. Tommy's and mine. Facing the clouds, belly up, I watch for signs of my youngest son and swim for him. Sixteen laps. Breathe in. Breathe out.

"Tommy, why do people get stomach aches?"
"Because there are earthquakes in your stomach. Then an avalanche blows it up."

Tommy at age 7

schnip schnaps

Gift of Journals

"A man loves to review his own mind. That is the use of a diary, or journal."
Samuel Johnson

Of all the holidays, our boys loved Christmas the most. I can't say it's because of the religious significance. I think it had more to do with the warm glow of red, green and yellow lights. The crackling sparks from the fireplace. Ginger and anise-flavored lebkuchen cookies from Germany. And *schnip schnaps*.

Jan initiated this family tradition years ago. He borrowed it from our German friends, the Goosmanns. Their three children—Christian, Matthias and Meike—had coined the terms. They describe the sound of scissors snipping off the bottom of a string of presents hanging against a wall. During the last 10 days of the Advent Season, the children were allowed to cut off one wrapped surprise each day from their own string of schnip schnaps. We adopted this tradition for our boys. Most of the gifts we bought were the same for each son: Hot Wheels, Gummi bears, apples, drawing pencils and occasionally, a crisp dollar bill.

"We cut them from the bottom up," David remembers. "The closer we got to the top, the more excited we became. Christmas would be any day. And then we'd get our real presents."

As the boys grew in size, so did their schnip schnaps. We still included pencils and apples. But we also started giving *Far Side* calendars and $5 as the boys reached the ages of 16 and 19. In spite of their disbelief in Santa Claus, they still humored us by pretending to revel in this family-honored tradition.

"Oooh, this is so much fun," Tommy would say in his deepening playful voice.

During Christmas 1993—his last—I remember him squeezing and shaking the schnip schnaps like a rattle. No matter how tall he had gotten, he exuded his holiday excitement like a child.

"Hmmm, wonder what it is? Feels like… a book?"

29

I had wrapped the uppermost surprise in a green gift bag with red–striped ribbon.

"Could be," I teased.

On Christmas Eve, Tommy cut his last schnip schnaps. His eyes widened. "Wow. An organizer. Just what I wanted," he said, while chewing a handful of Gummi bears. "Thanks, Mom. Thanks, Dad."

In retrospect, I'm grateful for the choice. For the next 51 days, Tommy, unknowingly, documented his final days. He faithfully rated the quality of his daily life on a scale of 1 to 10. His best days were those in which he socialized with his friends in Los Angeles, where we'd lived a year earlier. He publicly swore that he hated Irvine. But his journal revealed how much he really wanted to bring his two circles of friends together. Had he not died, we may never have peeked into this interior world. The one in which Jan and I made cameo appearances as his biggest villains.

Monday, December 27
Rating: 2
Well...thus begins the second volume of my "diary" so to speak! Got in an argument with Papy about German homework and borrowing the car. Planning to go to the "most magical place on Earth" (Disneyland, silly!) soon with my best friends—Rommel, Joe and their chicks.

Wednesday, December 29
Rating: 10
Went to Universal Studios today with Rommel, Marvi, Joe, Michelle (Joe's girl) and Tran. Had a lot of fun, plus Tran got to meet all of my friends. Actually...what really made the day for me was having Tran accompany me throughout!

Thursday, December 30
Rating: 7
Slept over at Joe's last night. Went with Rommel and Joe to Marvi's house. Stayed there trying to get the boyz to come down to Irvine. But all in vain. Got home late, but luckily, Mom and Dad were out someplace. Why am I thinking of Tran?"

Monday, January 10
Rating: 5
Became even more of a loner today. Didn't talk to nobody at snack. And at

lunch, I just went to the PE field and read a book (Pride and Prejudice to be exact). Don't really know why I'm doing this. Guess I'm just tired of all these phonies in Irvine!

Wednesday, January 12
Rating: 7
Had a dream last night about Luella. Dreamt we were going out. Strange thing is..it felt so perfect! Went to UCI [University of California at Irvine] with Andy and Ann. Saw Chris, Alec and Clements there. Hmph! Tran got a new boyfriend. Tried to call her, but she was busy.

Monday, January 17
Rating: 6
Earthquake! It happened around 4:30 a.m. and it killed around 30 people! Measured about 6.6! Why did this have to happen? Ann knows I like her. So I think I should just tell her…fuck! I hate this stupid flirting game. I know she's right for me!

Tuesday, January 18
Rating: 8
Finally got enuff courage to call Ann. Couldn't talk long though cuz the cows had to use the phone. She was really nice though. Joe said he talked to her until 4 in the morning yesterday. Plus, they're all going out tomorrow. Sheesh! Talk about having the short end of the stick!

Friday, January 21
Rating: 4
All hope with Ann is not abolished. Seems that Joe and her are "seeing" each other (in the lightest sense of the phrase). Sheesh! Even Rommel is doing better than I am and he ain't even trying! What am I? The biggest loser that walks the earth? Sheesh!

Monday, January 24
Rating: 8
Surprise! Mutti [Tommy's German grandmother when his father was a foreign exchange student] came for Dad's 50th birthday yesterday. Stayed home from school today. I was sick. Hee, hee, hee! Some weirdo named "Chip" called me and said his friend (whose name begins with an "s") thinks I'm cute. Huh…y'know, this could get kinda scary! Weird!

Saturday, January 29: 10
Dad's big party today. Flew kites, recollected and sang songs. What more could a guy ask for? Oh fuck! Been home all day. Was going to study for finals, but got sidetracked and just never found my way back. I'm so dead that it ain't eben foony!

Wednesday, February 2
Rating: 7
All right! Pop seyz that I don't have to go to Toughlove [a parent/teen support group] anymore. Went to Mike's to work out. Sheesh! I am so unmuscular!

Monday, February 7
Rating: 6
It was a dark and stormy night. My father was being an asshole. But that did not deter me away from my train of thought. I had more...how you say.. pressing matters to attend to..like how to get the DJ and girls from Los Angeles to Irvine.

Monday, February 14
Rating: 5
Called Cheryl for about an hour. Shoot! I should have asked her to be my Valentine. I really hope she likes me. Aaahh!

Tuesday, February 15
Rating: 8
Cheryl and I talked for about an hour. But she told me that she called Rommel. Should I be jealous? Darn! And I was starting to like her too! Hope it works out...

"This diary is going to be about "Tommy Sunoo." The book will start from "Tommy's Trip to Paris" on 7/18/87. I also dedicate my first diary to the person on page 52. I, at the moment, would truly give my life to her."

Tommy at age 9

faux pas
Gift of Emotions

"The voice of honest indignation is the voice of God."

William Blake

To Whom It May Concern,

I, Brenda Sunoo, do offer my experiences only to save well-intentioned individuals from future disgrace. At some point in everyone's life, someone loses a loved one. If you've ever sat down to write a sympathy card or met a bereaved friend on the street, you've probably been at a loss for words. The awkwardness is quite normal. When it comes to speaking about death, Americans squirm. But in the course of my friendships with other bereaved parents, I've learned to divide condolences into three basic categories: genuine, perfunctory and stupid. Below are my Top 10 examples of the latter—with imagined repartee.

#10. "I truly understand; I just lost my dog."
You don't know squat!. How many months were you pregnant with your puppy?

#9. "Your son is in a better place."
(If you're so convinced, wanna trade places?)

#8. "Thank goodness, you have other children."
Yeah, one less dish to wash.

#7. "You have to be strong—it's time to move on."
Who appointed you the 'grief cop?'

#6. "Why don't you buy a parakeet?"
Because I'm too grief-stricken to clean bird crap.

#5. "Time heals all wounds."
Another Hallmark moment. Thank you for sharing.

35

#4. "You've gained weight."
 At least my butt isn't as wide as your big mouth.

#3. "I've heard that 75 percent of bereaved parents get divorced."
 How many stepchildren did you say you have?

#2. "Did I tell you that Willie made it into Harvard?"
 Did I tell you that my Tommy is buried at Forest Lawn?

#1. "Your son would have wanted you to be happy!"
 Sure thing. Say 'hi' the next time you talk to him.

And last but not least, when you send your sympathy card, don't make the same mistake as one acquaintance. Instead of addressing it to me, Jan and my surviving son, David, she addressed the card to Jan, Brenda and Tommy Sunoo. At least get the name of the dead person right.

"I am ashamed of myself because I have lied to my parents. I lied to my parents because I could not take my responsibilities like a man. I am ashamed of myself because I could not control my own temper and chipped the butcher block. Since I chipped the butcher table, I can't live with myself. Next time, I will try not to lose my temper. If I do, I will feel real sorry for myself, and you will probably make me write a whole other essay. I would hate to do that because I really hate writing essays!!!!

If I ever write another essay I will know it's because of myself. I have learned that telling the truth is easier than lying because if you lie, you will eventually get caught and just get into even more trouble than you are already in. So, I will try very, very, very, verrry hard not to tell lies because I sure do not want to have to write a whole new essay."

Tommy at age 11

matter over mind
Gift of Courage

"The rule for overcoming fear is to head right into it."
Anonymous

There were times I wanted to die. Not kill myself, exactly. Just die—anonymously from grief. Each morning for the first two years after Tommy's death, I'd wake up disappointed that I remained physically intact. Although alive, my body felt stiff, as with rigor mortis. For someone who as a child—and adult—had always been known for her cheeriness and Crest smile, depression became a strange bedfellow. With the termination of my son's life, I felt no obligation to cherish my own.

This inner debate often unfolded on the San Diego Freeway in Southern California. I'd often fantasize that the car in front of me would come to a screeching halt. Would I notice the danger in time to swerve to safety? If not, would I die instantly, leaving a crumpled blue Volvo as a headstone in the center lane? In more foolish moments, I even drove without buckling my seatbelt. "Tommy, I'm coming..."

I indulged in these secret conversations quite frequently—until one rainy night around 5:30 p.m. With two exits to go on the Interstate 405, I suddenly noticed that my accelerator pedal stuck to the floor. I heard the engine racing. Fortunately, the rush-hour traffic proceeded slowly and steadily, at approximately five miles per hour. The roads were slick from the first drops of an autumn rain. I pressed my right foot against the pedal to test it, but couldn't feel any spring action. "Shit!" I yelled.

Shaken from my reverie, my shoulders tightened—my fingers strangling the steering wheel as though I had become a homicidal maniac. It didn't even occur to me to switch into the emergency lane and pull the hand brakes. If I pressed on the foot brakes, the red truck behind me would be the first in a line of cars to crash. "Hold on tight," I blurted out, bracing myself.

I stared ahead as my windshield wipers wagged like a mother's

accusing finger. Marvin Gaye taunted me in the background: "Brother, brother, there's too many people dying. War is not the answer...." I instantly turned off the radio, as if the silence would overpower my panic. The opposite occurred. Now, I could hear the rubber squealing against my window, making me more hysterical than ever. "God, damnit!" I screamed.

Fortunately, my car already had shifted into a lower gear. I couldn't have been traveling more than 15 miles per hour. As long as the traffic kept moving, I'd be relatively safe. The minute a car stopped, the trailing commuters would crunch metal against metal. I had additional worries ahead. For example, once I approached my exit, would the cross traffic intersect my dangerous path? I needed to make a right turn as soon as I reached the stop. The cars were yielding in my favor.

I still faced one last obstacle: The stop light at the first street, where I'd have to wait for a green arrow before I could make a left turn. "C'mon, God, make it green." As my body thrust back and forth, other drivers began to turn their heads in my direction. They probably assumed I enjoyed masturbating in my seat.

"Yes!" I shouted with relief. The green arrow changed just as I turned off the freeway. By then, I knew I'd reach home. Mann Street was only a couple of blocks away. I made the final turn, cruising slowly up the street. As soon as I approached the curb in front of my home, I yanked the emergency brake and forced my car to a jerky halt. Staring in the mirror, as if to verify my presence, I shook with nervous laughter. "Girl, you do want to live."

*"Got my organizer back...
miraculously. Parents still don't
know that I got mugged. If I told
them, I couldn't go to L.A. again.
School seemed boring. Fell asleep in
class. I feel so—so—dead. I feel like
God's with me, however."*

Tommy at age 16

Organ/Tissue Donor Card

I wish to donate my organs and tissues. I wish to give:

☐ any needed organs and tissues

☐ only the following organs and tissues:

Donor
Signature _____ Date _____

Witness _____

Witness _____

grace and good deed

Gift of Generosity

"A gift is pure when it is given from the heart to the right person at the right time and at the right place, and when we expect nothing in return."
Bhagavad Gita

I flipped over Jan's driver's license.

"Hon, you never told me you were donating your organs."

"I didn't? I signed for it years ago."

"What if you died, and as I sobbed at your bedside, they came after your heart? Imagine the fierce tug-o-war over your torso!"

Unlike my husband, I have not bequeathed my kidney or eyes. Jan has always been nobler, more practical. "It's the humanitarian thing to do. Besides, I'll be dead, for God's sake. What will I need them for? I like the idea of being recycled," he says.

I feel selfish for not sharing the same emotional reflex. For years, I've wavered. I donate blood periodically, but that's an altogether different matter. In my mind, it's less troubling because the donor is present and a willing partner. When the Red Cross attendant inserts a needle in my arm, I can immediately relate the prickling and flow of blood with the antici-pated extension of a human life. With organ donations, on the other hand, I visualize a more terrifying scenario—a dismembering, a reassem-bling of pieces fitted into a queer anatomical puzzle. This transaction, deadline-driven act is further dehumanized by an organ's dramatic arrival in a plastic Igloo ice chest. I know because I've seen this on *ER*.

I suspect my resistance comes from a combination of sources: a spiritual impulse that we should leave this world whole—just as we entered it—and a street-wise disdain for false nobility. Or is it something else haunting me?

Years ago, my Auntie Charlotte—a pastry chef—was hacked to death by her son who chopped her body into parts and stuffed it under-neath the kitchen sink. It made the local news in Hawaii. My father and I could never erase the violent image of her death. It made it difficult to retain the happier image of her seeing me off on a student cruise ship—

43

running up a gangplank in Honolulu's harbor, with a guava pound cake she had baked for my departure in 1967. This is probably the main reason I've resisted organ donations—on a subconscious level.

As I often do these days, I searched the Internet for further insights on organ donations. My first stop: altavista.digital.com—a favorite search engine. The message near the blank field instructed me to enter a sentence, question or phrase. I typed in the following question: "What cultures or religions believe in organ donations?"

To my surprise, I discovered a Web site with a document titled "General Religious Beliefs Concerning Organ/Tissue Donation," which is an excerpt from a guide for clergy published in 1989. The first sentence stated unequivocally, "All Major Religions Support Organ and Tissue Donation and the Concept of Brain Death."

In little more than one page, I learned about the Episcopal Church, Greek Orthodox Church, Judaism, Protestantism, Roman Catholicism, Unitarian Universalists and other faiths: Amish, Baha'i, Buddhist, Mormans, Jehovah's Witness and Religious Society of Friends—the Quakers. The Gypsy faith, it said, is the only one holding any restrictions regarding donations due to their beliefs about the afterlife. It didn't mention what they were.

So it's the gypsies and me?

I was outnumbered by world religions. So I put the document aside for a week.

When I returned online, I pursued my search. This time, I typed in only two words: "organ donations." I found a Gallup telephone survey of 400 U.S. adults regarding their attitudes toward and beliefs about organ donations. The Partnership for Organ Donations collaborated with the Harvard School of Public Health and posted their results on the Web. They posed three straightforward questions. The first one: "In general, do you support or oppose the donation?" Nearly nine out of ten Americans supported the general concept of organ donations. Support for the concept, is positively correlated with higher levels of education, the survey revealed.

The next question asked, "How likely are you to want to have your organs donated after your death? Would you say, 'very likely, somewhat likely, not very likely, or not at all likely?' " More than one-third of Americans said they're very likely to donate their own organs after their death and an additional one-third said they were "somewhat likely" to donate. One quarter are not likely to donate their organs at all. I started to feel better. I discovered that men and women donated in equal numbers. Also, the likelihood to donate also increases significantly with high

44

educational attainment. Blacks and Hispanics were less likely than whites to want to have their organs donated. And what about Asians? Don't we count? But the survey sponsors warned, "Conclusions that racial or ethnic status alone is a determinant of attitudes and behaviors within this data set would be erroneous."

Those who responded that they weren't likely to donate their organs were then asked, "Is there any particular reason you aren't likely to want to have your organs donated upon your death? What might that reason be?"

Approximately 13 percent cited perceived medical reasons, while 10% felt they were "too old." Black and Hispanic respondents were more likely than whites to indicate a desire to be buried "intact."

Aha! This idea of wholeness began to mirror my own reservations. I wasn't the only one who believed our bodies were holy.

Organ donations had never been an issue for me. Because I've remained healthy, I never thought about the possibility of my own death. No one in my family—my grandmothers and parents—had ever been donors whose actions would steer me in such a direction. When Tommy died suddenly, it never occurred to me that I would be approached.

"Mrs. Sunoo, I'm sorry to disturb you. But would you like to donate your son's organs? There's not much time. You'd have to decide now," the nurse at the hospital asked, minutes after the doctor pronounced him dead.

I shook my head repeatedly, left to right. I even recall waving my hand in the air in SOS fashion. Jan, David, and I simply wanted to stay with Tommy's body at the hospital as long as we could. Later, David would tell me that he agreed with my decision. But in my heart, I knew the image of separated body parts and fears of blemishing my son's body prevented me from considering otherwise.

When other bereaved parents say their child "would have wanted to donate his or her organs," I often wonder how they know. Did they ask them at age 4 or 15? Frankly, I don't know what my 16-year-old son would have desired. We never discussed it, so I couldn't make an informed, timely decision. In my own case, I do have a choice.

I also asked my in-laws what they wanted to do. My 81-year-old father-in-law said he would donate his organs, but he couldn't remember if he had signed his driver's license.

"And you, Mom? What do you want to do?"

"Well, I believe it's a generous idea. But going through with it is another matter."

"What reservations do you have?"

45

"I worry that some doctor could hasten my death just to get my organs."

"Mom is too suspicious. I trust everybody, so I don't worry about that kind of thing," my father-in-law said.

"I'd also be more willing to donate my organs if I knew the recipient," she responds.

"But wouldn't that defeat the purpose? You're assuming that everything's planned ahead and well synchronized. That's not always the case. The whole idea of donating is that you do it without necessarily knowing the recipient."

"Yes, I know. But it would be nice."

I could see her point. How comforting to exchange our doubts. I, too, didn't feel ready to stick a red dot on my driver's license.

The Internet further enlightened me. In Judaism, one is taught that saving a life takes precedence over the sanctity of the human body. An organ donation is the only "mitzot," or act of kindness, an individual can perform after death. Perform an act—after death? Now that intrigued me. These words offered an entirely different framework in which to consider the issue. I liked this idea of committing an act right after my death. By saying, "perform," the Judaic belief seems to acknowledge the human desire for control. Frankly, I don't believe organ donations are entirely selfless acts. Doesn't the word "performing" actually allude to the donor's ego, which is a natural aspect of our emotional makeup? Even in death, isn't the deceased also self-determining his or her legacy?

What one human gains in life, the other gains in death. In one of my husband's revealing moments, he admitted: "Giving away my organs is like beating death. The act guarantees my afterlife." Since then, I've wondered what my grandmother would expect of me—her altruism chiseled in the Korean name she conferred upon me—Un Sook. It means "grace" and "good deed."

"Dear Fairy,
* I am glad to say that I have lost*
another tooth. Please try to give me
a little more $."

Tommy at age 9

a grave situation
Gift of Burial Grounds

"Our earthly ball a peopled garden."
Goethe

Right before Tommy's funeral, my mother purchased four plots at Forest Lawn Hollywood Hills. Why pay for one when you could get a cheaper deal at a group rate, she reasoned. Besides, the idea of her family *resting* together assured her that our happiness on earth would segue quite nicely into the afterlife.

"I'm not afraid to die, knowing that we'll all be together, here at the same cemetery," she said.

Her generous offer didn't garner instant rave reviews. We were faced with a few practical dilemmas: Where would David's future wife and family be buried in years to come? What if he decided not to be buried with us? What would we do with the fourth plot? Sell it to a stranger?

"Don't worry," David said. "I'm not going to desert the family."

We then discussed who would be buried in what position. There were four spots reserved in a row. Tommy's ashes would be placed in spot number two, counting from left to right. David insisted upon spot number three. "Bury me next to Tommy. I don't want to be placed on the edge."

"Why not?" I asked.

"Because...it's too exposed."

"You mean on the edge?"

"Yeah."

"OK, hon, you've got it. Spot number three."

That left spots number one and four for me and Jan. We both liked the idea of our boys being buried side by side, each flanked by one of their parents. Neither one of us felt overly sentimental that as husband and wife we had to be placed in similar formation. But who would be buried next to Tommy, our youngest boy—in spot number one? That's the big question. Me or Jan?

"I think I should be buried next to Tommy in spot number one," I said with a coy smile.

"Why should you be buried next to him? I'm his father."

"Yeah, but I carried him."

"Yeah, well I helped conceive him," Jan said, as he drilled his knuckles over my head.

Eventually, Jan donned his professional cap and mediated what he described as a win-win situation.

"Here's what we'll do. The first one who dies gets to be buried next to Tommy. The last one gets spot number four. OK?"

"OK, I think."

It seemed like a fair consolation prize for the one who dies first. Or should it be the other way around? The survivor, for all his or her pain and suffering, should be the one rewarded in the end. To the outside world, we probably seem like a pretty demented twosome. But in the inner prisms of bereaved parents, our thoughts aren't very strange at all. Because we grieve out of love and longing, we often obsess over the departed more than the living. In a way, it's easier for Jan and I to discuss our burial positions in relation to Tommy because he *is* dead. We expect to be placed next in line. We don't argue over being buried next to David. Not because we love him less. We just don't want him to die—out of order.

Jan: "Where does Jesus live?"
Tommy: "In Heaven."
Jan: "What's Heaven?"
Tommy: "Where people go when they die. Then they become angels. Angels make love and that's how valentines are made."

Tommy at age 8

When I was young, I've always had a theory about death. I attended a funeral when I was young and somebody had died whom my dad admired alot. That person died young also, and my dad told me how accomplished this young man was. He achieved excellent grades, helped his family, strived to be the best. He died behind the car wheel because he was too tired to drive. When I heard Tommy had died, I thought about this young man who died. I feel that people who God take early are already fit to go and God wants them to be with "him" so much that he takes them early. Tommy always had something to think of. He always kept a diary everyday, which made me realize that he was a deep thinker. He was also very artistic which showed me he was creative. He never cared to "be cool" and he definitely wasn't a follower. He tried his own things. Tommy was like my little brother. Jimmy Pham
65P-0717

crow as messenger
Gift of Imagination

"*In happy hours, when the imagination*
Wakes like a wind at midnight, and the soul
Trembles in all its leaves, it is a joy
To be uplifted on its wings, and listen
To the prophetic voices in the air
That call us onward."
Henry Wadsworth Longfellow

Several years after Tommy died, I wanted to find some way to communicate with the dead. Tommy's interest in movies and crow lore provided that vicarious onramp. For years, he had been drawn to J. O'Barr's comic "The Crow." Not only did he fancy the comic art, but the story line of death, revenge and redemption. Sadly, he never saw the movie based on the book. The film studio released it soon after Tommy's death. Naturally, we wanted to see it. By participating in one of Tommy's favorite activities, we hoped to imagine his pleasure.

After we established the tradition of spending Friday Date Nights at the movies, Jan and I watched for ads of "The Crow." When we found it playing at our nearby Edwards Cinema, we were among the first to stand in line at the box office.

"Two, please," said Jan.

As we settled into our velvet-covered seats, we propped a carton of buttered popcorn and Dr. Pepper between us. The curtain rose. And so began the typical series of trailers and promos for soda pop and the Los Angeles Times.

By the time the movie started, I felt relaxed. Belly full. Thirst quenched. But after the first ten minutes into the film, my neck and shoulders stiffened as they do when I'm staring at multiple windows on my laptop. In an eerie set of circumstances, actor Brandon Lee—son of martial artist Bruce Lee—had been accidentally shot on the movie set while filming. He, too, died by the time the special-edited film had been released. I felt as though I had penetrated three overlapping deaths: Tommy's, the movie protagonist's and the actor's. But the notion of birds as messengers interested me the most.

Grief, I've learned, can lead one toward unexpected muses and wanderings. For centuries, human beings have looked to natural creatures during times of spiritual quest or disorientation. Ravens and crows, in particular, have often been associated with prophecies. These raucous birds—because of their perceived role as tricksters and messengers between two worlds—tempted my curiosity.

After seeing the film, I bought "The Power of Myth" by Joseph Campbell. He talked about spirits and sacred spaces. He said that "All these things are around us as presences, representing forces and powers and magical possibilities of life that are not ours and yet are all part of life.

"Then you find it echoing in yourself," he wrote.

My quest for crow lore continued. I felt like Ponce de Leon searching for the Fountain of Youth. My research—conducted mostly on the Internet—channeled my desire to feel as though I could find Tommy in some transformative state. By reading folktales, perhaps I could find some stories that would soothe my loss and help me confront my unfamiliar crossroads.

In one Buddhist tale I came across, the crow received praise for its wisdom: some elder crows tested three young ones to see if they had reached the age where they had the wit and maturity to fly with their elders. When asked what should crows fear the most, one crow said the arrow. The second said a skilled archer. But the third crow gave what appeared to be a strange answer: "The thing in the world most to be feared is an unskilled archer because you never know where his arrow will go. If you try to get away, you may fly right into its path. You never can know whether to move or stay still."

I began to view grief as an unskilled archer. Its arrow capable of injuring me for life. Like the third crow, I wanted to acquire the mental alertness to know when to move forward, when to be still. Ironically, what started out as a philosophical meditation about life, in general, evolved into a physical challenge—one I never expected to face.

After gorging my way through depression, I attempted jogging in 1996. My friend Linda, goaded me. "C'mon, I'll do it with you." A couple of weeks later, she hurt her back in a car collision. Suddenly, my cheerleader disappeared. I had two choices. Move or stay still. Drawing upon the Buddhist tale, I waited for signs of a messenger.

It came one Saturday morning in July. I set my feet on a dirt track at Woodbridge High School. The sun had barely been let out of the box. After a few laps, I started breathing heavily, slowed down by a slight wheeze. It sounded like an ensemble of violins. Just as I quit, I heard, "kaw, kaw" in the distance.

Crow, the black Trickster—dared me to run. To glisten in my sour sweat.

54

"My name is Hitler. I am a ghost now, but I still remember my life quite well. I led a good life, but most of my friends (not that I had many of them!) didn't. Now, however, in Hell, I wish I had treated my friends better. I also wish I hadn't treated my wife so bad by making her exercise 6 hours a day. But what I really regret doing was burning all of those books and killing so many Jewish people—all for no reason.

Now, alas, I am burning in Hell being forced to read books, to shave off my mustache, exercise 10 hours a day. And Satan has chopped off my knee-caps!

Of course, if I got a second chance, I would definitely change. I would get a better haircut and a face-job. I would also demolish all of Germany's weapons and put an end to World War II. Another change would be to make a better reputation for myself as a cool dude!"

Tommy at age 13

h. m. lee

Gift of Memoir

"Autobiographies are...only useful as the lives you read about and analyze may suggest to you something that you may find useful in your own journey through life."

Eleanor Roosevelt

A few years into my recovery, I decided to return to graduate school. In 1997, I enrolled in Antioch University's Masters of Fine Arts in Creative Writing Program in Los Angeles.

One mentor assigned me to focus on 'sensory details.' I decided to write about the scariest-looking man I had ever met: one of my dead uncles. To my surprise, what began as a cocky exercise turned into a humbling realization of my family's immigrant history. I revisited some childhood memories. In doing so, it led me to also re-read my auntie's memoir, "Quiet Odyssey." Her recollections corrected mine.

At age seven, my father invited me to visit his older sister's husband. I only knew that his name sounded like a ship. My other uncles had real American names like Sam, Hank, Ralph and Paul. And my auntie's name, Kuang, rhymed with gong. But when my father promised to drive our gray 1954 Buick sedan down Arlington Avenue, the thrill-seeker in me decided to tag along. "Can we stop for a hamburger, too?" I asked.

When we arrived at his sister's home, my father insisted that I sit on Uncle H.M.'s lap. Reluctantly, I mounted his long legs, which stretched like an on-ramp. My limp hands were sweating like they did before a piano recital. Uncle H.M.'s left thigh looked as stiff as a music bench; his feet like quarter notes pointing toward the street. And his face—well, I'd never seen a Korean face so red and rough-hewn. Attached were two giant ears—five-inch flaps of paisley-shaped flesh, hanging on each side of a triangular head. The only handsome features were his high cheekbones, brown eyes and black hair that protected a sun-burnt scalp.

I held my breath, knowing that within a few seconds, I could

disembark to safety. But as I twisted my agile body counterclockwise and jumped off his lap, ready to flee, he trapped my right hand in his—and laughed. I didn't scream, but I clamped my lips and began a tug-of-war against this scary creature who smiled like Howdy Doody and smelled like a Cuban cigar. I pulled. He pulled harder. Two of us, conjoined by the physics of family and friction, of skin against skin.

Years passed. I seldom saw my Auntie Kuang and Uncle H.M. Most family birthdays and Thanksgiving holidays were spent with my mother's side of the family. Although Dad came from a family of ten children (seven boys and three girls, including Auntie Kuang, the eldest daughter), I had always been more drawn to Mom's relatives. As social director of our family, she tended to favor her side when it came to planning special events.

Years later, in the '70s, Blacks and Chicanos were at the forefront of ethnic awareness. I followed their lead, but couldn't find any literature about Korean-American history. Then I met an African-American professor of folklore at UCLA who explained that "some blacks were illiterate, so we passed down our history through oral tradition. Otherwise, our stories would've become lost." The epiphany reeled me back into the lives of the Paiks, whose family history had been dormant.

Uncle H.M. had died in 1975, at the age of 83. My auntie still lived nearby my parent's home in Baldwin Hills in the Crenshaw district of Los Angeles. Her stucco apartment was located on Chesapeake Avenue. My mother had encouraged me to visit Auntie Kuang since she knew of my budding interest in our family's history. I had always felt comfortable around her. Unlike Uncle H.M., she had what Koreans referred to as a "moon face," her unblemished skin well massaged with dollops of cold cream. An unintimidating woman, barely 5 feet 2, she responded easily to my affection.

As I sat down on her sofa, my head resting against a hand-crocheted afghan, she excused herself to boil a pot of barley tea. While waiting, I scanned her small living room. On a shelf behind her portable TV, she displayed a family picture of her, Uncle H.M., and their three sons: Henry, Allan and Tony. It had been years since the day I sat on her husband's lap at my father's insistence. I still remembered the unyielding grip of his large, callused hand—and yet I still knew very little about this older man whom my father seemed to revere. My auntie's apartment reminded me of my grandmother's. My nostrils were titillated by the familiarity of boiled chicken, garlic cloves and freshly chopped scallions.

"Smells like mandoo," I said.

"Just made a fresh batch of this soup and the dumplings," she said. "Would you like to stay for lunch?"

"I'd love to. What did you put in your mandoo?"

"Fermented cabbage with garlic and chili (kimchi), scallions, ground pork and tofu. Then you wrap it in wonton skin and boil it in a pot of water until it floats. That's when you know it's done."

"Sounds great. But before we do, can I ask you about something? Mom tells me you wrote a book. What's it about?"

Her posture straightened, and her eyes flickered like candle flames. She quickly disappeared from the living room to fetch something out of her bedroom. I could hear a wooden drawer squeaking in the background. Within a few minutes, she returned with a one-inch thick, handwritten manuscript compressed with metal fasteners. The tabs of a manila folder were trimmed so the file could be used as the cover and a back page. Her smile announced the manuscript's completion. The elation of a mother who had finally delivered her firstborn.

"Here's my manuscript. It tells the story of the Paik family—from the day my parents, brother Myung and I left Korea's Incheon harbor on May 6, 1905, on the SS Siberia to come to the New World."

I folded back the cover to the first opening page. She had selected a quote from the Bible: Hebrews, Chapter 11, Verse 1: "Faith is the assurance of things hoped for. Conviction, of things not seen." At the bottom of the first page, my auntie signed her American name: Mary Paik Lee.

Since the publication of her memoir in 1990, "Quiet Odyssey—A Pioneer Korean Woman in America" has become required reading in many Asian-American Studies courses. I felt both proud and envious of my aunt. I think my father also felt a bit jealous. He never read his oldest sister's book in its entirety. He remained too peeved because his name hadn't been mentioned in Chapter 5, the one that detailed the family's life in Idria, California, where he was born. Had he read Chapters 6 and 7, however, he would have read about his birth—and being three months old in Willows. Never mind the fact that Auntie Kuang included a picture of him as a little boy—standing with his siblings in front of a blackboard cluttered with the Korean alphabet.

What intrigued me the most, however, were the passages about Uncle H.M. I discovered that he was born in Seoul, Korea in 1892—his mother having died while giving birth. His father remarried, but his stepmother resented a young child's presence. So at age 12, he dreamt of running away from home. Since hundreds of Koreans were also trying to

escape Japanese occupation, Uncle H.M. learned about a ship in Incheon harbor, waiting to take Korean workers to Mexico for work on the hemp plantations. It didn't matter that thousands of miles would separate him from the Land of Morning Calm.

"When his stepmother sent him on an errand one day, H.M. decided to escape. He boarded the ship, telling the guard at the gate that his uncle and family were coming later, and hid below. After the ship had sailed several hours out of port, he went on deck," my Auntie Kuang wrote.

Because he was too young to work in the fields, the patron in Mexico sent my uncle to school and named him Antonio Eduardo Lee. He graduated from high school in Mexico City. And as soon as he had learned enough Spanish, the patron used him as an interpreter. He became the workers' advocate and also worked as a sanitary inspector in Mexico City.

"At the age of 20, he married a friend's daughter, but their life together was brief. His wife died from burns caused by an explosion while she was refilling the fuel on her alcohol stove," my auntie wrote.

In 1914, a year after his wife died, my Uncle H.M. moved to San Francisco, California. Then to Willows to serve as a foreman on a large rice farm. There he met my Auntie Kuang and married her in 1919.

Upon further reading, I discovered why his face had always been so red.

According to my auntie's book: "By 1919, airplanes were being used to sow the rice seeds from the air. After the land had been properly prepared and seeded, a little water was let in from the irrigation ditch to moisten the ground and get the seeds sprouted. As the rice plants grew, the level of water was increased until it reached about four feet deep after three or four months. The rice plants were quite tall, but a tough weed called "watergrass" grew faster and taller than the rice plants and had to be pulled out by hand. The men stood in stagnant water up to their waists all day under the hot summer sun. This caused painful skin irritations and other medical problems. The stagnant water had a scum on top. It must have had harmful bacteria that affected the skin."

My Uncle H.M. continued to suffer miserably with the effects for 30 years until he discovered the short-term relief from weekly sulfur baths in Williams, California—and later, penicillin. When the rash worsened, yellow pus broke out all over his body, including his face. No one had told me anything about my uncle's suffering—much less his generosity toward my father's family.

I learned that over the years he had financially supported the Paik family. He gave my grandfather $3,500 to buy a farm in Tremonton, Utah. Later, $2,500 to start raising chickens. Uncle H.M. also bought the Paiks a second-hand Ford automobile, and allowed my auntie's brothers to live with them in California whenever the boys were without homestead. Alienated from his own father—a strict country preacher—my dad must have looked up to Uncle H.M. as a benevolent surrogate. That explained the frequent visits to his sister's home.

By 1995, my Auntie Kuang passed away, two years after my father's death. I attended her burial at Inglewood Cemetery, where her family laid her to rest next to her husband's gravesite. In some respects, though, I felt I represented my father. Now, in my auntie's absence, "Quiet Odyssey" has become my literary ark. Guiding my passage through our family's first wave of history. Mostly, I think of Hung Man Lee, the 12-year-old stowaway, aglow with enterprise and escapade. Not the strange man whose largeness wrapped a seven-year-old in fear. I marvel at the Korean boy who crossed the Pacific in 1905. Alone, without chart or compass.

Lost in New York

The trip was long and hard. Randy, a stowaway, was getting tired of hunting around the ship at night for food. He had been on the ship from Japan for about a month and a half. This night, he couldn't find any food. He had been living off of food he brought when he snuck on board.

He was very hungry, for he hadn't eaten anything all day. Finally, he smelled food. His nose led him to the captain's cabin. How could he get the food, he kept asking himself. The question left him pondering and his stomach empty.

Finally, he got an idea! What he would have to do is lure the captain out, sneak in, take his food and leave. Of course, after this, the captain would be furious to know he had a stowaway on his ship for a month and a half.

He would have to run to his secret hideout before the captain knew his food was missing. Randy had a superb hiding place. It was below the deck behind a stack of boards, under a huge shelf, beside some equipment, under a blanket.

Now that everything was planned, he had to distract the

captain. He decided to do it with a pillow. When he got to the captain's window, he threw some feathers from the pillow into the window. He left a trail of feathers from the door to the top level of the boat.

After that, he climbed down a rope to the deck below. He ran into the cabin, took the food, then spied on something. It was the captain's wallet. He took that with him in case he needed something in New York. He snuck out of the cabin and got to his hideout.

For the next few days, he didn't get too hungry and slept through most of the trip. Finally, he arrived in New York City––the Big Apple. Now, only one more thing to do. Randy had to get off the ship! His plan was to pretend he was somebody's child.

He would walk closely to a couple without any children. Randy knew he would have to stay on the opposite side of the captain. The ship was now docked, and people were getting off. Now was his chance. Everything went according to plan. Soon, he was off the ship safe and sound.

Tommy at age 11

you've got mail
Gift of E-mail

"It's completely usual for me to get up in the morning, take a look around and laugh out loud."
Barbara Kingsolver

Tommy died before the Internet really took off. But he had already experienced the wizardry of computers. He and his friend Feng used to download video games and Japanese animations from the Internet, in its infant stages.

I remember us debating the family's next computer—a PC or a Mac? Tommy preferred a PC because of all the available software. I preferred—and bought—a Mac after he died because of its user-friendlier operating system.

Later, I joined America Online. To my surprise, technology became a therapeutic lifeline between me and the outside world. Especially between me and Gail, Tommy's godmother. Both of us are in our 50s, but we act more like reincarnated teenagers.

Between Instant Message and regular e-mail, we've been shamefully known to chronicle our days—angst by angst. In fact, I usually head to my computer before I've even brushed my teeth. Since I'm on her Buddy List, Gail usually spots me before I spot her. I don't use my Buddy List feature because I don't like "seeing them" and feeling guilty for ignoring them.

"Wassup?" Gail usually types in the small, upper left-hand window.

"Hold on, I gotta poop. LOL."

"Hurry up. I have to leave in 10 minutes."

"OK. Write while I'm in the bathroom."

"I have a training to do today. Not sure what to wear. What do you think about that blue silk pants and chartreuse blouse?"

"I'm back. Aaaahhh. Outfit sounds fine."

"Thanks."

Over the years, I've been amazed at the quality—no, variety, of

our online self-help sessions. We've covered broad terrain: What's new at Marshall's? How to talk about sex with teenaged sons. Recommendations for B&Bs in Vancouver. The merits of L-Carnitine and Ginko Biloba. Insistent reminders to get a sygmoidoscopy. How to take better photos of a waterfall. Not only have we LOL (laughed-out-loud), we've also brought each other to tears. Every November 13, for example, Gail lights a candle in memory of Tommy's birthday. She never fails to ask me, "How are you feeling? What are you planning to do today?"

One time, I attended a conference in Honolulu. Jan and I were staying at a hotel in Waikiki. Even though we missed our customary Instant Message session, I wrote her a regular e-mail about a dream. It gave me a safe way to admit my guilt.

To: Gail
Subject: Potent dream!
Hey, wassup? Our stay in Honolulu has been relaxing for the most part. Yesterday, we saw our cousins. OK. Take a deep breath. This is going to be a journal entry of my dream this morning. Before I go into it, I'll give you a context. Three things happened yesterday: (1) a car accident occurred on Auntie Mary's street. Cops used her driveway to park their car. (2) Jan and I had an argument about punctuality. We were late for a social engagement. I always want to get somewhere early. He always says, "Slow down!" (3) This Hawaiian healer named Ansara worked on my body. She wanted to help me 'release some emotions.'

So here's the dream: Tommy and I were driving across the Oakland Bay Bridge, heading toward San Francisco. All of a sudden, I took my hands off the wheel. My body was ejected from the car. The car went out of control, swerving toward the left lane and the edge of the bridge. Standing on the right side lane, I turned my head and watched in horror as the car tumbled off the bridge, with Tommy inside. I screamed.

Next scene: I walked into an apartment and saw Jan sitting on the couch talking on the phone to his mom. He continued chatting very calmly as I became more hysterical. I couldn't stop crying as I told him there had been an accident.

"Something horrible happened to Tommy," I said.

He ignored me and kept talking to his mom. Finally, Jan got off the phone, and I repeated what happened. He gradually tried to figure out what to do. He scratched his head and said, "Hmmm, who should we call in a situation like this?"

I screamed, "Call the police, damnit!"

At that moment, we heard a news report on the radio about the car jumping off the bridge. I thought to myself, "Oh my God. Everyone is going to know I killed my son."

As we headed toward our car and the police station, we saw three cops walking toward us. I immediately ran toward them with my hands up in the air. "Don't shoot. I just want to know if my son is alive."

One of the policemen nodded his head to say, yes. I felt a big sigh of relief. When they took us to see Tommy, he stood in the station. He looked thinner than usual. It seemed as though he had been at the beach. A trail of sand peppered his exposed chest.

David stood nearby, talking to his brother. I ran up to Tommy and squeezed him as though we had won the lottery. I could actually feel his cold skin as I cried, "I'm so sorry. I'm so sorry."

Tommy's body locked in my embrace. He could hardly breathe, but he wore that self-conscious embarrassed smile that teenagers wear when adults steal a kiss.

End of dream.

Well, gotta go. We're off to snorkel at Hanauma Bay. Alo-o-o-ha!

Love,

B

"Tommy has become quite good at the computer. He enjoys it. He still sometimes gets involved in his reading and doesn't hear the teacher."

Mr. Freund, third-grade teacher at George Moscone Elementary School, San Francisco
1986

stone spirits

Gift of Spirituality

"The past is a kind of screen upon which we project our vision of the future."

Carl L. Becker

There's a saying among the bereaved: "The anticipation and fear of an event is worse than the actuality." We are haunted by dates, terrorized by events: birthdays, graduations, weddings, anniversaries, Christmas—anything that reminds us of absences. I agonized for months—no, a year—about what I would do for my 50th birthday. I couldn't imagine recreating the festive ambience of Jan's party four years earlier. I threw the best party ever, and Tommy was alive.

That January 1994, I rented a three-bedroom beach house in San Clemente, off El Camino Real. Perched on a high cliff, it overlooked a wide stretch of the Pacific coastline. During the week before the party, our German relatives—with whom Jan had lived as a foreign exchange student in the '60s—stayed in our rented villa for six days. The accommodation would hopefully lure them to Southern California.

"Imagine waking up to the sound of seagulls and surf," I tempted them by phone.

Eleven of the Siemens family members, including our then 84-year-old German "Mutti," arrived one by one. Jan greeted each one in total shock. We culminated the week with an all-day celebration among 60 close friends and relatives spanning three generations. David and Tommy were in high spirits—both gyrating their hips like Elvis after a pompadoured impersonator crashed the party.

The invitations read: "Tickle your toes at Jan's 50th birthday on San Clemente's ocean front. Saturday, January 27, 1994. Fill the afternoon winter sky with kites on the beach. Swing to the music of the '40s. Dress the times."

We were lucky that week, as there were no winter rain storms. The weather, in the upper 70s, remained warm enough for Jan to wear his red Hawaiian shirt. At night, we lined the bricked terrace with Mexican

71

luminarias. All the while, Glenn Miller held us "In the Mood." I thought it incredible that the celebration even took place. Recent floods and canyon fires had plagued Southern California. At one point, I thought the party might have to be cancelled. Some things, though, are meant to be. Jan's birthday may have been the public occasion for the party. But in retrospect, the celebration seemed like an omen. Tommy died 19 days later. I think of it now as our communal sendoff.

Without him, I would have to observe my 50th birthday differently.

There were other emotional dilemmas. Tommy's death not only followed Jan's birthday. He died three days after my own birthday—and exactly one year after the death of my father. I couldn't reconcile a celebration given the proximity of these dates. Birthdays and death dates, back to back. Finally, his godmother, Gail, told me, "You don't have to celebrate on the 13th. And you don't have to throw a party."

Suddenly, I felt liberated from the burden of convention. Instead of culminating my 50 years with one exclamation point, I could celebrate all year long. I would visit my closest friends—whether they lived in San Francisco, New York, Hawaii or abroad. Instead of them coming to me, I would go to them. Under most circumstances, I wouldn't travel so much in one year. But I was turning 50, for God sakes.

What I yearned for most were new destinations. I wanted to feel the co-mingling of ocean mist, fog and ever-changing skies. A place where the sun shined, but wasn't too hot in August. And a place where locals elevated their food to an art. Drawn to the sea, I chose Brittany, the northwestern region of France, for one of my trips. It seemed within reasonable distance to Berlin, where many of the Siemens live. Jan and I were planning to see them at our German nephew's wedding, after our 10-day vacation on the coast.

Brittany, I discovered, is a land of seafarers—a peninsula embraced to the north by the English Channel, and to the south by the Atlantic Ocean. Prehistoric civilizations favored this site and left behind megalithic monuments—called menhirs and dolmens (standing stones)—more than 5,000 years ago. Today, these dolmens and menhirs still exist side by side, the architectural symbols of the Christian culture. Those located in the small towns of Carnac and Locmariaquel especially appealed to our curiosity.

Since Tommy's death, I've naturally veered toward churches, cathedrals and cemeteries. It doesn't matter where we are. I find them. If I

have an occasion to light a candle in his memory, I will. I also make it a game, of sorts, to walk up and down narrow cemetery lanes—searching for the gravestones of young children. I do a lot of simple subtractions: 1,907 minus 1,894. 1,922 minus 1,915. The less the remainder, the more lucky I feel. When I see burnt incense, toy trains, fresh ginger or red geraniums placed on a gravestone, these gestures diminish my own fears. People, everywhere, do remember the dead.

Observing these graves isn't enough for me, though. My hands seek physical contact. Upon kneeling on a cold marble grave or a wet grassy mound, I feel my body penetrate two spacious worlds—Tommy's and mine.

In Carnac, I searched for similar affirmations. A Neolithic religious center, the people here were believed to have a strong relationship to the afterworld. The stones allude to this belief. But modern visitors like myself cannot grasp the significance of these stones' immortality without learning about the area's history. The granite megaliths, for example, are the work of Neolithic populations—sedentary farmers and stockbreeders, for whom the changing of seasons defined their culture and beliefs. There were miles of stones I wanted to see.

So Jan and I drove back to each site after the tour. We were able to walk among the megaliths in silence. Each stone—sculpted by centuries of rain, wind and human activity—projected its own liveliness. They also cast their own shades of grey, blue and rose complexions. I stood before an eight-foot tall flat menhir. I wondered how many people it took to set it in the ground? Did a family place it in memory of a husband? The one beside it was short and round.

Scientists believe that only a well-organized society could have undertaken the erection of such huge monuments. But their exact function remains a mystery. In and of themselves, each menhir didn't strike me as extraordinary. Except, perhaps, the one referred to as 'Le geant,' which resembled a fat penis. Jan posed next to this 20-foot menhir—annoyed that a spiritual symbol would be spray painted with green graffiti.

"Smile," I said.

"Cheese," he replied, wincing.

Many archeologists have agreed that collective burials in stone-built tombs were practiced in Brittany by the first settled farmers around 5000 B.C., over 1,000 years before the Egyptian pyramids were built. Many of these dolmens, we learned, were derived from two main types of structures called passage graves and gallery graves. In its simplest form, the passage grave is a circular or rectangular chamber. One enters by a passage

or corridor leading from an outside doorway-like entrance. Gallery graves, on the other hand, consist of a long rectangular chamber inside a long mound. These graves, built with natural elements and bare hands, seemed more personal than the expensive coffins we Americans order today.

Some symbols carved on these ancient stones were clearly representational. An axe-head, for example. But what did they mean to the people in the tombs? Did they signify authority, weaponry or simply agricultural need? A circle with projecting rays seemed to be a common motif. To prehistoric man, it may have symbolized the sun or moon—or warmth or the seasons. How did Neolithic children play in the summertime, I wondered? Could they have ever imagined that thousands of years after they died, humans would press their skins against the same stones they left behind?

The menhirs and dolmens reminded me of the concrete Friendship Bench we erected at Tommy's high school in Irvine. Like the megaliths, it marks the passage of a human life.

The idea of a memorial initially came from his grandfather. A proud Korean scholar, he believed that Tommy's short life had outshined his own.

"I've written so many books, traveled and taught. But Tommy's death really made an impact on other people's lives. More than mine," he said with genuine humility.

He referred to the outpouring of condolences, flowers, gifts and donations given in his grandson's memory. Jan and I were surprised by his unexpected candor.

"Since Tommy joined the Ethnic Awareness Club, why don't we do something on the campus," he said.

Shortly after the funeral, we established an art scholarship in Tommy's name. A gifted and prolific artist, Tommy had left a collection of paintings, animated drawings, illustrations, pencil sketches and flip books by which to remember him. But Jan's father wanted to do something more.

"If we leave something visible, others can remember him," he said.

We all agreed that since Tommy died on campus, it would be appropriate to mark his presence there, to heal the sorrow and promote friendship among the high school youths.

The principal at University High School told us, "Whatever your family would like to do is fine with us."

With that go-ahead, we decided to erect a Friendship Bench. Jan's father seemed pleased. His brother, Cooke, also got behind the idea and

suggested some ingenious ideas. An urban planner in Los Angeles, he had seen silk-screened tiles inlaid in the stucco wall of a building at Japanese Village Plaza in Little Tokyo.

"You could select drawings from Tommy's portfolio, silkscreen them onto tiles and lay them into the concrete backing of the bench," he said.

"That's a great idea," we said, excited by the possibilities.

We selected five pieces—four of them were from Tommy's sketchbook. The one we placed in the center is a song written by Steve Bagatourian—a fellow comic book artist and our son's frequent "ditching buddy." Tommy's photograph is placed at the corner of the text, which is titled "Pencils in Heaven." In Steve's handwriting, visitors can read these lyrics:

Can you hear the song I'm singing?
It's for you, my friend.
Do the pencils up in Heaven
Suit you well, my friend?

Can you draw a landscape?
Up there in the sky...
And can you dream in color?
Not just black and white...

Do they tell you when
To go to bed at night?
And can you see me crying,
In the morning light?

How do you expect me to carry on?
We almost conquered the world.
We were going to live so long.
We were going to live...so long.

My friend...
Died just the other day
And it's all too close,
Yet I'm so far away,

Can you hear the song I'm singing?
It's for you, again.
How are the pencils up in Heaven?
Goodbye, my friend.

The other four tiles we selected show Tommy's broad range of talent. On the extreme left is a black pen-and-ink drawing entitled "Castlemaster," one of the last drawings he had completed.

"I remember that drawing," said Anthony, our son's friend who visits us periodically. "Tommy finished it during recess. He drew all of these black lines really fast."

Interestingly, "Castlemaster" was chosen to represent University High School in the 1994 Disneyland Creativity Challenge Awards in the visual arts category—albeit posthumously. Tommy had drawn an old man with a white beard, long curly hair, rimless glasses and solemn eyebrows. His hands, engrossed in constructing a miniature castle, are curled. And if you look closely, you can also see a cylindrical tower with an arched window, merlons and turrets. From different angles, you can project your own interpretation. I see my father. Others tell me they see animals in the shadow of these finely drawn lines. It pleases me that Tommy's art evokes different reactions.

Next to "Castlemaster" we placed a pencil sketch of his cluttered bedroom. There's a headless action figure, a cross on a chain hanging out of a box, an electric cord, a Zenith stereo speaker—and four CDs: Bjork, Tchaikovsky's "The Nutcracker Suite," "Phantom of the Opera" and Vince Guaraldi's "Merry Christmas, Charlie Brown." When Tommy turned in the art assignment, his teacher had criticized it for lacking a theme. Rather than improve his drawing, he submitted it unrevised in the annual Orange County Student Calendar contest. On Christmas Eve— two months before he died—he gave the calendar to us as a surprise.

"Why the mischievous smile?" we asked.

"Hurry up. Open it," he instructed with confidence.

He watched with anticipation as we flipped through the pages— month by month. When we finally came to September, he flashed a cocky smile—as though he had cheated on a test.

"My art teacher didn't like it," he explained. "So I titled it—- 'Unfocused.' "

That's classic Tommy—unwavering in his instincts, smug in his victories. In his range of subjects, he not only captured real-life subjects, he spent hours creating cartoons and animated characters. He dreamt of attending Cal Institute of the Arts in Valencia, California—a sure pipeline into the Disney animation studios. The third tile—to the right of "Pencils in Heaven" —reveals Tommy's whimsical and robust imagination. It could have launched a very promising career. More than the other drawings, this one attracts children.

I've witnessed this on Saturdays, when the local Chinese-American residents of Orange County use the facilities as a language school. During one of their breaks, I observed young boys and girls kneeling in front of the bench to read Steve's poem. They asked each other, "Who is he?" referring to Tommy's picture. Then their eyes were riveted to the right. They spotted four enchanting characters. One of them is a little girl with straight bangs and long black hair. Her elbows are resting on her knees, while her fists prop up a stubborn chin. With her eyes shut very tightly, she is transforming a rock into a space figure—presumably herself—armed with two ray guns.

Tommy once explained, "She has psychic powers, and she changes into different forms."

A beaming Superman stands beside her. Of course, the emblem has been changed from an "S" to a "T." Who else, besides Tommy, could save the superheroine from the menacing clutch of Dr. Doom, pictured at the bottom?

The last tile—on the right side of the bench—is the one that intrigues me the most. We included it because it hints at Tommy's budding sexuality. He drew a picture of a young girl with large almond-shaped eyes, generous eyebrows and glossy lips that are sharply defined. She is leaning forward with her left elbow anchored on the knee, her head tilted to the right in a relaxed, coquettish pose. Her right arm is extended downward, teasingly, as her fingers are spread against her legs slightly above the ankles. In addition to her eyes, her legs are the most noticeable parts of her body. They extend prominently from underneath a mini-skirt—so short—you can see her thighs. I would be lying if I said I didn't want to know of her identity. I never saw the picture while Tommy was alive. Who was this acquaintance—a sexual interest or just a model? And what would she think if she learned that her image enhanced the Friend-ship Bench—in memory of the artist?

It's been three weeks since our visit to Brittany. Normal routines and obligations have already intruded upon my escapes. Tommy's 21st birthday is less than two months away. And once again, I am gripped by seasonal anxiety. How will my family observe November 13? Our family has no established tradition or expertise in defining what is appropriate for times like these. The day of his birth, the day of his death. Each year, our commemorations have been different. We simply do what feels right for the moment. It could be a picnic at the gravesite, a potluck at our home, or a quiet evening with his best friend, Joe. This particular birthday will be

more difficult than the others. When we commemorated his 17th birthday, for example, only eight months had passed since he died. We could still picture him in our minds: a rebellious Scorpio with black marble eyes, dark-fringed eyelashes and lips ready to be kissed. Even today—almost five years after Tommy's death, we still see teenagers sporting the same baggies that droop down to their knees—much like Tommy's did when we moved to Irvine in 1992.

What's most terrifying is that with each subsequent year, it becomes more likely that we'll imagine him, more than remember him. What would he look like today at 21? Would he be an artist? Would he and David be living together in Los Angeles? Would he be in love? These questions are natural for the bereaved—even though we're told by others to "let go."

Instead, I think about the granite megaliths that are still standing—thousands of years after their placement. They make me feel hopeful, even buoyant. Walking among the stone spirits in Brittany, my imagination transcended time. I pray the Friendship Bench, a modern day menhir, will divine the same magic.

On Matches

"In conclusion to my report on matches, I would like to explain why the subject I researched is important. Matches have a long history, and we just take them for granted. Without matches, it would be very hard to start a fire so conveniently. And without fire, we could not cook, go camping, roast marshmallows or just sit in front of a fire on a cold winter night. Also, matches provide jobs for the people of Sweden, Britain and the U.S. Without jobs, there would be even more homeless people than there are now!"

Tommy at age 13

art in private places
Gift of Art

*"Art's most effective
When concealed."*
Ovid

Like most teenagers, Tommy loved to keep secrets from his parents. I suppose it was his way of maintaining control over his life. And ours. We knew his friends in Los Angeles. We were just beginning to meet his new friends in Irvine. Whenever they came to our home, they'd head straight to Tommy's bedroom. One could bypass the front door and enter his room through the sliding glass doors overlooking our green-ferned courtyard.

But as soon as they wanted to raid the refrigerator, I could hear Tommy holler. "Ma, I'm home with the guys. Are you dressed?" God forbid, they should catch me leaping from room to room in my elastic-worn panties and thin cotton T-shirt—my favorite knock-around outfit.

"Coast is clear!" I would assure him.

In time, I could match the names and faces of two of his new friends: Anthony Wong and Andy Lin. They were the same two boys who sat in the waiting room at Irvine Medical Center the day that Tommy died. Mrs. Wong, Anthony's mother, had accommodated their pleas to drive them to the hospital. I still remember facing the three of them—sitting in a row—courting fear in their yielding eyes. "I don't know how to tell you this, but the doctors couldn't revive him. Tommy's gone."

Several hours later, his death made the evening news. Our family watched a TV news clip about Tommy's death. There he was, our son in living color. His somewhat dorky high school photo had been plastered next to Hank Gathers—the African-American basketball player who died of heart failure at age 23—four years earlier, also on a basketball court. The TV caption read: "Another Athlete Has Fallen." Upon seeing the newscast, David's eyes widened in shock.

"Wow, Tommy's on Channel 9!"

Five days later, the local media attended Tommy's funeral. The TV reporter interviewed Anthony on camera. Furious at the media for sensational-izing Tommy's death, he set the record straight. With anguish—and anger—

81

he blasted into the camera, "Tommy wasn't a jock! He was an artist!" And he was right. Tommy even hated to change into his P.E. shorts.

From that moment on, Tommy's new friends had endeared themselves to me. We kept in contact by phone and e-mail. But I had no idea how their loss would mirror mine. It would take several years before I would learn how the death of my youngest son had transformed the lives of his peers.

It happened over Christmas—1998 or thereabouts. Jan and I were shopping for books at Borders bookstore in Costa Mesa. Jan browsed the sports section for an instruction manual on golf. I needed to use the restroom, so I walked in that direction. All of a sudden, I heard someone call out my name next to the pay phone. "Mrs. Sunoo. It's me, Steve."

It was Steve Bagatourian, one of Tommy's fellow artists and also a friend of Anthony's. Upon seeing me, he suggested that he, Anthony, Andy and his brother Abe visit our home during the holidays. We invited them over for dinner and were touched that perhaps, we were starting a new tradition. When they arrived, they couldn't wait to present their special gifts to us. Steve wanted to give back some drawings that Tommy had doodled and given him. The excitement in Steve's voice as he explained each measured stroke evoked more pleasure than the drawings themselves.

"See what he's doing here? Tommy's trying to do perspectives like Frank Miller in 'The Dark Knight Returns.' "

As Steve 'translated' each line and composition of Tommy's work, he guided us into the realm of our son's imagination. The world of Batman, Wolverine and X-Men.

Anthony and Andy waited their turn to present their own surprises. There were two. The boys were part of a band called the Ex-Presidents. They used one of Tommy's illustrations of a transformer for the cover of their self-made CD. They also mentioned his name in the credits.

"That's sweet, you guys."

As the evening progressed, we ended up in Tommy's bedroom—their former 'clubhouse.' The boys wanted to revisit the animated drawings Tommy depicted on yellow Post-It pads. He stored them in a white shoebox in his closet. They remembered.

We didn't get through the whole box, though. Out of nowhere, Anthony turned to us and said, "Mr. and Mrs. Sunoo, I wanted to keep this next surprise until now. Surprise! Merry Christmas!"

He lifted his blue plaid shirt so we could see the elastic top of his designer briefs. Emblazoned across his waistband, I saw the name 'Tommy.'

"Cool! I love Tommy Hilfilger," I said. "I've been tempted more than once to buy a T-shirt that says, 'Tommy Girl.' "

"Mrs. Sunoo, look closer. Not just at the pants," he continued.

"Wait a minute. Let me get my glasses."

There, below and to the right of his belly button, he wore a three-inch reproduction of one of Tommy's sketches: a young man wearing a trench coat and smoking a cigarette. His neck scarf blowing in the wind. That particular drawing had always reminded me of a black-and-white movie poster I've seen of James Dean—the one in which he's strolling the streets of Manhattan. Privately, I used to think of Tommy as an Asian James Dean. A sexy *Rebel without a Cause*.

"Anthony, you've immortalized Tommy's art," I squealed. "When did you do that?"

He told us that whenever he tried to put his feelings about Tommy's death into words, it never came out right. By tattooing one of Tommy's drawings on his body, he could express himself more accurately.

"Tommy's death was the single most important event in my life. It was my coming of age," he said. After high school, Anthony went away to college at University of California, Berkeley. His biology classes, I suppose, best explain his organic metaphor.

"I was a larva at first. I had my own little world because I was little. I didn't know much of anything except for my little branches and little leaves," he said. "After Tommy passed away, I became a kind of pupa—enclosed and introspective."

He started to think about tattooing a piece of Tommy's artwork at age 18. During his pupa stage. Anthony wanted to demonstrate his ease with all the transitional youth-to-adult complexities.

"But I didn't want to be rash about it, either."

It took him two years—from the time he envisioned the tattoo—to actually get it. On his 20th birthday, he finally went to a tattoo parlor on the Sunset Strip in Hollywood with Andy and another friend.

"It hurt," he said. "But if you look carefully, you'll notice that the sketch is mysterious in several ways."

"It looks as though something is on his mind. What's he thinking about? What's in his pocket? Where is he? Is he sad, mad or glad?"

Anthony said he chose that particular sketch because it mirrored his moody relationship with Tommy.

"Sometimes, I'm the guy in the tattoo. You wonder about me. I just might surprise you. Or it signifies something about me—the bumps in my road or how I've changed over the years. Other times, it's really Tommy."

He told us that he often reaches down and holds his tattoo when things are going bad. "It's like talking to God through Tommy, or talking

straight to Tommy himself. I touch it for advice. What should I do? What do you think, Tommy?"

Very few people have seen Anthony's tattoo. Some have caught a glimpse of it when his shirt flapped in the breeze. Only a select group of friends have been invited to his private art gallery.

"It's my most prized possession, and I'm a scrooge about sharing it with anybody."

To deny his tattoo, he says, would be tantamount to denying his identity, his personal journey since Tommy's death. From pupa to man.

"Why do mommies have milk? I know why...because they have little cows in them."

Tommy at age 7

seaweed and shamans

Gift of Compassion

"It is the experience of touching the pain of others that is the key to change…Compassion is a sign of transformation."
Jim Wallis

In 1993, I worked for the *Korea Times English Edition* in Los Angeles. I wrote a story with the headline "A Mother's Sorrow." It would haunt me a year later.

The opening two paragraphs described the first time I met Mrs. Kim, then 43 years old.

She sat on the floor of her living room and sipped a cup of ginseng tea. It will give her strength, she said, to bear the cross of supporting her 16-year-old son, who is facing a murder charge.

The whole Korean community is unable to sleep," said Mrs. Kim, a former nurse and Catholic who immigrated to the United States from Seoul in 1971.

Her teenaged son had been arrested with four other youths in the 1992 New Year's Eve slaying of Stuart Tay, a 17-year-old Chinese-American who lived in Orange County.

"They all cry for me. They felt like it was their own child's incident," she told me.

I knew what she meant. Many other Korean-American immigrant families wondered: If this could happen to a middle-class Christian family like the Kims, could it happen to them, too? And what about me? Wasn't my curiosity in this murder case driven by my own fears—of not being able to protect our children from all negative peer pressure? I empathized with Mrs. Kim's shock and bewilderment.

The media traumatized her even more. They provided the grizzly details. Tay and five high school students had been involved in a plot to rob a computer salesman who worked out of his Anaheim home. But Tay fell out of grace with his peers for using a false name to protect his own reputation. In retaliation, they bludgeoned him with a baseball bat and sledgehammer before dumping him in a grave dug at least a day before his slaying. The newspapers described how one of the murderers poured

87

rubbing alcohol into Tay's mouth and duct-taped it shut. Tay then suffocated as the harsh liquid filled his lungs.

I remember when this horrific murder occurred. It hit pretty close to home. Tommy actually knew Mrs. Kim's son. Both of them had attended the same Korean American summer camp in the San Bernardino mountains. "He wasn't my friend," Tommy insisted.

When we talked about this murder over dinner, I could tell that he felt disturbed. Tommy kept stirring his noodle soup with a bamboo chopstick. How could someone he knew commit such a gruesome crime? One in which the victim had been buried alive.

"What was Mrs. Kim's son like?" I asked.

"Kinda quiet. A kiss-up with the counselors," said Tommy.

"Did you hang out with him?"

"Nah, he was too nerdy."

"Did he seem susceptible to peer pressure?"

"I don't know. Ma, stop asking me so many questions."

I backed off, but still felt immediate sympathy for the mothers—Stuart Tay's mother, of course, but also the mothers of the perpetrators. I couldn't even begin to imagine the depths of grief, guilt and shame these Asian immigrant parents would have to face. All under the glare of public scrutiny and intrusive media.

Soon after the incident, I contacted Mrs. Kim. Our other *Korea Times English Edition* reporters were covering the police reports and court proceedings. I wanted to understand the emotional impact of this killing on the mothers. I wanted to interview Mrs. Kim, so I drove to her home and rang the doorbell. Surprisingly, she invited me in and allowed me to ask her personal questions, with the exception of any details about the murder case.

The Kims' lifestyle mirrored many aspiring Korean immigrants' version of the American Dream. She and her husband, a doctor, were well respected in the Korean-American community and in Orange County. Their then 18-year-old daughter attended the University of California at San Diego. They lived in a two-story home, drove a Mercedes-Benz sedan and a Jeep Cherokee, and could afford summer vacations like the one they took in 1992 to Puerto Vallarta, Mexico.

In a few more years, she would be able to befriend the empty nest. Life seemed sweet. Until the police informed her of her son's murder charges.

"I wanted to die right away," she told me. "But if I died, who's going to take care of my son? For his well-being, I have to survive."

As I talked with her, I learned that she became an active school parent. She also served as former president of Sunny Hills High School's Korean Parent Support Group in 1991. In 1992, she then received an award from the Orange County Human Relations Commission for promoting cultural awareness and dialogue. The recognition suddenly seemed painfully ironic.

About two months after the killing, Superior Court Judge Francisco Briseno ordered that Mrs. Kim's son, then 17, be tried as an adult. He was convicted and sentenced to state prison for 25 years to life.

I can't remember how many times Mrs. Kim and I spoke to each other afterwards. But she must have felt the hand of compassion when I offered her an opportunity to tell her side of the nightmare.

Little did we know that our lives would crisscross again—a year later. When Tommy collapsed and died on the school campus, his death made the local news on TV and in print. *The Los Angeles Times* ran three stories: "Teenager Collapses During Gym Class, Dies," "Heart Failure in Youth Likely is Congenital," and "Friends Recall Boy's Zest for Life."

As soon as Mrs. Kim learned of Tommy's death, she drove to our home in Irvine. Upon her arrival, she walked into our living room with a five-gallon jar of seaweed soup—known in Korean as 'miyok kuk.'

"Here, this is for you. It will give you strength during these dark days," she said.

Ironically, the only other time anyone had given me 'miyok-kuk' occurred during the happiest days of my life—my older son David's birth. Another Mrs. Kim made me the same soup, 20 years earlier in Bergenfield, New Jersey. She told me, "Here, this is for you. It will give you strength in the days ahead." I needed it, especially after enduring 21 hours of Lamaze breathing techniques at Columbia Presbyterian Hospital in Harlem, before David popped out of my canal.

What odd synchronicity, I thought years later. Seaweed after the birth of one son. Seaweed after the death of another. In both cases, these two Mrs. Kims identified with our common umbilical chord—motherhood. They both prepared Korean comfort food—savory nutrients originating from the Land of Morning Calm.

I admit there were few Korean traditions or customs I actually turned to during my earlier years of grief. But the tradition of offering 'miyok-kuk' during a child's birth or a loved one's death soothed my tender stomach. It also enlightened me about Korean culture and superstitions.

The brown seaweed called 'miyok' is different from more well-

known Japanese varieties, such as wakame and nori (for sushi). Most American health food stores sell both types. But miyok, when soaked, actually looks like a flat ribbon of dark, slimy green tails floating in a sea of muddy-colored broth. I don't make it very often, but when I do, I usually wash and soak the seaweed in lukewarm water for an hour, then drain and cut it into three-inch pieces—or longer.

I then put the beef in a pan with garlic, onions, salt, soy sauce, sesame oil and pepper, cooking it until the meat is brown. Then the seaweed is added with six or more cups of water and simmered until it's tender. Lastly, I add tofu, with scallions as a garnish. I usually serve it with rice on special occasions—none of which has had anything to do with childbirth or death. To me, miyok-kuk remains just great soup.

But post-partum mothers, Koreans believe, are better able to lactate when these nutrients compensate for the lost blood during childbirth. So when the first Mrs. Kim gave me her pot of seaweed soup, I remember lactating like Elsie, the Cow. I could even squirt a stream of sweet milk seven feet across the room.

Aside from its nutritional value—calcium, iodine and other minerals—'miyok-kuk' also plays a role in appeasing the supernatural. In the olden days, after bathing the newborn, Korean women prepared a 'samshinsang'—altar for the three divine Shaman beings. They boiled white rice and brown seaweed soup, and brought these gifts to the altar—with three bowls of each.

These 'samshinsangs' lay on a corner near the mother's head in her bedroom, conveying gratitude to the three gods. The 'samshins' or three deities are influenced by Buddhism, Confucianism and Taoism and represent the Shaman concept of magic that influences fertility from conception to birth. The number three is supposedly a lucky number for a Shaman. As communicators between the world of the living and the world of the afterlife, Shaman icons often display fatalism in the art.

I didn't know of these connections between seaweed and shamans before Tommy died. Even after he died, I still viewed miyok-kuk simply as great soup. It took another encounter with Mrs. Kim, in 1994, to make me compare our back-to-back destinies. Jan accompanied me when I made my second visit to her home.

We had all survived our first year of grief. My son had lost his life. Mrs. Kim's son had lost his innocence and freedom. As we sat with her in her living room again, she gazed at us with puzzled eyes.

She asked, "Whose grief do you think is worse—yours or mine? Is it better for one's son to die so young and innocent? Or for one to be alive, but in prison for killing another human being?" I sat stunned by her question.

Neither of us knew how to answer her question. I can't remember the exact words we said. Most likely, we said something neutral.

"Both circumstances are difficult."

But as soon as we walked away from her door, I turned to Jan.

"Honey, what do you really think? It's a tough question to answer."

"I don't know."

As we drove back to Irvine that night, neither of us spoke much in the car. I stared at the bright lights beaming from the other side of the freeway.

Was there a right answer? Or just an honest one? I admired Mrs. Kim for her openness and candor. It couldn't have been that easy for her to pose such a question—to us or to herself. If my grief is worse, is that saying the quality of her son's life is better because he's alive—even as an imprisoned felon? Or if her grief is worse, what is that saying about Tommy's early death? That it's less sorrowful to be dead at 16, as long as your short life had quality and meaning?

"I don't like answering her question," I told Jan.

"How come?"

"It makes us compare losses. And there's no winner."

If I've learned anything from my son's death, it's that we have no control over the time of our death. Only the conduct of our lives and how we struggle to create meaning out of death. Perhaps Mrs. Kim began questioning the fatalism of the shamans. Wondering if her son's life— maybe, even her own—could still be worth saving.

After six years of no contact, Mrs. Kim called me out of the blue. As it turned out, she still suffered from extreme depression about her son's imprisonment. He wouldn't be eligible for parole until age 32. We talked about him for most of the conversation.

"He's doing better. But I can't visit him as often because he's been transferred to San Diego."

"I'm sure he knows that you love him."

Then she apologized.

"I'm so sorry. I called to make you feel better. And here, you've given me comfort instead."

She sounded terribly weak, like a first-time mother after child-birth—fragile from the loss of too much blood. I wanted to make her a pot of homemade seaweed soup. With dark green ribbons of nutrients—to invoke the powers of more forgiving shamans. "Mrs. Kim, this 'miyok-kuk' is for you. It will give you strength for the years ahead."

"Can kids really drown in their tears?"

Tommy at age 7

Chile

santo domingo
Gift of Honesty

"Circumstances reveal us to others and still more to ourselves."
La Rochefoucauld

We first landed in Santiago right at the peak of Chile's winter. The capital is as far south of the equator as Dallas is north. I couldn't imagine that we had just left Los Angeles in 80-degree weather and had arrived in a country swarming with local and foreign skiers in July.

Jan would be tied up with his business affairs for two weeks; I envisioned a week on my own. For years, I've romanticized the idea of writing in a room facing the sea. I would never be able to afford a home by the ocean—at least not in Southern California. This excursion seemed like the next best option. My intentions were simple: to write, stroll along the beach at sunset—and brag about it upon my return.

Being unfamiliar with Chile, I asked our friends Christiane and Matthias (the latter a fourth-generation German living in Chile) if they'd recommend a location where I could write for five days in absolute solitude. Somewhere with a magnificent view. Somewhere near the shore. Away from barking telephones, TVs, cell phones and beepers. Only me, my backpack and a laptop.

What I underestimated about myself is how much of a suburban wimp I had become. Traveling in the Third World, I rediscovered, is an exercise in trust and doing without. Our friends took my needs into consideration. They recommended Piedra del Sol in Santo Domingo—a quiet suburb by the sea—somewhat like Carmel, California, in winter. Located less than two hours outside of Santiago, I would have to take the underground Metro and then board a Pullman bus for 1,600 pesos, the equivalent of $3.20. Whereas before, I might not have ventured out on my own in a foreign country, now I felt my life beating at a faster pulse rate.

Within a six-year period, I had lost my 76-year-old father, my 16-year-old son and my 82-year old mother. Feeling that my own days were numbered, I wanted to take more risks. No longer would I be discouraged by the shrill voice of a mother or the adolescent criticism of a son: "What? You're traveling by yourself on a bus in Chile? You're crazy!

95

You may get killed." Indeed, a middle-aged Korean-American woman traveling by herself can raise several questions in the minds of her observers: Where is she from? Why is she by herself? What's in her backpack?

At first, I didn't think any of these concerns would bother me. But the night before I left, Jan and I both suffered from insomnia. Our restless toes untucked the flat sheet from underneath the mattress at our hotel in Santiago. And sometime during the middle of the night, we bumped into each other as we groped our way toward the toilet. He seemed nervous about his presentation; I couldn't sleep because of the excitement related to my journey and some anxiety, as well, mostly about arriving at my destination without any mishaps or regrets. Jan's colleague's wife, a newlywed, brought this to my attention over dinner. "Gosh, you're so brave, but aren't you going to be lonely?"

"No, I've actually been looking forward to...." But just as I was finishing my sentence, our bodies jerked into attention. We felt a 15-second jolt from an earthquake that evoked images of my body buried in rubble.

Later that night, I turned over to my side and asked Jan, "What if there's an earthquake while I'm in Santo Domingo? Will the ocean waves crash against my cabana?"

"Just watch the tide. If it begins to recede, you're in big trouble. Start running."

"But what if it happens during the night while I'm sleeping?" I said.

"Then you'll never know what hit you."

I must've snoozed a few more hours in spite of Jan's unnerving reply. After my 7 a.m. wake-up call, I jumped in the shower and double-checked a few last minute details: put 500 pesos in my pocket so I can buy one Metro ticket and use the change for my later taxi; jot down my phone number for Jan in case of emergency; pack my passport; separate my traveler's checks from my pesos.

By 8 a.m., I walked down Avenida 11 de Septiembre to my Metro stop. I hate to admit this, but we did a trial run the day before so I would know exactly where to hop on and hop off. Even so, in my excitement, I got off at the wrong stop. Instead of the Universidad de Santiago, I had jumped off at the Universidad de Chile—six stops too early. I suspected a mistake when I noticed the unfamiliar stairs leading up to the street, where pedestrians' legs were marching in tick-tock fashion.

"Where are the Pullman buses?" I asked the ticket man.

"You want another station," he replied in Spanish. Feeling embarrassed, I re-boarded the subway until I reached the correct stop.

A few minutes before 9 a.m., I boarded the Pullman bus headed toward San Antonio and Llo Lleo. The ticket agent recommended the front

seat so I could enjoy the view. But fifteen minutes into the ride, we were rolling through the fog. The only thing I could watch inside the bus were the driver's plastic hibiscus, a Minnie Mouse key chain and a purple-haired Troll doll swinging back and forth as the bus traveled along the invisible highway.

As the fog gradually lifted, my driver displayed the dexterity of a juggler. With a hefty stack of bills in his hands, he began to steer the bus with his elbows. At one point, he lifted his arm completely off the wheel in order to lick the finger assigned to flip the corners of the bills in rapid succession. If that wasn't enough to scare me, he then proceeded to fold the larger units of pesos, bind them with a rubber band and count the remaining coins jingling in his pocket. His eyes occasionally peered at the road while I—as if to disprove my visible anxiety—whipped out my compact and lipstick.

My two-hour bus ride taught me something about transitions. I doubt I would've learned this lesson on an American freeway. Transitions must inevitably rely more on faith than predetermined road signs. Whenever my bus driver approached a fork in the road, he turned in the direction I least expected. If the sign to Llo Lleo pointed to the right, he steered the vehicle to the left. Would the turn toward San Antonio still lead to Llo Lleo? I simply did not know. Rather than question his choice, I remained silent—trusting that he'd lead me toward my desired spot. I looked like the purple-haired Troll swinging back and forth, eye level to the driver. Inanimate, yet amused.

When I arrived at Piedra del Sol, a young Chilean caretaker named Luis walked me to my cabana. What Chilenos call cabanas are basically self-contained units or cottages equipped with small kitchens. The four-room unit I selected could easily accommodate an entire family of five or more. But I chose it anyway because I could watch six lanes of waves tumble froth along the shore at a 45-degree angle. The view reminded me of what life feels like after a loss: an entire panorama of ocean spilling a palette of grays—moving sideways instead of head on.

There were no other tourists at the beach resort. In fact, Christian Kupfer, the Swiss Chilean owner, told me: "Tourists come during the weekends and holidays. I see as many people year-round that I can see in one day in Switzerland." That delighted me even more. In fact, the low attendance enabled my friends to negotiate an off-season rate of $40 per night, including breakfast. If I wanted lunch or dinner, it would cost me an additional $5 per meal.

"What time would you like your meals?" the owner asked.

"I'd like to have breakfast at 8; lunch at 1 and dinner at six, if possible."

"That will be no problem. Just come to the dining room when

you're ready."

Once my mealtimes were established, I settled into my oceanfront quarters. After taking a few snapshots of the spectacular view, I immediately moved the round table in the living room closer to the sliding glass doors. Luis had provided me with an extension cord so I could situate my computer at any distance from the wall. My desk would face the ocean, unobstructed by any condos, trees or cement walls. There would be no excuses for writer's block here. And just to make sure that my equipment worked, I turned on my computer to hear its familiar chime. Relieved that there would be no technical problems, I began to explore the rest of my surroundings.

Like a dog that circles its territorial claim, I moved through the cabana with a buyer's curiosity. The owners had furnished the living room simply: two daybeds, a glass top coffee table, an ashtray and five hard wooden chairs encircling the dining room table. I moved four of the chairs outside so I wouldn't feel as though other family members were missing. The only sign of creative flair were the raspberry-colored drapes with teal polka dots, also hanging conspicuously in the bedroom. Someone must've really loved polka dots because the window curtains in the kitchen also sported yellow, blue, red and green spots with planetary circles reminding me of the TV comedy *Third Rock From the Sun*.

Stepping outdoors, I stretched and inhaled the peppermint-like breeze. I drooled at the large backyard, but it offered more space and opportunity than I would need. A large patch of healthy grass extended to the edge of a sloping hillside—where ice plants, bordered with purple and white daisies, cascaded down toward the beach. Adjacent to the property, I could also see phone and electricity lines, safely distanced from the tall eucalyptus trees adding life to the landscape.

I felt so cold that I came back indoors, looked at my watch and decided to eat lunch. Luis had prepared a salad plate with sliced avocado, beets and tomato; bread; rice and meat. The dining room—about hundred feet from my cabana—could host ten tables at a time. But no other guests appeared at the resort, as far as I could tell. It felt a bit odd to sit alone in the restaurant, luxuriating in exclusive service. Me, the ocean and a pork chop.

Since I had come to write, I began my work that Monday in the late afternoon. I kept to a rigorous schedule of waking up at 7 a.m., showering, eating a light breakfast in my room and pecking away in three-hour shifts—with meals in between. I only walked on the beach one of those five days. Most of the time, I glued my fanny to the chair. There were moments I sat there frozen, gazing at the ocean from afar. It reminded me of watching flames belly-dance in my own fireplace at home.

Unfortunately, I didn't feel as warm.

Luis had shown me how to use the small propane heater. But one had to aim it at the body part you wanted to heat. Each day, I chose between warming my feet or bending over to warm my hands. There were no thermostats to regulate heat for the entire cabana—much less a room. Since I had packed only a few pairs of sheer knee-highs, I could barely tolerate my Popsicle toes. Determined to have warm feet, I took a two-dollar taxi ride into Llo Lleo to buy a thick pair of athletic socks and a box of regular-sized Kleenex. These were minor annoyances and adjustments I had to make, compared to what I faced with the bathroom toilet. It didn't flush on two hefty occasions.

Poor Luis. Each time I had trouble, the manager dispatched him to my rescue. I made sure that when he came to my cabin, I had already left to eat my meal in the restaurant. My instructions were spelled out on yellow paper in Spanish, according to my Larousse English/Spanish dictionary: "No se puede apretar el boton del inordoro." (The toilet won't flush). "No abierta esta tapa." (Do not open this lid.) I could laugh off the first time it happened. But the second time, I was so embarrassed I couldn't look Luis in the eyes during the rest of my stay.

Taking a bath presented another challenge. Aside from the narrow tub, I couldn't get any hot water. When I asked Christian about it, he explained the delicate procedure: "Turn the faucet on very, very slowly. Then let out a little water before turning it up again. You won't get any hot water by turning the faucet all the way up in the beginning. Hot water comes out gradually. And when it does, be careful. It burns."

Once I learned this little trick, my baths became the substitute for the heater. Whenever my body felt chilled, I lay in the narrow tub—my kneecaps poking through the surface of the water. Imagine drying off your body with a skimpy towel as thin as paper—and as small as a hand towel. I dried my neck, shoulders and armpits, but I blotted the rest of my body with a sopping wet rag.

By the time I took my third bath, I wanted to retire around 11 p.m. I executed the same ritual each night: I wore sweatpants to bed, double layered the top, put socks over knee-highs—and pulled the top sheet and blankets over my mouth. One night, while lying on the daybed in the living room, I heard something flutter across the room and thump itself against the wall. At first, I didn't want to move. But since I hate bugs and wouldn't be able to sleep unless I knew the flight path was clear, I turned on the light. A one-inch flying red beetle headed toward me—the likes of which resembled a giant ladybug without the black spots.

"Aaaagh!" I screamed. Hiding under my sheet, I waited for the beetle to land before I could whack it with my wooden clog. Splatt!! Its

blood and guts added instant color to the otherwise drab bare walls.

By the fifth day—and 30 pages later—I desperately wanted to return to Santiago. The two-hour bus ride back to Hotel Neruda seemed twice as long as my ride to Santo Domingo. My body ached from constant shivering, and I suspected I was coming down with the flu. A day earlier, I had succumbed to a mild case of diarrhea. Hopefully, I'd arrive back at the hotel in dry underwear.

When I arrived at the front desk, I hurried the reception clerk. "Room 315, por favor." I didn't even wait for the elevator. I was so relieved to be back in Santiago that I rushed toward the stairs—skipping every other step. The minute I entered our room, I threw my backpack on the bed, kicked off my shoes and dived into the snack bar. I reached for a bottle of apple juice and a can of honey-roasted peanuts. Probably the worse thing to drink and eat after suffering from a queasy stomach. But when you're hungry and sensory deprived, it's amazing what you'll do.

By the time Jan arrived at 5:30 p.m., I sat tucked in bed watching CNN, my stomach bulging from the snack.

"Hi, hon. How was your week?"

"Fa-a-bulous! The room had the most spectacular view. I wrote a lot, ate a lot and watched the sunset every night from my living room couch."

"Did you get lonely?"

"No, not at all. I stayed too engrossed in my writing."

"How were the accommodations?"

"Worth every dollar!"

I left it at that, at least for a few hours. I didn't want to let on that my week in paradise had its imperfections. Why spoil the tale? Those five days in Santo Domingo did offer me more than a spectacular view of the ocean. They were a blessing and a trial. I discovered that I could travel on my own in a foreign country, get along with my conversational Spanish and learn to survive amicably among strangers. Fear, to my surprise, had become the least of my personal obstacles. Without physical comfort, I'm a wuss.

When Jan asked me if I was ready to go out for dinner, I shimmied into my fluffy pillow.

"Can't we order in?"

don diablo drive

Gift of Family Memories

"The fellow that owns his own home is always just coming out of a hardware store."

Kin Hubbard

Even before my mother passed away in May, I promised not to sell our family home. At least not for a few years. On good days, she held me to that vow. On bad days, she flung her arms up in the air: "Look at this mess. It's your father's entire fault. Go ahead. Sell it."

After she died in May 1999, our relatives and friends asked me: "What do you plan to do with the house?" They were curious about our 10-room home in Los Angeles on Don Diablo Drive. Aside from the basic advice of many psychologists: "Never make any major changes within the first year of mourning," I didn't feel ready to sell the house. After all, my father and I had spent weeks house hunting every Sunday afternoon in our white 1958 Ford station wagon. At age 12, I even used to scour the real estate section of the *Los Angeles Times,* drooling over the expensive ranch-style homes selling for $40,000. My mother's financial instincts drove our move from 29th Place and Arlington Avenue. But Dad and I were the scouts assigned to comb the middle-class residential areas near Crenshaw Boulevard, then plagued by white flight. After weeks of open houses, we eventually found the right homestead for our family of five: Mom, Dad, Grandmother Yim, my sister, Bonnie, and I. Over the decades, I would skate in and out of this home—my life undergoing as many inner and outer transformations as each individual room.

We moved to Baldwin Hills in 1960. As Asians and blacks began to settle into the "Dons," the Anglos and Jews fled to the posh areas of L. A. county: Bel Air; Brentwood, Westwood, Cheviot Hills and Sherman Oaks. For the Paiks, living in the hills with Spanish names meant our family moved up a notch or two. We were minutes away from the May Company, Broadway, Desmond's, Silverwoods, Lerner's and Sav-Ons. And ten minutes away from the Los Angeles airport. With a miser's eye toward their investments, my parents bought our four-bedroom home for $46,000—a big stretch in those days for a restaurant supply salesman and an elementary school teacher.

The former owners had built the house in the '50s, customizing

it with the latest features of the decade: exposed wooden beams in the living room and family room; slate floors in the entry way; a built-in brick planter by the front door; indirect lighting; multi-colored tiled linoleum for each bedroom; carpet for the master bedroom; a built-in oven; sliding glass doors; and a service porch so large that one could set up a ping pong table and still have room to slam the ball. The children's pink bathroom seemed fit for a princess. It came with two sinks and pull-out foot boards for kids to stand on, a built-in hamper with holes to air their stinky laundry and a heater to fry a wet butt.

I lived in this home for nine years—between the ages of 12 and 21. From the time I ratted my hair into a five-inch beehive until I recited my wedding vows in a mini-skirt overlooking the City of Angels. Jan and I met in our family room during the summer of 1967. I accepted his proposal for marriage in our living room in 1969. And years later, we brought our sons David and Tommy to their grandparents' home for the holidays, especially when my dad promised to dress up as Santa Claus. On such occasions, we first ate dinner—a meal embellished with my mother's homemade Korean kimchi— a garlicky and spicy pickled cabbage. Then we'd wait for the bells to jingle before rushing out to the street. Once assembled, we looked for Santa dancing on the rooftop. With Christmas lights flickering at his feet, my dad tossed the goodies in the air—each one descending in balloon parachutes that safely landed in our hands.

After my sister, Bonnie, and I left home in the late '60s, our home on Don Diablo Drive morphed into something even my mother could not fathom. My dad—the seventh of ten children born to a poor immigrant family—began hoarding and sneaking in the small stuff first. Items as harmless as a bottle of screws, a power saw, a compressor and a blow torch. Even a few industrial cabinets. But when he arrived home one day with a wall that once enclosed part of Bank of America, my mom screamed, "What in the world is that?"

"You won't believe this. I saw the wall down by the old bank. You always wanted a patio. So here's the foundation. I hired these young Mexican kids to carry it up the stairs."

My mom shook her head, not realizing this scenario forecasted decorator's doom. Years later she told me, "I don't know how this happened. One day, I looked up and we were living in a junkyard like 'Sanford and Son.' "

Dad always defended himself. "We're saving money, aren't we?" He said he learned to scour, save, fix and build anything from his own father—a resourceful and clever man. In order to feed their huge family, the Paiks lived in no less than ten places, including a move to Tremonton, Utah in 1926. My father swore he would never live on a farm again. He had had his fill of milking cows at dawn and spooning protein from the residue of homemade tofu (soybean cake). And no matter how ingenious

his inventions, they all looked like shit—excuse me, functional objets d' art. Except for one loving creation: Amber's doghouse.

One day, my sister, Bonnie, found our stray dachshund-beagle while walking home from school. We suspected Amber had been an abused puppy, so my parents said we could keep her. During the colder months, Amber stayed in her doggie bed in the service porch. But during the warmer months, my dad fixed her up in fancier accommodations. He built her a customized A-framed house with glass walls and a see-through roof. We were assigned to remove her nose prints with Windex once a week. Carried away by his own architectural endeavors, my father set the glass house on a Formica pedestal (a liberated piece of restaurant equipment, no doubt) that stood high enough for Amber to relish the view. If she needed to poop, Bonnie and I didn't even have to take her for a walk. Dad enabled her independence. He attached her collar to a cable that allowed her to run back and forth—at will—to a dirt patch up the hill.

"Now Amber can crap as much as she wants," he said.

Years later, after Amber died, my dad adopted another dog—a Doberman—that he named Brandy. He replaced the glass house with a wooden one, much larger, that stood on the ground. As expected, he continued to improve upon his pet innovations. You could call my dad a cross between TV character Tim, the Tool Man, and comic artist Gary Larsen—humanizing the lifestyles of God's four-legged creatures. One time, my parents were planning to go away for the weekend. I asked if they wanted me to watch Brandy.

"That's OK," said my Dad.

"You're leaving him at Pittman's Pet Motel?"

"No, Brandy can feed himself."

"He can?"

"Yeah, look outside."

My dad beamed as though he had won First Prize at the county fair. Then he admitted he stole his latest idea from a restaurant that served wine from an Austrian decanter. Instead of raising a wineglass to a pin that releases Cabernet from an inverted vessel, Brandy could manipulate her tongue to lick a similar pin that released water from a bottle. And three times a day, an alarm sounded off to automatically release Purina Dog Chow from a recycled Clorox container—straight into Brandy's dinner bowl.

"What do you think. Pretty clever, huh?" he said.

"Like nursing from a breast," I joked.

Some of my father's other handiwork doesn't deserve as much praise: the green fiberglass he used to enclose the backyard; the 14-foot bamboo trees he planted to secure his fortress; the aluminum pipes he reconnected and welded into a banister for the front stairs; the barbed wire he strung along the bushes to avert possible burglaries; the industrial fans he installed outside the bathrooms to eliminate the stench; and the

AstroTurf he laid in the backyard so he no longer had to mow the lawn.

And that was just the outside. Indoors, our home also began to lose its flow and glow. In our large service porch, we used to be able to walk across a wide uncluttered space of linoleum tiles. But Dad decided to save money by repairing his clothes by himself. He bought a state-of-the-art Singer sewing machine that he set up right in the middle of the room, thus reducing the walkway to three feet instead of nine.

"I'm teaching myself how to sew. Look at this," he said, pointing his two elbows in my face.

"Dad, what did you do?"

"These sleeves will never wear out."

"But the patches...they're made out of plastic."

"Yeah, they'll outlast those iron-on patches any ol' day."

He didn't stop there. In our former bedrooms, out went the beds and all the furniture I had handpicked at Fedco—a local discount store—as a teenager. In their place, my dad assembled metal shelves, a recycled pie rack from Marie Callendar's and other scrap tables to stack boxes of knick-knacks, such as plastic containers with sewing thread, picnic supplies, wrapping paper, extra rice cookers, shopping bags, plastic bags—and more tools. What used to be his study when he sold Litton microwave ovens, suddenly became known as "The Room."

"Don't go in The Room," my dad would say.

Not that he was secretive or private by nature. The former study had become the only place left to stack what no longer fit elsewhere in the house: five sleeping bags, musty old blankets, boxes of newspapers that pictured him in the Los Angeles Koreatown Parade, restaurant supply catalogs and a zillion other odds and ends. Not to mention the thick layers of dust that had accumulated over the years without one spring-cleaning.

Later as an adult, before I stepped into the house on visits, my mother always warned me, "Don't you dare criticize. I know what you're thinking."

"What? That this should be in *Ripley's Believe It Or Not?* "

"Don't start. Once I'm gone, you can do whatever you want."

It went on like this for years, even after my father died in 1993. She got rid of some of the junk—mainly, his junk—and gradually learned how to hire all the necessary laborers and repairmen to substitute for my father's absence. At one point, she expressed such anger at my dad for leaving her that I deliberately encouraged her rage.

"Damn your father. How could he leave me with such a mess?"

"Let it out, Ma! Go ahead. Punch a pillow!" I urged her over the telephone. I couldn't see what she actually did, but I could hear her voice cringe with frustration.

"Dad would flip in his grave if he knew what I threw out. Not to mention the money I'm spending for a gardener, a painter and a roofer. You know how he hated to spend a single penny. Your dad was so tight."

But as a God-fearing Christian, she always ended her scathing remarks on a forgiving note. "But your dad, he was a good man."

I usually laughed and replied, "Ma, it's OK to be angry." Her periodic ranting amused me. She usually expected two things from me: an empathetic ear and a "Good Housekeeping Seal of Approval" whenever I visited our home after my father's death.

"Look in your bedroom. I cleared it out. And how do you like my new living room carpet?"

"Ma, the house looks great, but..."

"But what?"

"When are you going to clear The Room? "

"It's too messy. I told you, you can deal with it after I'm gone."

The truth is, my mother could never bring herself to discard, move, clean or give away anything in my father's former study. Could I blame her? I hadn't discarded, moved, cleaned or given away anything from Tommy's closet either—even though piles of papers and books still collect dust along the perimeter of my deceased son's bedroom. I suppose my mom, in a similar way, had let time stand still. As long as one room or area remained untouched, we could each see and smell snippets of our translucent past.

One night, though, I actually entered the study to begin tackling this humongous chore. I didn't get very far. After 15 minutes of sorting through rusty paper clips, a plastic tray of Helena Rubenstein cosmetic samplers, Christmas cards dating as far back as 1962 and other miscellaneous odds and ends, I slammed the door—sneezing my way out of the dustmite-infested quarters.

"What a health hazard," I proclaimed. "How can you stand it?"

"I don't. I just leave the door closed.

I didn't reopen those doors until my mother died. Overwhelmed with the responsibility of sorting through 50-plus years of belongings, I hired a professional organizer (office therapist). She granted me the serenity, courage and wisdom to know what to keep and what to throw away—in just "The Room."

"What are these rusty keys?" asked Donna McMillan, the organizer.

"Who knows? I say dump them."

"And these photos? Who's the young lady?"

"That's Dad's favorite picture of Mom."

"Lots of valuable stuff here," said Donna. "I love going through other people's things, don't you?"

The two of us spent no less than eight hours carefully sorting through every file folder, drawer, box, bag, metal can, envelope and plastic tray. And that was just the small stuff. Most of the items ended up in either the designated "give away" plastic garbage bags or the "throw away"

garbage bags. Without Donna, I probably would've thrown away too many mementos. She tempered my haste and frustration. To my surprise, I found a tiny datebook that my mother used as a teenager. In one entry, she wrote: "I hope to become a pianist." She did.

With such discoveries, I accepted the housecleaning and renovating tasks with greater zeal. A week later, I hired a Korean painter to redo the walls and I also ordered new carpeting for this and other rooms. I marveled at the metamorphosis that occurred before my very eyes. Where once I could only step two feet into "The Room," I could now lie down on the floor, roll across the room, leap toward the ceiling and open the windows, breathing in the summer air.

Even while I refloored the other half of the house, added a chenille sofa set in the living room, replaced a gaudy baroque dining table base with one made of Italian travertine, "The Room" remained empty. After so many years of homeowner's neglect, it deserved a rest. Besides, I had no idea what to do with this space.

Since David had agreed to move into the house as our temporary caretaker, he helped lighten my physical load and offered a few renovation suggestions of his own.

"Why don't you use The Room as a study for yourself?"

"Maybe I'll turn it into a guestroom or a meditation room. I want to do something different with it."

My instincts to leave it alone have served me well. I'm comfortable with the clean space, the ambiguity of its future. It mirrors this stage of my life as a bereaved mother. But in the course of clearing out "The Room," I finally did make peace with my Dad's death—after six years of delayed grief. Since my mom had continued to live in their house after he died, she handled most of the immediate sorting. I remained too absorbed in Tommy's sudden death in 1994 to address the loss of my dad in 1993— on the same exact day. "The Room" finally gave me the opportunity to sort through his physical clutter. Deep inside, I knew I was clearing away emotional dust. He was there, in every quirky way. From the table base he spray-painted green to the pen that undressed a sexy brunette when you turned it upside-down.

And the backyard? Jan and his brother, Cooke, could hardly wait to tear down the fiberglass wall. With crowbars and hammers in hand, they reclaimed our panoramic view in several hours. Now we can see parts of Los Angeles while sitting outside, especially on a clear, smogless day. Just like on the day we were married 30 years ago. If our dog, Amber, were still alive, she'd be happy too. Poking her wet nose against the inside of a glass house overlooking the City of Angels. Her miniature castle, compliments of Dad, on Don Diablo Drive.

"What, my life at home? Well, it was pretty boring to a kid like me. You see, I liked to create. And in a small house it was hard. Sometimes I would get so frustrated at home I would throw temper tantrums. One game I played was Drive Mama Psycho! I would do anything possible to drive my mother crazy. For instance, I would repeat everything she did or said. I would sometimes purposely run into walls head first, cry, then when Mom came, start laughing insanely."

Tommy at age 13

say it with a list

Gift of Family Healing

"We are not going [around] in circles, we are going upwards. The path is a spiral."
Hermann Hesse

As my life twirled out of control, I graduated from Post-Its to reporter's notebooks—the kind that fits in one hand and flips at the spiral wires at the top of the pad. One of my journalist friends, D'Arcy Fallon, used to write columns for *The Gazette* in Colorado Springs. I blame her for getting me hooked. One Christmas, she handed me a gift-wrapped package.

"Here, doll, this is for you!"

"Thanks, D'Arcy. Feels heavy. What is it?"

"Go ahead, open it," she said.

It didn't have a ribbon, so I was able to open my surprise with two less strokes. My friend had packed a stack of four-inch wide reporter notebooks.

"This is great! I've been using steno pads, but they're so cumbersome."

"Hey, compliments of *The Gazette*."

Within two months, I used up my supply. Fortunately, I found the phone number of the manufacturer printed on the pad. I've since ordered them in bulk whenever I get down to my last three notebooks.

I use one per project and go absolutely wild with my lists. I create my plans with an extra fine Pilot Precise Rolling Ball pen. I check off my items with a No. 2 pencil—sharp as an ice pick. And I prioritize my tasks with a neon-yellow highlighter. And that's just the foreplay. The climax comes when I've completed my list. With heavy breaths and crescendoing glee, I rip the pages off along the spiral edge, crush them in my hands and scream, "Oh, baby!"

Some of my lists read like a diary. They validate the life and times of a woman Desperately Seeking Joy in a life gone awry. Before, my lists served as daily reminders. Now, I use them as measuring sticks to see how far I've come.

111

Junk Food Heaven
Pringles (sour cream and onion)
Buttered popcorn
M&M peanuts
Chocolate chip ice cream
French-fries
Doritos

Must-See TV
Young and Restless
All My Children
West Wing
ER
Late Show with Dave Letterman
Actor's Workshop on BRAVO
Food Channel
Ally McBeal

Sign Me Up For Classes
Reiki
Intermediate Spanish
Salsa
Poetry
Italian cooking
Instant Piano for Busy People
Grief Recovery
Financial Planning
MFA in Creative Writing

Accessories to Camouflage My Sorrow
Yellow leather jacket
Black suede boots
Silverfox boa
Parisian silk beret
Cashmere cape

Inspiring Books on Grief
Heaven's Coast by Mark Doty
The Bereaved Parent by Harriet Sarnoff
A Grief Observed by C.S. Lewis

Why Do Bad Things Happen To Good People by Harold Kuschner
In the Midst of Winter edited by Mary Jane Moffat
Companion in the Darkness by Stephanie Ericsson
How to Survive the Loss of a Love by Melba Colgrove, et. al
Beautiful Death by David Robinson

<u>Annual Weight Chart</u>
1994: 107 pounds
1995: 110 pounds
1996: 115 pounds
1997: 120 pounds
1998: 120 pounds
1999: 123 pounds
2000: 128 pounds
2001: 110 pounds

<u>My Body Suddenly Speaks</u>
Sinusitis
Menopause
Root Canal
Polyps
High cholesterol
Asthma
Metatarsalgia
Misaligned vertebrae
Shooting pains in the kneecaps

<u>Enough Already. Get in shape!</u>
Jogging
Swimming
Rockclimbing
Walking
Scootering
Yoga
Dancing

<u>Best Rated Movies about Death and Grief</u>
Secret of Roan Inish
Shadowlands
Steel Magnolias
Himalaya

Life is Beautiful
Big Blue: Director's Cut
Philadelphia
Under the Sand
K-Pax
In the Bedroom

<u>Toughest Days of the Year</u>
February 16 (Death date)
November 13 (Birthdate)
Mother's Day
Weddings
Graduations

<u>Brazilian Sounds to Soothe an Aching Heart</u>
Djavan
Marcos Ariel
Milton Nascimento
Ivan Lin
Chico Barque
Dori Caaymi

<u>Favorite Places</u>
Zion
Iguazu Falls
Crystal Cove
Del Mar
Tommy's bedroom
My daily bath
Pillow talk in bed

"Tommy's work has improved in quality since his seat was moved."

Mr. Freund, third-grade teacher
1986 (second report card)

Top: Author with Helen Foster Snow in Madison, Connecticut, 1985. Bottom: Helen Foster Snow in Yenan, c. 1937. Courtesy of L. Tom Perry Special Collections, Brigham Young University.

in memory of helen foster snow
Gift of a Mentor

"The important part of writing is living. You have to live in such a way that your writing emerges from it."

Doris Lessing

I often wonder what legacy we are destined to leave behind. In the case of my son, he led a short, but gifted life. As a journalist, a big part of me yearns to leave meaningful stories in my wake. As I struggle to find my direction, I often think of Helen Foster Snow. A remarkable, but overshadowed journalist, she became the first wife of American news correspondent Edgar Snow, author of *Red Star Over China*. Both of them had sailed off to Asia in the early 1930s, sniffing the odor of revolution. Over the years, they became revered as leading experts on China. When I learned that Helen Foster Snow had co-authored a memoir about an unknown Korean patriot in pre-revolutionary China, I stored her name in my mental file cabinet. She inspired daring, scholarship and tenacity. Could I be like her?

I had first learned of Snow in the early 1970s. My husband, Jan, and I were living in New York while he attended a post-graduate fellowship in community psychology at the Albert Einstein College of Medicine. Both of us were also antiwar activists. Like many other Asian-American activists in the '60s and '70s, we were politically dizzied by the democratic movements of the Third World, particularly those in China, Vietnam and Korea. We marched against the war in Vietnam. We published a human rights newsletter called "Insight" and organized the first public demonstrations for Korea reunification at the United Nations in 1972. I even sewed a South and North Korean flag that flapped in the wind on First Avenue—the first public display of solidarity for one Korea. "You're our Korean Betsy Ross," says Jan.

Like many of my Asian-American peers, I embarked on a search for my ethnic roots. I collected as much information as I could about my grandparents' homeland. Through history books and anti-war teach-ins, I became more aware of Japan's brutality during its 35-year occupation of

117

Korea between 1910 and 1945. This political backdrop propelled the first wave of Korean immigrants to the United States in the early 1900s. My grandparents were among this first wave—assisted by American missionaries to escape Japanese colonialism. With few belongings, they crossed the Yalu River and boarded the SS Siberia at Incheon harbor. The early immigrants landed in Honolulu, whereupon they were signed on as contract laborers to harvest the island's sugar plantations.

Although Korea achieved its independence from Japan at the end of World War II, the former is still the only country in the world—besides Ireland—that is divided. Foreign powers—Russia, China, Japan and the United States—have always sought to dominate this tiny peninsula known as Land of Morning Calm. Thus, Snow aptly named her book "Song of Ariran" after a famous Korean folk song that emotes the people's sadness and longing for peace.

I first learned of Snow's book through my father-in-law. A former political science professor at Central Methodist College, he directed me toward three must-read classics in order to understand pre-Revolutionary China: *Man's Fate* by Andre Malreaux, *Red Star Over China* by Edgar Snow and *Song of Ariran* by Kim San and Nym Wales (Helen Snow's pen name). I had never read a book about a Korean, much less a Korean-American. (These discoveries occurred during the eve of Ethnic Studies.) I accepted his timely advice. Most of our political friends were devouring history books and quotations from Mao Tse Tung, Ho Chi Minh, Fidel Castro and Che Guevara. Jan and I had no such political heroes of our own ethnic background—until we discovered *Song of Ariran*.

What still amazes me is that Helen and Kim San met among the remote caves of Yenan in 1937. She was 29, a tall, blue-eyed beauty from Idaho. He, a 32-year-old Korean patriot and secret delegate to the Chinese people's councils in the Shensi province of China.

These two unlikely strangers met in pre-Revolutionary China due to a combination of circumstance and mutual curiosity. In the course of two rainy summer months, their relationship forged the last link between exiled Korean patriots in Manchuria (those opposing Japan's then occupation of Korea)—and the outside world.

Mao Tse Tung had completed the 6,000-mile Long March in 1935. Braving a brutal winter, the communists had moved from Kiangi to the far Northwest near the Great Wall—seeking refuge from Chiang Kai-shek's Nationalist (Kuomintang) forces. Meanwhile, Japanese troops were penetrating the northern provinces of China.

"It was a very dark and dangerous time for China," Snow wrote. "I

knew I had a scoop as soon as I talked to him. He placed his immortality in my hands."

So in 1937, the Korean revolutionary, who had earlier been a member of the Chinese Communist Party, entrusted Snow with his exclusive story.

Few, if any, books relate the personal story of a Korean like Chiang, whom Snow named Kim San to protect his identity. No other book I've read in the '70s has rivaled *Song of Ariran* in terms of impacting my politics, pluck and profession. When I became a journalist in the 1980s, I wanted to meet Snow and thank her for co-writing the book. I also wanted her to know how it had inspired my life as a Korean-American human rights advocate and writer. After first reading *Song of Ariran,* I no longer felt alienated from the Third World movements I publicly supported. Finally, a Korean nationalist personified the same passion, political ideals and human desires as the other figures we studied and emulated. Kim San's story validated my own idealism in the scheme of contemporary politics. Without his memoir, I never would have learned that a Korean like him had ever existed. When I read about his suffering, I could juxtapose it with the stories my grandmother told me about her family's tragedies during Japanese occupation. "The Japanese soldiers scalded the skull of my younger brother," she told me. "And you have no shame for having a Japanese boyfriend?" Snow's book amplified my grandmother's anger and bitterness. The author also became a role model for me as a journalist because she demonstrated the value of documenting the chapters of social history that bordered one's life.

After contacting her publisher in the Bay area, I learned that Snow lived in Madison, Connecticut. I called information and obtained her number.

"Hello, Mrs. Snow? I've read your book *Song of Ariran.* Can we meet? I would love to interview you."

"That's wonderful. I don't know many Korean Americans. But you'd have to come and visit me in Madison."

We first met in May 1985. Helen greeted me in front of her red mid-18th century New England colonial farmhouse. I had just arrived by taxi from the Old Saybrook train station in Connecticut, less than two hours away from New York's Penn Central. I imagined her living there since 1941, nestled inside the woods and minutes away from the tranquil view of the Long Island Sound. What a writer's paradise I thought, as I compared it to my urban surroundings in the Mission District of San Francisco, where I lived in the mid '80s.

Prior to my trip to Madison, I had secured a Korean version of the book, which I brought her as a surprise. But before I could present it to her, she quickly steered me past several piles of manuscripts and books cluttering a small cozy living room with two old-fashioned armchairs.

"You sit here. And I'll sit here," she said. With an unexpectedly high-pitched scratchy voice, she asked, "Are you hungry? I just made some New England stew."

"Yes, please," I replied, taking my seat on the armchair next to a windowsill claimed by her silver-gray tiger cat, Marilyn Monroe.

Snow and I established an instant rapport. "Tell me about your background and how the book affected you," she said.

As I revealed my family's Methodist background—my grandfather's ministry—she perked up and informed me that my Protestant upbringing contributed to any open-mindedness on my part. Snow, whom I eventually addressed as Helen, seldom spoke with doubt or ambivalence. A detailed historian and vocal advocate of the Puritan revolution, she strongly believed in productiveness, democracy, honesty and self-respect.

"I hate liars. Don't you?"

My two-day interview broke convention, to say the least. An editor of a Bay area newspaper had encouraged me to write an article. But there were moments when the tables were actually turned: I became her interviewee. Helen seemed as curious about me as I was about her.

As a budding journalist, I searched for inspirational role models. Very few women I had met were so widely acknowledged in the areas of writing, politics, philosophy, culture, art and history. Helen Foster Snow, a two-time nominee for the Nobel Peace Prize (1981 and 1982 for launching the Gung-ho cooperative movement) is one of America's most under-recognized journalists, a woman far ahead of her time. I was drawn to this adventurous ingenue who had sailed off to China—photographed in a fur-trimmed coat and stylish hat that framed her Anglo beauty. In my fantasies, I sailed along with her.

Born on September 21, 1907, to John Moody Foster and Hannah Davis in Utah, Helen recalled setting out on her productive destiny at the age of eight. As a youngster, she became an instant winner of spelling bees and an admirer of writers such as Louisa May Alcott, Harriet Beecher Stowe, Sir Walter Scott, the Bronte sisters, George Eliot and Edith Wharton. She served as vice-president of her high school class in Salt Lake City, Utah, and became noted as the top A-student as well as co-editor of the school paper and yearbook. "Girls were always tandem with the male at the top," she said.

By the time she reached the University of Utah, she embraced the view that no American could ever write decent books, much less be published, unless he or she had stayed abroad long enough to gain a distant perspective on one's own regional situation. While a tidal wave of expatriates had flocked to Paris, 23-year-old Helen Foster created her own tidal wave and went the other direction—to Shanghai in August 1931. She passed the Foreign Service tests and joined the American Consulate General as a clerical secretary—only one of her jobs. She also worked as a stringer for the Scripps-Canfield League of newspapers based in Seattle to help revive the dead tourist trade to the "golden, glamorous Orient."

In her memoir, *My China Years*, Snow recalled her arrival:

"I stood in the prow [of the SS President Lincoln] facing the future like the figurehead on an old clipper ship, bursting with health and ambition. Getting to China had been a federal case for me, and I meant to make the most of it, not to waste one minute. My foot was on the rail, ready to step out on the soil of China as soon as the tender drew up to the jetty."

She intended to stay for only one year, but didn't leave Asia until nine years later.

"I was torn away from my goals [to write The Great American Novel] by the typhoons of history," she wrote.

Journalist Edgar Snow, meanwhile, had just returned from assignment in India. On the day of her arrival, he and Helen met at the Chocolate Shop—the only place in Shanghai to get a dish of ice cream. She had already intended to track him down, and carried a folder filled with clips of his articles. Her interviews were to be published by the Scripps-Canfield League.

The most revered American correspondent of the Far East married Helen in 1932, on Christmas day in Tokyo. Both were in step with the future and knew it. Edgar Snow referred to Helen years later in his book *Journey to the Beginning* as "the very unusual woman who was to be my frequently tormenting, often stimulating, and always energetically creative and faithful co-worker, consort and critic during the next eight years in Asia." When I asked Helen why she divorced him at the end of those eight years, she explained the decision simply: "Our marriage had just run its course. It was time to end it."

As Helen faced me from her armchair, she asked pointedly, "Have you ever heard of Ida Tarbell, the pioneer journalist who asked Owen D. Young, the top capitalist executive, what was the secret of his success?"

Her quizzing nature and blue eyes aroused my curiosity. "No,

what reply did she get?"

"Never repeat your own mistakes and also learn the mistakes others have made and never repeat them either."

Helen had reexamined her previous years and passed on a bit of advice. Her tone sounded slightly bitter and regretful. "I did repeat my own worst mistake, year after year. This was to sacrifice my own work for do-gooder activities, large and small, on the theory that there would be plenty of time later on for my own work. That time never came."

The activities she referred to were three significant events that placed her at the center of world history: initiating the December 9 student movement in China in 1935, embarking on a dangerous trip to Yenan in 1937, and launching the 'Gung Ho' Chinese Industrial Coopera-tive movement in 1938.

"I knew it was right. These [events] had a life of their own, apart from my own volition and against my sense of self-preservation. I was a pilgrim in search of facts and in search of truth," she wrote in her preface to *Song of Ariran.*

I had traveled more than 3,000 miles to thank her for document-ing Kim San's story. In my mind, her regrets weren't mistakes at all. If anything, the earlier clique of publishers were to blame because they had failed to disseminate the ideas of this independent-thinking journalist. In China, however, Helen's scholarly work is as highly esteemed as the contributions of her former husband. Upon her death in 1997, in fact, the Chinese held a memorial in her honor at the Great Hall of the People in Beijing, according to her niece Sheril Bischoff of Riverside, California. I've also learned that a school has been named after Helen in Sian.

During her nine years in China, Helen not only collected the material for three books; she participated in shaping the fate of China during wartime. She and Snow worked day and night supporting the student movement, from the fall of 1935 to 1936. They both sympathized with the youth of China and the youth of the world who were about to be drafted into big wars and slaughtered in the millions.

One of those students, Wang Ju-mei, later called Huang Hua, served as China's ambassador to the United Nations and minister of foreign affairs for many years. The students began to call at their house at 13 K'uei Chia Ch'ang in the fall after school started. As Chinese publica-tions banned the news, the students came by to find out what the Japanese were doing. Foreign correspondents, such as the Snows, were held in high esteem because of the critical information they gathered.

"Ed and I were in the middle of the anti-Japanese student move-

ment that broke out in December 1935," she wrote in her memoir.

In June 1936, Edgar Snow made his famous trip to Pao-an in North Shensi, where he collected material for *Red Star Over China* and had conducted interviews with Mao Tse Tung, Chou En Lai, and others who later became the leaders of China. His book is the only one on the Pao-an period and hers, *Inside Red China,* became the first to record the Yenan Period. Both books are still regarded as the most authoritative works on that period in China, according to Asia scholars.

Helen's notebooks on Yenan were collected when she made her own independent and dangerous trek to that region. She had to climb out of a back window of the Sian Guest House to escape to the Red Army-controlled area.

"I spent four months in the capital and collected interviews and other material for my three books," she said. They were *Inside Red China, Red Dust* and *Song of Ariran.*

Almost 60 years since its first publication, *Song of Ariran* has become a collector's item. The John Day Company Inc. first published the book in 1941, and it was later reissued by Ramparts Press in 1972. It saddens me that the book is no longer available, although I've learned that it may be reissued again. After an extensive search on the Internet, I found one Bay area book dealer selling an original hardback copy for two hundred dollars. I almost wrote a check to purchase it. "Helen would want me to have this," I muttered to myself. But just as I was about to mail the envelope, I decided against this extravagance. As much as I'd love to own an inscribed copy, my paperback copy will have to suffice. Besides, the curled pages, torn cover with a Chinese papercut design and unglued spine affectionately record the frequency of my vicarious escapes to Sian.

Helen's memory of that period—between mid-June and mid-August 1937—remained fresh when I interviewed her in 1985 for two days and again in 1990. In 1985, I wrote two articles for EastWest, an Asian community newspaper based in San Francisco. Five years later, I called Helen again to recall in more detail the writing of *Song of Ariran.* One of my professional mentors, investigator reporter K.W. Lee, urged me to pursue the follow-up interviews while I served as news editor for the *Korea Times English Edition* in Los Angeles.

"You've got to interview Helen before she dies. It would be a travesty to lose her eyewitness account of her meetings with Kim San," he said.

Fortunately, Helen expressed eagerness to share her memories—although this time, I interviewed her by telephone. Her keen memory hurtled her back into Yenan.

"There was nobody to talk to in English. I went up to the [Lu Hsun] library and asked the librarian, Agnes Smedley, who could speak English. I was told the one who took out the most books was a secret Korean delegate to the Chinese people councils [called soviets.] So I asked if she could arrange an appointment. And so she did."

The delegate had come to Yenan on behalf of a Korean socialist league to insist they have their own communist party in China. (The Japanese had colonized Korea since 1910.) Meanwhile, Kim San and other patriots had fled to China, where they could better support Korea independence from outside their country. China, considered an ally of Korea, would hopefully be open to Korean partisans joining China's revolutionary forces to defeat Japanese expansionism and fascism. Kim San supported himself by teaching math and science at a nearby university. After Snow sent him a letter via a messenger, more than a week had passed before the mysterious delegate visited the American journalist's temporary quarters at the Foreign Affairs Compound.

Although she wanted to pursue this young man, she also had other reporting objectives. Helen had left Beijing for Yenan to collect more than 34 life stories of Chinese communists, which were eventually documented in her two books: *Inside Red China* and *Red Dust*. The Chinese Communist Party had scheduled a secret congress, and Helen wasn't about to sacrifice the opportunity to secure the historical profiles of those individuals who would be attending. But she never expected to meet Kim San, a Korean revolutionary who had a story of his own to tell.

Her first impressions when they finally met: "He came to the door with his arms full of books on Korea and looked very businesslike. He was tall. His shoulders were straight, but he was very thin. His face was quite pale and he didn't look much like a Korean or Oriental. In fact, he looked Spanish or Italian."

Helen said she had never known any other Koreans before. But she had been to Korea for a month and had visited Geumgang-san—Korea's grand 'Yosemite' in the north. She told me that she wrote *Song of Ariran* under the pen name of Nym Wales, which Edgar Snow says partly came from Shakespeare (Corporal Nym who appears in "Merry Wives of Windsor" and King Henry V") and her parent's native land. Using a Waterman fountain pen—in her possession until she died—she collected seven notebooks of tales recalled by Kim San in "shattered English."

When he spoke about Korea, Kim San described it as a country so beautiful that "I want to take all of it in my arms and embrace it—the whole population, the trees, also the poplars." She recorded this in her notes

archived at the Hoover Institute at Stanford University in Palo Alto, California.

"We sat at a square Chinese table with very hard benches for chairs. He never squirmed around. Just sat there. He put his hands out on the table and didn't move them around. He had very shapely, masculine hands and nice eyes. And he was an animated person."

He learned English entirely from reading, she said. He had never been able to speak it with anyone before. "He didn't pay any attention to tenses. But strangely, we understood each other perfectly, as though we were communicating in Esperanto."

He had kept diaries for many years, written in code. And although he had periodically destroyed them, they served to fix incidents in his mind. Fortunately, he could tell wonderful stories. During those two, fateful humid months in the summer, the unlikely pair met two to three times a week in the late afternoon. Snow would document his life as he retold it in sketches, which included tales of his childhood, stages of his political development and the Canton Commune—a failed uprising in the 1920s, whereby thousands of Chinese and 300 Koreans were massacred. "They died like salt in water. No records. It accomplished nothing. He resented that, but he didn't let it cripple him in any way," Snow said.

Kim San also talked about his imprisonment in Beijing in 1930 and 1933 and his views on Korea, literature, art, love and marriage. He reminisced about cherished friendships with an ex-monk and communist named Kim Chung, a terrorist named Oh Song-yun whom he met in Shanghai at age 16; and Korean-American nationalist Ahn Chang-ho, whose second-generation daughter, Susan Ahn Cuddy, lives in Southern California.

The interviews began in June, Helen said. "I lighted a candle because of the dark and dreary room. My small room came with rats in it. Fleas occupied the floor, and the flies were thick."

In this room, located near the ancient loess caves and stone Buddhist temples, they visited together. Kim San began the memoir with his childhood. "I was born on a mountain in the middle of a battlefield. The Korean villagers had all fled to the mountains for safety during the constant fighting, and my mother had escaped to the site of our ancestral graves. That was on March 10, 1905, and the Russo-Japanese War did not end until August.

"My home in the little village of Chasan-ri on the outskirts of Pyongyang (in north Korea) existed under Japanese occupation." In addition to his parents and two brothers, six other family members lived in the same dwelling, a typical Korean house with a grass roof. The raised floor, he said, was made of stone covered with oil paper and heated by a

flue underneath for warmth in the winter. His most pleasant childhood memory evokes the image of a young boy snuggling close to a warm floor and bitter winds howling through the thick grass roof.

Between the ages of 14 and 32, his life would detail the unrelenting vision of Korean nationalists for independence from Japan. He became one of thousands of Korean patriots who crossed the Yalu River into Manchuria to help the Chinese revolutionaries defeat Japan and avert the fascist reaction that eventually led to World War II.

Kim San left home at age 14, after the failure of the March First (Samil) Movement in 1919 in which Koreans, including my grandfather-in-law, demonstrated and appealed to the world for independence. Kim San served three days in prison for participating in the street actions with other young students.

Between 1919 and 1928, he evolved through many different stages of political development: from a Korean nationalist to a member in the Chinese Communist Party. "These experiences had broken my health, but strengthened my spirit," he told Snow.

In one incident, he told of a day in Foochow, when Chiang Kai Shek's reactionary Kuomintang Army had occupied the city. The troopers ran into an old coolie with a big bag on his back. When they wanted to examine it, he claimed that potatoes were in the sack. But they discovered the bodies of seven two-year-old boys inside, whose organs had been sold for money. They had no brains, nor stomachs, and all the oil had been taken from their bodies by steam.

These events upset him psychologically. And at the time Snow met Kim San, he had already been suffering from tuberculosis and malaria, which he contracted in 1928. "We slept on the wet grass under hats in the mountains (and) had nothing to eat but sweet potatoes," he told her.

All of their discussions weren't grim. Snow and Kim San also shared mutual literary interests. "He suggested I read 'Grass Roof,' a novel written by Korean-American Younghill Kang in the United States. Kim San seemed well read and told Snow he had read Tolstoy, Dante and Jack London. He had also begun writing a novel about a Korean exile in Manchuria called *Shadows of the White-Clothed People*.

He also loved to sing, said Snow. Years before in Shanghai—where the Korean Provisional Government had been established by exiled patriots—Kim San met a Korean-American nationalist named Ahn Chang-ho who was the second-greatest personal influence on his life. Ahn, he told her, taught him songs he learned in America such as "Old Black Joe," "My Old Kentucky Home" and "Massas in the Cold, Cold Ground."

Like most Chinese revolutionaries in those days, Kim San did not have much of a personal life. Until he met his first lover in Hailufeng, he seldom paid any attention to the few female cadres he had met. He told Snow: "I have two sons. One I don't know where he is. In Hailufeng, I met a Cantonese girl, a relation of three months only and she became pregnant. She served in the women's army—she had unbound feet, was strong and beautiful. Where she is now, I do not know. In 1931, when I got out of prison, I had my other relation."

They had met while he lived in Beijing. The daughter of a high government Chinese official, she and Kim San were arrested by the Kuomintang police in 1933. A year later, Kim San—at the age of 29—married the woman named Zhao Ya Ping. She bore his second son, Gao Yong Guang, on April 20, 1937. But Kim San first heard the news in a letter sent by his wife. He never saw his second son or wife again.

Sacrifices, however, were the norm for revolutionaries. He told Snow he planned to go to Manchuria to join the Korean partisans. There he would be among his closest friends, including the ex-monk, Kim Chung-ch'ang. On the day before Snow left Yenan, she saw Kim San for the last time. He came to the compound to say goodbye, trusting that she would not publish his story for two years. In addition to her handwritten notes, she took only one photograph of him, which appears in the Ramparts Press edition of *Song of Ariran*.

In 1939, Snow spent 40 days at the Baguio Country Club in the Philippines to write "Song of Ariran." "I stayed alone there, and I tried to give it the best literary touch I could," she said. She returned to China afterwards, but eventually set sail for the United States at the end of 1940.

Kim San, presumably, headed north, his destiny uncertain. As he told Snow, "No Korean plans his grave. It might be anywhere, anytime."

Between the time I first interviewed Helen in 1985 and a final phone conversation I had with her ten years later, we had established a periodic correspondence. In my possession today are several typewritten letters, a manuscript about 'Ethics and Energism' and essays she sent to me, double-spaced on onion skin paper. One of them included her general views on writing. She wrote the essay for a new magazine in Japan at the urging of a Korean professor of literature and English. But I believe she sent me a copy as a mentor so I would glean her best lessons as a writer.

No. 1: "Nearly all writers should insist upon having a private room or a separate house, with no distractions at all. Then write about five hours a day or more, if conditions are good. My [former] husband, Edgar

Snow, always had a separate building or a wing of the house. I never interrupted him at all until lunch. No phone existed in his office when he wrote his books."

No. 2: "I discovered the most important thing about writing is that you must go directly to it as soon as you wake up from sleep. This is because the human brain grabs hold of the first experience that happens. You can eat breakfast, but don't ever read a newspaper, look at television or talk with anyone at all. I think Ernest Hemingway always left a sentence unfinished so his mind could grab hold of it the next day."

No. 3: "Great novelists or writers have to experience life outside of their own background. You can write about your childhood only when you are very grown up and able to look back with objectivity and nostalgia."

She co-authored one book with a Korean revolutionary and wrote her own memoir in 1984. Inscribed in my copy are these words: "For Brenda, one of the people for whom this book was written, hoping she will carry the torch. With every good wish, Helen Foster Snow."

My last phone conversation with her took place on March 7, 1995. We were still thoroughly engaged in our conversations. We talked about Korea's unfulfilled reunification. We also shared the titles of good books. She reminded me to study only the best biographies to understand people in different times and places. I had no idea then that I would later attempt to write a memoir of my own—inspired by her faith in me.

Helen once expressed that she hoped to see her book become a movie or a grand opera. "Wouldn't it be wonderful if an actor like Richard Chamberlain could play the part of Kim San?" She never saw *Song of Ariran* become a Hollywood film. Helen Foster Snow, a dear mentor, died in January 1997 at the age of 89. Her life—a grand opera of its own.

The Paper Route

Once a boy dreamt about what he would do with the paper route money he just earned. "With the money I earned I shall put it in the bank to double," said the boy.

"When the money is doubled I shall put all my other money earned in the paper route in the bank. Certainly I will have earned enough money to buy a new bike. With the new bike, I shall do wheelies and be the best kid in school."

And without thinking, the boy did a wheelie and his newspapers got thrown in the sewer. That ended his dream because when he got back he was fired.

Don't Count Your Money Before It's Earned!

Tommy's essay at age 9

Photograph by Larry Desmond, 1970

close encounters of a different kind

Gift of Love

"What a grand thing, to be loved! What a grander thing still, to love!"
Victor Hugo

Over the course of our grieving, friends often said, "You and Jan must've become closer after your shared loss." When I first heard this comment years ago, I bristled with anger. Closer? Somehow, that description seemed to miss the mark. Try lonelier. Helpless. Insecure.

Whenever Jan suddenly broke into tears, I would hold him close to my chest in awkward silence. During such moments, we were always physically available to each other. But the truth of the matter is that we had landed on different emotional planets. On days when I felt "well-managed," he oozed sorrow. We grieved differently, and some reactions, I've discovered, were gender-based.

In Jan's case, he buried himself in work. I, on the other hand, couldn't wait to leave the office and devour my grief literature at home. If I wasn't reading *Why Do Bad Things Happen to Good People?* I filled my emptiness by talking to friends on the telephone or crunching my grief away with a neat stack of sour cream Pringles.

Becoming closer certainly didn't mean having greater sex. Ask most bereaved couples and they'll tell you (assuming they're honest), that nothing destroys one's self-esteem and sex life quite like the death of a child. The absolute feeling of futility and helplessness make it nearly impossible to "give in bed." At least, in the earlier stages of grief. Simply put, it's too labor intensive. And if one partner is demanding IT—while the other withholds IT or reluctantly consents to give IT, you can pretty much bet that there will be worse forms of communication down the road.

If, by saying "getting closer," people meant we were becoming more co-dependent, that approximated a greater truth. Fortunately, most couples will never experience the degree of loneliness and helplessness that grief bestows upon bereaved parents. Sometimes I think we've become fraternal twins conjoined by a fragmented heart.

In our case, we've also tended to hug, kiss and cling more after Tommy's death, perhaps out of a primal need to verify each other's

physical presence. Simple overtures fill my emotional cracks. Romance, I'm afraid, is too labor-intensive. These days, we opt for less strenuous signs of affection. Even now, I feel most satisfied when I'm falling asleep at night, my right leg crisscrossed over his left. Or when we wake up on a Sunday morning—extravagant with time—Jan will indulge my unilateral pillow talks, mostly centered on my neurotic obsessions. Things like:

"Hon, I sure hope I die first because I don't want to bury you. I couldn't bear it."

"Well, that's a selfish thing to say."

"I know, but think of it this way. You can always marry some hot chick afterwards. Who would want to marry an old bag like me?"

In truth, I'm always testing Jan's reactions. Although my statements seem playful, deep down I know he knows that Tommy's death has gripped me with constant fears of abandonment. Whenever he has to leave on a business trip, I worry that his plane will crash—that I may never see him again. If I drop him off at the airport, our very last glance and smile at the curb always evoke tears from my eyes. (Is it no wonder that both of us have folders on our computer hard drives with instructions for the surviving spouse? Jan's folder is titled "Me." My folder, "Adios.")

"Call me when you land," I always remind him.

Members of our support group scared me even more. One of the parents reported that 70 percent of bereaved couples' marriages end in divorce. "We're doomed," I warned Jan. "Why do they scare us with such good tidings?"

"Aaaah, don't worry. That's only 20 percent more than the U.S. average," Jan reasoned with confidence.

Fortunately, we were married for 25 years when Tommy died. The biggest hurdle we had ever faced, up to then, occurred during a three-month separation in 1980. We had been married for 11 years. Radical politics and too much of an alternative lifestyle put a strain on an otherwise healthy and stable relationship. We survived that temporary marital glitch. And in comparison to our son's death, that was a piece of cake. A dress rehearsal, perhaps, for the final act.

When you say your marriage vows, as we did in 1969, you never know what challenges will test your mettle. We never expected to face the sudden death of our youngest son. What many people don't realize is that the first year of grief is typically a wash. I didn't cook dinner for at least nine months. The waiters at Sam Woo's in Irvine must've thought it strange that we would come to the same restaurant three times a week. "Tofu again?" asked the waiter, befuddled by our lack of imagination. We were more preoccupied by questions unrelated to food: Why us? Why

Tommy? Why then? Why did he die the way he did?

Although we had survived the first year, the second felt worse. Once you've buried the dead, paid the funeral bills, survived the first holidays without your loved one, and possibly…just possibly, packed a few of your child's belongings, reality rams its way back into your life. You stare into the void of a pathless universe—and wonder, "What now?"

To this day, I don't really believe that the death of a child causes divorce. It only exacerbates what already exists. Hopefully, a given couple can call upon the strengths of their marriage to survive, rather than succumb to the weakest links in their relationship. Two of our New York friends, Jeff and Laura Isler, warned us early on, "Make every effort to communicate openly and daily." They survived the loss of their baby daughter and knew the strain such tragedies could impose upon a marriage. In this regard, I've been very lucky, as Jan's patience and accepting attitude has never waned.

Although we share the same loss, our sorrows have circulated through separate mazes. Men and women do grieve differently. I've accepted this truth with ease and difficulty. Throughout the course of our marriage, we spirited the dual tracks of social activism and parenting. Now, with both of us immersed in our respective careers and adjusting to our lives as empty nesters and elder caretakers, we face another daunting panorama as aging boomers. Although we have both grown in our compassion, we also have become more self-indulgent and protective of our time and space. Jan swings a golf club. I place Reiki-guided hands on people's chakras. He blows a harmonica. I play the piano. He enjoys traveling on business trips. I hate crowds and airport Radissons.

Together, though, we also have built some new traditions in our marriage. Whenever he goes away on a business trip, he returns on Friday night—just in time for Date Night. Most of the time, we head to our local Edwards movie theater. Other times, we listen to jazz at Steamer's Café, a local club in Fullerton, California. More recently, we bought a used 1995 VW Eurovan/camper, similar to the one we drove in the early '70s. I suppose we both wanted to recapture our halcyon days as post-hippie newlyweds. Years ago, we'd stuff our backpacks with toothbrushes, jeans and T-shirts, and drive off to Carpinteria, a white-sanded beach near Santa Barbara. In those earlier idealistic days, we lived as though there were a million tomorrows.

Now, we meet each day with greater tolerance. On new terms. On new emotional terrain. For 32 years, Jan has been my constant companion. Although we often hum different tunes, raising David and Tommy has been our most creative collaboration. An encounter as improvisational and iridescent as jazz.

134 | Drawing by Tommy Sunoo, 1993

Everdearest Michelle,

I'm sorry I died, but I don't want anybody getting depressed about it. I feel I've lived a pretty good life, met good people and shared a great deal of experiences with many people. Gosh, I don't know how to end this letter since it's my last, so I guess I won't. I'll let you finish it...I don't want you to remember my corpse but to remember the time you and I _____ (Here's a hint. Keep the ending changing. And whenever you read this letter, keep a picture of me handy!)

Tommy at Age 15

Sunoo family Christmas card. San Francisco, 1984. Photo by Jan Sunoo

free fall

Gift of Faith

"Faith is the strength by which a shattered world shall emerge into the light."

Helen Keller

I've visited a psychic several times since Tommy's death. Each time, I've fooled myself into thinking that someone might be able to foretell the future and avert all imminent catastrophes. Never receiving these guarantees is a real bummer. But at the end of each session, my psychics have predictably asked if I had any further questions. I always did. "How's David?"

During one session, I spoke more specifically. "My son wants to jump out of a plane. What's with that?"

I explained the background to this drama. The three of us were attending a relative's wedding reception. In between the hors d'oeurves and the call to the buffet table, David leaned over and announced, "Mom, I'm thinking of skydiving."

"You're thinking of wha-a-at?" I responded, as I twisted a crab's leg asunder. "The last thing I need is to bury another son! Don't you dare do that to me. I couldn't bear it!"

Once the glass doors to the hotel dining room swung open, we curtailed the discussion until the car ride home. I begged the question.

"David, tell your Dad what you told me earlier."

"Go ahead. You tell him."

"Honey, David's thinking about jumping out of a plane. Tell him how stu-u-pid that is."

"Mom, you worry too much!"

"Jan…tell…"

"David, what interests you about skydiving?" my husband cut me off with precision.

"I don't know. I just think it would be fun."

"Assuming you land on your two feet!" I chimed in.

"Let David explain," Jan said, his eyebrows curling with impatience.

"I just want to see how it feels."

137

By then, I picked up my cues and listened without agitating myself into a hot flash. I posed more questions: where would you seek the training? How would you know if you were learning from an experienced skydiver? Would you jump solo or tandem? Meanwhile, my heart pumped in anticipation of the second son I would have to bury.

We didn't discuss it any further, except to caution him to take lessons from a reliable training program. But when we got home, I asked Jan what he really thought about David's seemingly self-destructive quest for adventure.

"Well, I'm not sure he's going to actually do it. The question is what it represents at this time in his life."

"You're right. If he said this right after Tommy died, I'd really be freaked out."

"Yeah, you're just projecting a mother's fears."

The first few years after Tommy's death, David understandably sunk into his own version of depression. He quit art school. He smoked marijuana. He got drunk on weekends. He basically shut down. Having been the first-born rebellious son, he suffered through years of survivor's guilt as though God had punished him for his teenage transgressions. He declined therapy, didn't care to join any sibling support groups and seldom shared his grief with even his closest friends.

"I don't want any pity," he'd explain.

Jan and I provided his only place of support. Starting with the day that Tommy died, the three of us have tried to communicate with honesty and gnawing vulnerability. I don't know if I would've revealed my sorrow so openly had it not been for the advice of other bereaved parents. They trusted the notion that we could be open with our grief and still let David know that we cared about his life moving on.

"Your surviving children will take their cues from you," we were reminded.

I appreciated the thoughtful advice. After all, where would David have possibly picked up the life tools to cope with the death of his younger brother and closest confidante? Tommy's death not only affected us, but David as well.

When I say that the three of us communicated well, I think what I'm really saying is that we all tried. Very, very diligently. Quite often, our talks occurred when he'd come home for a weekend dinner. Or when we'd drive up to Los Angeles to see him and check-in. We passed along whatever new insights we had learned from Grief 101. For example,

prior to Tommy's death, David had never heard of the term 'survivor's guilt.' It seemed to give him a handle on his own psychological sorrow. A focal point from which to measure his progress. We also shared why the anticipation of Tommy's birthday—or death date—caused the pop-up bouts of depression, anxiety or anger.

Indeed, the only thing more painful than my own grief was to watch—and imagine—David suffering on his own. I had Jan. Of course, David always knew we were there for him. But parents are one thing. What he didn't have for many years—and now does have—is an intimate partner with whom he can be embraced and loved for who he is. Healing, he learned, requires the constancy of trust and touch.

Very often, our friends would ask us, "How's David?" We spoke only of the given moment. When Tommy died, we surrendered all parental bragging rights related to the future. "He's horribly depressed." "Keeping himself busy and distracted." "Not good." "Doing Better." "Much better." "Starting to smile again."

I remember when David took art classes. Two years had passed since Tommy's death. He showed us a self-portrait that he drew in pencil. It only showed half of his face. The left eye appeared open, but dazed. The lips, pallid. It didn't worry me. Quite the opposite. He slowly came back into full view. His drawing taught me that people grieve and heal in their own way. In David's case, he didn't have to tell us when he was drowning or getting better. His sketches did the screaming.

Jan and I clearly wanted him to stay in art school. In fact, we promised to support him, as long as he did. But David kept telling us, "I don't feel inspired to draw anymore. And computer graphics are too sterile." Fortunately, my cousin Patti—a career counselor—warned us early on. "If he's already talking about dropping out, be prepared to accept his decision."

We crossed our fingers. Jan didn't want to witness another half-hearted attempt at college.

"If he quits school, then what's he going to do?

"Calm down," I said, in one of my more rational moods. "If David decides to quit and seek an alternative, that's not a bad thing."

My own words were a shock to me, too. But what I've experienced in the course of parenting—grief or no grief—is the inevitable struggle between enabling and allowing. I'd be the first to admit that we may have smothered too much attention on David in the earlier stages of our recovery. It felt right. (Yes, I bought him a new car so he wouldn't have to drive an unsafe vehicle on the Los Angeles freeway. Yes, I've attempted to bury his sorrow under mounds of steamy rice and a juicy T-bone steak.) Not to mention, the numerous times we transferred funds from our

checking account to his.

But there have been substantive decisions as well. Our family has a New Year's Eve tradition. Each of us writes down one or more new year's resolutions. We fold them into origami boxes, cranes or samurai helmets—stashing them away in a drawer until the following year. At midnight, we read the previous year's resolution to see who achieved their desired goals. (I never came on top because I made the foolish mistake of making weight loss my No. 1 goal. I have since changed my strategy.)

One year, I decided to face my parental insecurities—my anxiety about David's happiness, David's future, David's life. I wrote, "Back off. Let him grow in his own way."

I remember the day when he announced he quit art school, in favor of taking a clerical position in downtown Los Angeles. He knew he would have to start at the bottom of the rung. But with hard work, he could move up the ladder.

"My friend wants me to come work for her. She thinks I'm reliable and have great potential."

By the time he accepted the job offer, he had put aside any plans of jumping out of an airplane. The psychic explained it to me this way: "Your son is much stronger now. Could it be that he's no longer afraid to run the risk of living?"

His life, a free fall—flying at the speed of a sound wave.

"This morning, we took the tram to see the highest peaks in the Swiss Alps. I saw snow, wildflowers, a few forests, villages and even a glacier on our hike. The whole place looked spectacular."

Tommy at age 12

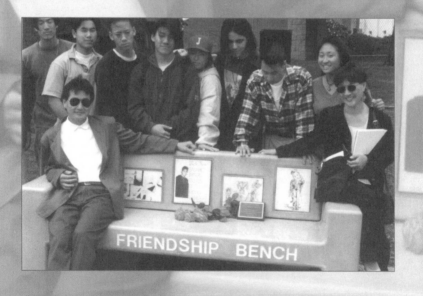

FRIENDSHIP BENCH

FRIENDSH

afternoon meditation
Gift of Meditation

*"Our existence is but a brief crack of light
between two eternities of darkness."*
Vladimir Nabokov

When we lived in San Francisco, Jan would often take a lunch break at Cypress Lawn in Colma, where his Grandma Shinn is buried.

"I like it over there. It's quiet. I eat my sandwich in the van, think about Halmoni, then take a 15-minute snooze," he said.

"Do you take flowers?"

"No, just my lunch. I go there to get away."

The more I thought about this ritual, the more I liked it. He seemed to free himself from expected duty, fanfare and unnecessary schmaltz. I, on the other hand, believed that as Tommy's mother I should visit Forest Lawn in Hollywood Hills on my son's birthday, death date, Easter, Mother's Day, Father's Day, Christmas, New Year's Day and of course, on Valentine's Day. No one told me to do this. It just seemed right. Until my support group pointed out, "Don't 'should' on yourself. It's not like you have to pay penance for Tommy's death."

Reassured, I abandoned my idealistic rules. A cemetery is only one of many places where a mother and father can mourn. One can go as little or as often as one feels the need. I have one friend, Astrid, who visits her son's grave several times a month. She lies on the grass next to Christian's colorful headstone, which is bordered by a rainbow and a photo of him proudly exhibiting his action figures for all to see. "I got power!" he says to his parents, friends and passersby. I have learned so much about others and myself when I observe how different individuals grieve. Astrid, for example, really aches for her four-year-old son who was struck down by a speeding train, due to the neglect of her babysitter's husband. On many of her visits, she curls her body into Christian's gravestone—warming it with her own tender flesh.

In my case, Tommy's gravesite is located more than one hour away from our home in Irvine. I barely make it into the city for my bi-monthly haircuts. But when I do visit Forest Lawn, I always feel as though

I'm visiting a temple. Even though people say, "He's with you wherever you go" or "It's only his physical remains that are there," I find peace knowing there is a community of the dead with a neighborhood of its own. A place where one can bow a head, offer a prayer, burn incense or even stick a cigarette into an empty flower vase, as David has done on several occasions.

"Can't you stop putting cigarettes in the flower vase? It's so filthy and irreverent," I remarked to David after one of my visits.

"It's all right," said Jan. "It's his way of bonding. Don't forget, the boys used to light up together."

Over the years, I've struggled to not judge the way individuals grieve, especially the three of us. God only knows how many dresses, shoes, capes, scarves and rings I've bought to accessorize my grief. There's no right or wrong way to mourn. No blueprint or box of instructions waiting in the mailbox to teach you how to crawl your way through the tunnel of despair. Whatever establishes the human-to-spirit connection is a very private and fruitful meditation.

For me, it might be a more conservative gesture: placing a bouquet of fresh irises or a bright trio of sunflowers on Tommy's gravestone. For David, I suppose, the cigarette became a symbol of their shared rebellions. Or a reminder of deeply exhaled discussions about girls, movies, art and sex.

In recent years, though, we've established our collective and separate days for visiting Tommy's gravesite. Because David lives in Los Angeles, he visits the cemetery more frequently. In the trunk of his Honda Civic, he stores a plastic bottle of mineral oil, a rag and paper towels to polish the gravestone during his occasional visits.

"Mom, don't worry. I'll pull the weeds that cover Tommy's name," he assures me.

Each time we visit, we observe different things. One time, I noticed a middle-aged Filipino man walking toward the gravesite next to Tommy's. He carried a clear plastic bag with a white booklet tucked inside. I couldn't take my eyes off of him. After all, he was visiting one of Tommy's neighbors, Crisanto C. Tolentino. Born: May 21, 1927. Died: September 30, 1994. "Beloved husband, father and grandfather. He lives in our memory forever."

As he knelt beside the gravestone, the man prayed for a few minutes and then placed the bag on the grave. Shortly after, he walked away as though his brief mission had been accomplished. I debated (for 15 seconds) whether or not I would even dare to peek in the plastic bag. Fortunately, the clear bag allowed me to peer into it without any difficulty.

The man must have been Tolentino's son. He apparently brought

his own son's high school commencement program to share with his father, the graduate's grandfather. I imagined that the elder probably bounced his grandson on his lap years ago, and that the man visiting the gravesite wanted to share this bittersweet event with the elder. I also envisioned that years from now, the two of us might see each other again at the cemetery—both of us with plastic bags containing wedding announcements of our respective sons. After all, we are occasional neighbors.

More recently, our family visits tend to fall on Christmas and Tommy's birthday. Beyond that, Jan and I go as a couple or alone. On another occasion, I visited the cemetery in late June. After a late morning haircut in Los Feliz, I decided to pick up some sushi, and write in my journal while sitting on a Japanese tatami mat that I kept rolled in my trunk for outdoor occasions.

I exited on Forest Lawn Drive and drove past the massive iron entrance gates. I then followed the lane to the Vale of Hope. We chose this spot for several reasons: the view of the entire cemetery, cheaper plot rates than those at the Court of Valor, where my parents and grandmother are buried, and because the Walt Disney Studio's animation division is located nearby. You can't miss it. Driving along Forest Lawn Drive, you can see the sky blue and white-starred sorcerer's cone that Mickey Mouse wore in the animated movie "Fantasia." Tommy had dreamed of becoming an animator. And I had once left a Fantasia-themed pencil at the gravesite in memory of his whimsical art. Being close to the institute, we could imagine what his future may have been like. We also fancied the notion that Tommy's gravesite was located near the marble crypts of actors Lucille Ball and W.C. Fields.

"Wow," David said, upon learning that his brother rested in peace among Hollywood's favorite comedians. "Tommy would dig this."

I think of these amusing tidbits whenever I walk up the gentle slope leading toward his gravesite. Our family can always find it because we look for the two pine trees, our permanent guideposts. When I visited the cemetery on this particular day, I sweated under a blazing sun. I rolled out the tatami mat and started talking to Tommy.

"Hi, honey. It's me. Mom." I looked around to make sure no one heard me. "Look, today is a very hot day in June. I forgot my umbrella, so I'm not going to stay very long. You know how I hate the heat." I convinced myself that he empathized with my discomfort. Once I finished my sushi, I headed for the shady pine tree. Looking back at the gravesite, I threw him a kiss.

"Tommy, I won't be far."

Castlemaster, an ink drawing by Tommy Sunoo, age 16, 1993

"Woke up crying today. I had a dream that my mom had another kid and my Grandma died at the same time. I'm positive it had to do with Grandpa [dying]. Went out with Mimi today. Twas fun. We cuddled, we kissed and we talked. What else could a guy ask out of a girl? Trust!"

Tommy at age 15

Dear Vater,

Hope you've had a happy birthday... Thanks for putting up with all of my little adventures and mischievous escapades. It may have been a tough 16 years but don't worry 'cuz I'll make sure the next 20 will be even tougher (have ta keep you on your toes dontcha know).

Mit Liebe,
Tammy

last day, first day
Gift of Dreams

"Dreams...are sent by Zeus."
Homer

I flung my car keys in the air. Tommy snatched them in mid-flight—his eyes flashing in disbelief. Three months had passed since he turned 16 and obtained a driver's license. But we hadn't come to any agreement about his using my Volvo.

"Is this for real?" he asked.

I nodded. "Just drop me off at work and pick me up on time, OK?"

"Cool."

"And Tommy, no ditching off campus."

"Mom, trust me."

"Yeah, right."

Three hours later, I heard my page over the company intercom. It sounded off a little before noon— February 16, 1994. Expecting a call from one of my magazine sources, I walked out of the conference room to my partitioned space next to the lunchroom.

"Hello."

"Mrs. Sunoo?" asked a woman's voice. "This is University High School in Irvine. Your son Tommy collapsed in the gym while playing basketball. Can you come to the school right away?"

"No....I mean, yes. My son drove me to work today. He's got my car. I'll have to get someone here to drive me. Is he all right?"

"We don't know. Please hurry to the school."

After I hung up, I took a very deep breath and started biting my lower lip. Of all days for this to happen—the very first day my 16-year-old son had assumed his new privilege. I was stranded. Within seconds, I felt a sharp propeller wrenching my stomach. But I calmly walked back to the conference room and announced that I needed a ride to the campus.

"Can someone please take me to my son's school? I have an emergency."

"I'll drive you," said Allan Halcrow, my then publisher. His quickness took me by surprise. We had hardly worked together since I had started my new job a month earlier at *Workforce,* a national business magazine. Allan is a tall, lean man with quiet resolve, a choirboy face and

a soothing voice. "Everything will be all right," he said. No sooner had he taken the keys out of his pocket, than I received a second phone call. The lady's words were more hurried than before.

"Mrs. Sunoo. This is Uni High again. Stay where you are. We're sending the campus police to come and get you."

"OK," I said, halfway suppressing the alarm I began to feel. I didn't want to jump to any conclusions. After all, over the years, school clerks had called me whenever Tommy complained of a fever, cut his finger or skipped class. I had no reason to believe this time was any different.

Nevertheless, as I sat at my desk waiting, I grabbed my purse out of the steel drawer, shoved it into my tote bag and shut off my computer. I began to wonder what might be wrong with Tommy. He must've been tired. Probably stayed up until 3 a.m. again playing computer games or chatting online. Maybe he has epilepsy, and I never realized it. In my nervousness, I began to stack my story files on the desk in case my boss would need to delegate my duties to the other staff writers. That's the tao of shock; individuals activating their compulsive rituals. I obsess over logistics, deadlines and schedules. In those few moments, I had already decided to take off the rest of the week and return on Monday.

No sooner had I convinced myself that I maintained control when I received the third phone call. "Your son isn't responding well. We're sending him by ambulance to Irvine Medical Center. Please meet us there as quickly as possible." As Allan drove me to the hospital, we hardly exchanged a word during those ten minutes heading south on Interstate 405. My eyes were fixed on the freeway signs ahead so we wouldn't miss the Sand Canyon exit. As we whizzed by the orange groves, I began to speculate: Could the problem be something Tommy ate?

I replayed our earlier hours at home. Jan, Tommy and I ate our usual breakfasts before 8 a.m. Jan woke up first as always. Brewed himself a cup of coffee, fried an egg with a couple of Brown 'n Serve sausages and toasted a slice of sourdough French bread. Then he got Tommy out of bed to eat his bowl of Honey Bunches cereal. I trailed behind and shoveled some cold rice into a bowl and microwaved it with leftover chicken-and-broccoli stir-fry. Jan and I always seemed to eat more than Tommy, a lean, 5-foot-8-inch teenager. But parents have to pick their battles. Sometimes food just doesn't rank as important as your kid taking out the trash, giving up smoking, learning German vocabulary, washing the car or picking up a job application at Ranch 99, the local Asian food store in Irvine.

"Tommy, did you finish all of your English homework?" I asked.

"Yeah."

"What about your art project?"

"Yeah."

"Great. Then here," I said, throwing my car keys in the air.

Within minutes, we were both off to work and school.

As soon as I entered the emergency room, a young admitting clerk greeted me. My watch read 11:25 a.m. The woman immediately whisked me away into the employee lounge. I knew she meant well, but her pacifying arm around my shoulder intensified my fright.

"Mrs. Sunoo, please feel free to sit here in private until Dr. Kim talks to you. I can get you coffee. And you can use the phone on the wall. Let me know if there's anything else I can do."

"Where's my son?" I said in a lowered voice.

"He's in an emergency room nearby. The doctors and nurses are doing everything they can for him. We'll keep you informed."

The door closed and she left me in the room by myself. Even the painting of a snow-covered village in ice blue and white cast a lonely chill. The pink Formica lunch table barely revealed signs of life—just a few specks of salt and pepper, a smudged paper towel and a bent paper clip.

Feeling useless, I grabbed my organizer and starting calling my two cousins who lived in Irvine: Howard, a pastor and Fred, a Von's market produce clerk, who had always been like a brother. Although my 20-year-old son, David, also lived in Irvine, I didn't call him until my cousins arrived at the hospital to give us emotional support. I tried to locate Jan and must have made half a dozen phone calls to family and friends who asked me, "What's wrong? You sound upset. I haven't heard from Jan today. If I do, what should I tell him?"

"Just tell him to call me at this number: 714-753-2250."

I wished Jan had a beeper. But Tommy became the first one in our family to have the latest widget. He always knew what electronic game or gadget he wanted to buy next. Among his friends and cousins, he wore the title of a Nintendo Mario Andretti. The rest of us were either too cheap or techno-backward to understand the merits of owning such paraphernalia. As long as they were coming out of his allowance, we didn't object. We believed he'd learn responsibility that way.

Now, each breathless second diminished my faith in his survival. I wanted to talk to the doctor, but I didn't want to see his grim face darken the room. By 12:30 p.m., I began to plead with God. "Don't let Tommy die." Then I felt guilty for even thinking of death. He will be OK. He will be OK.

During the next 15 minutes, Dr. Kim entered the room twice. The first time he said, "We're doing everything we can. There are several doctors and nurses with your son." The second time he shook his head. "Your son isn't responding." I felt too numb to ask, "Responding to what?" His basketball coach, who followed the ambulance to the hospital, told me scant details. Other students, he said, were watching Tommy block, crossover and allyoop from a glass-enclosed cage above the bleachers. He suddenly grabbed his left arm with his right hand before collapsing on the gym floor. The campus policeman, Eric Bianchi, began CPR until the paramedics arrived. By then, Tommy went into ventricular fibrillation without any pulse or respiration. He arrived at the hospital in full cardiac arrest.

At 12:54 p.m., seconds after I glanced at the clock, the doctor entered the lounge for the last time. I quickly jumped up from my chair while my cousin Fred instinctively moved closer to my side. "I'm sorry," said the doctor. "We tried everything we could. We weren't able to save your son."

A lightening bolt suddenly ripped into my stomach—the sacred cradle in which I had rocked my son. "No-o-o-o-o-o, God, no," I could hear myself wailing over and over again. As my body curved into convulsions, my mind snapped in disbelief. Every mother, I suppose, prays she won't face this abrupt, terrifying moment. And now, my worst fears came true. Even my cousin's firm grip underneath my elbows couldn't prevent my legs from buckling. The pronouncement left me breathless, as I collapsed into Fred's rescuing arms.

"How could Tommy be dead?" Just a few hours earlier, we had laughed about the new pair of Dickies pants he wanted to buy for school. I could still hear his words echoing in my ear. "Mom, can we drive to K-Mart to get my Dickies?"

"I don't know," I replied. "The cops are going to think you're a gang banger."

"Sheesh, Ma, what do you want me to wear? White T-shirts and Bermuda shorts like all of them Irvine nerds?"

Leaning against my cousin, I hobbled back to the chair. The doctor remained silent. He let me sob and wipe my face before asking me, "Would you like to see your son now?" After trusting myself to stand, I asked my pastor-cousin, Howard Yim, who had arrived earlier, to accompany me into the room where my son's body lay. I clutched his sleeve as I inched toward the black stretcher on wheels.

My steps were uncertain, like a one-year-old's. At first, I just stared at Tommy's firm body without even touching him. I could see no bullet,

blood or broken bones to verify his sudden death. Only a thin cotton sheet to drape it. Denial protected me like a blanket. How could my child, whose Korean name, Inchull, means steel, be lying on a gurney with plastic tubes snaking out of his nose? If it weren't for the gold hoop still inserted in his left earlobe, I might have even believed this was a case of mistaken identity. I stepped closer. Tommy appeared peaceful, as if he could be adrift in dreams—the way he always looked before we nudged him from his sleep in the morning. Whenever he fell asleep as a baby, his father and I used to place our ears to his cheek every night—just to assure ourselves that we could hear and smell his milky breath. I stared at the cracks in the ceiling, fretting that the plaster might fall into his crib. Now, there was no human sound. Only the faint whir of an air conditioner. Tommy lay there in his blue sweat pants and Nike Air Charles Barkley shoes still sealed to his feet. I almost nudged him, but my pastor interrupted my hopeless reverie. "Brenda, let's pray."

By 2 p.m., one of Jan's colleagues had finally located him in Long Beach. In my desperation to summon him quickly, I had to make the most painful choice of my life. Should I tell him on the phone that Tommy died or let him find out when he arrived? If I said, "Tommy is in the hospital," Jan would ask why, and I wouldn't be able to lie without breaking down. He'd hear the crack in my voice even if I tried to compose myself.

"Jan, Tommy died."

After a brief second, he must have let go of the phone. I could hear him sobbing uncontrollably. It seemed so heartless to tell him this way, but I kept thinking, "He's Tommy's father. He shouldn't be the last to know."

"What happened?" he asked in a broken voice.

"I don't know," I stuttered between my crying. "He collapsed at school, and they brought him here to the hospital. You've got to come right away. The doctor promised to let us be together before the coroner takes his body away. David's already here. Fred picked him up earlier. Don't drive here yourself. Fred will come and get you too."

When Jan arrived, the doctor kept his promise. "Take as much time as you need to be with your son." The three of us reentered the room where Tommy lay. Jan immediately buried his face on our youngest son's chest. Here we were, the four of us. Our last communion as a family. We ran our hands across Tommy's adolescent stubble and kissed his face. It even seemed to warm to our caresses. With conscious hands, I gently covered his mouth and nose with the white sheet so the tubes wouldn't show. I couldn't bear the clinical evidence of the grief that was to follow. But David lifted the sheet, exploring his brother's arms, chest and hairy

153

legs, hoping to discover some explanation—or more likely—a mistake. At one point, he almost rolled back Tommy's eyelids.

"What are you doing?" I asked nervously.

"Maybe I can find a sparkle in his eye," he said, "some sign of life." But he decided not to touch his eyes after all—anxiety and fear prevailing over his curiosity. David expressed fear that if he did, he might find Tommy's soft eyes hardened like plastic domes glued on a stuffed animal.

We huddled together as Jan gripped our shoulders tightly, three heads bowed in prayer. None of us wanted to leave the room. We knew the next time we'd see Tommy's body, it would be cold and stiff—a husk without any sweat or heartbeat to place beneath our hands. None of us believed in reincarnation. But even then, as numb as we were, I began to wonder, "Where is he?"

When the three of us arrived home from the hospital, David immediately walked into Tommy's room. As if guided by a divining rod, he went straight to the desk, which stood underneath a pine loft. Inside the drawer, he reached for a letter Tommy had written to his soulmate, a 17-year-old Korean girl named Michelle. We had all seen the letter several months before on his desk, but no one dared to open it. The two had met in junior high school and had grown to be the closest of friends—but not in the way Tommy, presumably a virgin, had fantasized. For some compelling reason, he penned this letter and folded it into an origami helmet with the explicit warning: "Michelle—For Your Eyes Only."

David opened it and began reading it aloud:

"Dear Michelle, If you're reading this, obviously I'm already dead. Well, if I'm dead, you better savor this letter since it's the last thing I'll ever get to say to you. To start things off, I just wanted to say how much I valued you as the only person who never let me down. You've always been there for me when I needed you—giving me advice, telling me what to do with my hair, and making me a better person altogether. Oh, also thanks so much for introducing me to God. At least I'm waiting for you in Heaven (I hope) rather than sitting in the fiery depths of the place down under (not Australia!) N-E-WAYZ, there's a few things I need to ask of you for my coffin. I want you to make sure that they bury me in clothes (that you approve of), a pencil, my hair fixed up cool (make sure they cut off my tail and give it to you!), a picture of you and me, and I want you to write me a final letter so you can let me hear you one last time and help yourself cope with my death. It's good to write down your feelings, y'know.

"Well, I've said my piece. Just remember that I'll always be with you, always be watching over you and always waiting for you. But don't get spooked out if you see me as a ghost. Don't run! And please tell my family I loved them."

Love, Tommy

The next morning, raindrops were tapping on the skylight above our futon. I could smell the dampness of quietude—an invisible mixture of dew and dust. Turning over on my left side, I saw a reflection in the cold mirrors attached to the sliding closet doors. A worn couple lay buried underneath an oversized down comforter—their bedroom, sparsely decorated with white carpet and white bookshelves. Jan seemed deep in slumber. His warm body next to mine, a queer reminder that we were stlll alive. David had stayed overnight, nesting himself in a sleeping bag beside Tommy's bed. He must have left the radio on all night because I could hear faint voices cooing behind the half-shut door. But none of them resonated with familiarity.

Staring into a void, I pondered my son's letter to Michelle. The symmetry of his death occurring exactly one year after my father died. Tommy once confessed, "I can't imagine getting old like Grandpa."

If only I could hear Tommy clicking the iron gate, his feet shuffling through our tropical-ferned courtyard. But hearing no such sounds, I fell asleep again. My exhaustion served me well. Tommy quietly appeared in a dream, as he still often does. Standing before me in his baggy pants and hooded burgundy sweatshirt, he handed me the car keys.

Moment, stay awhile. You are so beautiful.

Photo taken December 1993.

"About my odd dream: I dreamt about how I was going to die! It was weird. In my dream, I swore it was real. I remember coping with it by making a large sandwich. I remember being so scared. To cease to exist, to cease to think...it really shook me up. I really don't know how to describe it. I was scared, but I was calm, not hysterical. And I was sure it wasn't a dream! That was two days ago, and I'm still thinking about it. It literally made me shudder. Dead. Just the word scares me. I wonder if this has anything to do with my being mugged the other day? I also for some reason or another remember being at the corner of a store with a lot of windows. And in my dream, everything looked bright. Maybe it means heaven. At any rate, I can't describe how much death horrifies me. People just take life for granted. It makes me want to cry to think that I'm going to die. Lord, help me! Please...Well, from now on, I've got to live life to the fullest. That's my new motto!"

Tommy at age 14

1. I wish i was Superboy
2. I wish i was rich
3. I wish I would stay Six for ever

author's epilogue

It's been 12 years since my son Tommy died, and six years since I completed the first draft of the manuscript in 2000. Since then, *Seaweed and Shamans* has undergone further revisions. Also, two chapters have been published in full or shorter versions on www.salon.com and in the anthology *Asian-Americans: The Movement and the Moment.*

In 2002, my husband and I moved to Hanoi, Vietnam for his three-year work assignment with the International Labor Organization. Although I have continued my freelance journalism and photography, I have also provided online grief counseling through www.sharegrief.com and compiled grief recovery resources through my website: www.compassionatwork.com.

You may wonder after a decade, are we finally healed? If being healed means living your life more meaningfully, and accepting the bittersweetness of it all, I would say, yes. Laughter and joy did return into our lives.

BPS
Hanoi, Vietnam
2006